Leckie×Leckie
Scotland's leading educational publishers

National 4 & 5
GRAPHIC COMMUNICATION
COURSE NOTES

N4 & 5 GRAPHIC COMMUNICATION COURSE NOTES

P Linton • S Hunter

TABLE OF CONTENTS

CONTENTS

CHAPTER 01

INTRODUCTION TO THE GRAPHIC COMMUNICATION COURSE

WHAT YOU WILL LEARN

- **The structure of the course**
 units • assignment • exam

- **How you will learn skills**
 your path through the course • using this book

- **How you will be assessed**
 assessment standards • assessment mapping

- **The exam paper**
 content • marks • duration • study skills

ASSESSMENT MAPPING

PROJECTS, ACTIVITIES AND ASSESSMENT

The table below shows how the projects, activities and drawings in this book fit the assessment standards across both units.

Assessment standard		Page	Chapter
1.1	Produce orthographic sketches	53	Freehand sketching
		156	Project: gizmo
		166	Project: sports bottle
1.2	Produce orthographic drawings	22	2D drawing techniques
		166	Project: sports bottle
1.3	Extract information from drawings to inform new drawings	22	2D drawing techniques
		166	Project: sports bottle
1.4	Identify and apply drawing standards	18	Drawing standards
		58	Construction drawings
		166	Project: sports bottle
1.5	Explain CAD commands and techniques	62	Computer graphics
		71	2D Computer-aided design
		166	Project: sports bottle
2.1	Produce 2D Illustrations	146	Pencil illustration
		96	Computer illustration
		156	Project: gizmo
2.2	Plan layout and colour schemes	149	Project: graphs and charts
		156	Project: gizmo
		166	Project: sports bottle
2.3	Explain aspects of colour theory	142	Colour
		149	Project: graphs and charts
		156	Project: gizmo
		166	Project: sports bottle

(left column labelled: 2D graphics unit)

Assessment standard		Page	Chapter
2.4	Plan and justify choice of information graphic	149	Project: graphs and charts
2.5	Identify design elements and principles	131	Design elements and principles
		149	Project: graphs and charts
		156	Project: gizmo
		166	Project: sports bottle
3.1	Produce single page layouts	131	Design elements and principles
		149	Project: graphs and charts
		156	Project: gizmo
3.2	Produce an information graphic	149	Project: graphs and charts
3.3	Explain DTP terms	109	Desktop publishing
		149	Project: graphs and charts
		156	Project: gizmo
		166	Project: sports bottle
3.4	Explain impact of GC on society and environment	13	3Ps
		109	Desktop publishing

(left column labelled: 2D graphics unit)

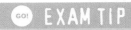 **EXAM TIP**

The chapter on visualisation (pages 49–52) provides exam practice.

"IMAGINATION IS MORE IMPORTANT THAN KNOWLEDGE ... KNOWLEDGE IS LIMITED. IMAGINATION ENCIRCLES THE WORLD."

Albert Einstein

INTRODUCTION

WHAT IS GRAPHIC COMMUNICATION?

Using graphics to communicate information is an essential part of our society, our industry and our commerce. In fact, the need to understand, interpret and create graphics has never been as important as it is now in the global market place. Graphic communication breaks down language barriers, promotes trade and provides a shared understanding between societies and cultures.

PURPOSE AND AIMS OF THIS TEXTBOOK

To help you develop graphic skills and acquire graphic knowledge, this book covers:

- **skills** – vital when creating different types of graphics
- **knowledge of standards and conventions** – crucial when reading and interpreting drawings
- **creativity** – essential when developing promotional graphics
- **problem-solving** – indispensable when developing solutions to graphical problems
- **knowledge of equipment and technologies** – important when learning new software and drawing techniques
- **the impact of graphics on society and the environment** – essential in understanding the many roles of graphic communication in our world.

PRIOR KNOWLEDGE

This book covers N4 and N5 Graphic Communication. Ideally, you should have completed Level 4 Broad General Education (BGE) in Technology to tackle the N4 course and either Level 4 BGE or N4 Graphic Communication as an entry to the N5 course. You may access National 4 Graphic Communication from Level 4 BGE or National 3 Design and Technology.

THE STRUCTURE OF THE GRAPHIC COMMUNICATION COURSE

The course has four main sections.

2D GRAPHICS UNIT — PASS OR FAIL ASSESSMENT

The 2D unit covers orthographic projection, including sections and assemblies, and geometry (cylinders, prisms, cones and pyramids). It also covers project work in 2D illustration, graphs and charts, and DTP layout.

3D GRAPHICS UNIT — PASS OR FAIL ASSESSMENT

The 3D unit covers pictorial drawing: isometric, oblique and planometric, one and two-point perspective sketching. It also covers project work in the form of 3D computer modelling, pictorial illustration and physical modelling.

ASSIGNMENT — ASSESSMENT 60 MARKS

The Assignment is 50% of the course mark and is completed in class time. It starts with a design brief and allows you to demonstrate your skills in preliminary, production and promotional graphics. The unit projects will prepare you to do your best work in the Assignment.

COURSE EXAM — ASSESSMENT 60 MARKS

The exam lasts 1½ hours and represents 50% of the course mark. It tests your understanding of: CAD, DTP, creative layout techniques, drawing standards and conventions, visual literacy and the impact of graphics on society and the environment. It requires written answers and sketching is encouraged as it can help explain your answers fully.

HOW TO USE THIS BOOK

Drawing topics in the book are arranged in groups (geometry, pictorial views, assemblies and sections, for example) and in an order that your teacher is likely to follow in class. Following the step-by-step guides will help your drawing board and CAD skills, and improve your problem-solving skills.

Knowledge sections, covering topics such as DTP and 3D modelling, creative layout, colour theory and building drawings, will support your learning when your teacher introduces them in lessons.

Project work, including 2D illustration, graphs and charts, 3D illustration, 3D CAD and physical modelling, demonstrates techniques and will help develop your skills and creativity.

Your teacher will decide whether you tackle the **units** one at a time or mix and match your project work between the units. It does not matter: you will learn the same skills and enjoy the creative design work and the problem-solving approach to drawing and modelling.

WORKING THROUGH THE COURSE

How you progress through the course will depend on what your teacher thinks is best for you.

- You may learn most of the drawing skills on a drawing board before learning CAD skills on the computer.
- Alternatively, you may learn most of the drawing skills on a computer and do very little work on the drawing board.
- It is more likely that you will learn key skills on the drawing board and transfer your knowledge to the computer to develop CAD skills.

WORKING WITH THIS BOOK

PROJECTION METHODS – STEP-BY-STEP GUIDES

Each drawing topic is presented in a way that demonstrates orthographic and pictorial projection methods. You will learn these techniques using either a drawing board or 2D CAD software, or both.

3D CAD TECHNIQUES – STEP-BY-STEP GUIDES

The drawing topics are also demonstrated using 3D CAD software. This way you will learn how to draw using both 3D and 2D methods. You will learn CAD techniques quickly by creating models of items that you know already, from the drawing board or 2D CAD.

GRAPHIC KNOWLEDGE – LEARNING THE THEORY

Sections on DTP and CAD will help you gain essential knowledge to prepare you for the course exam. Producing creative layouts and tackling CAD projects will be made easier.

PROJECT WORK – CREATING AND PROBLEM-SOLVING

Designing exciting promotional layouts should be creative, challenging and fun. This book will give you the skills and confidence to tackle design tasks successfully. You will experience working from a brief and develop problem-solving skills to carry with you after you complete this course.

SUGGESTED LEARNING PATH

This route through the course will help ensure that your learning builds on prior experience and that your skills and knowledge improve progressively.

The key to success in graphic communication is to see all of the skills and knowledge in the course as linked and to learn these skills by working through design tasks. Develop your creativity by learning skills and using knowledge to produce exciting layouts and stunning graphics.

Bear in mind that this is not the only way to approach the course; your teacher may have a different and equally successful route in mind.

THE EXAMS AND THE COURSE

Only the National 5 Graphic Communication course requires that you sit a course exam. If you are taking the National 4 course, your assessment will be based entirely on your Added Value Assignment.

The National 4 qualification is assessed at pass or fail – there is no grading at N4. The tables below show the differences in assessments of the National 4 and National 5 courses. Both courses require that you pass each unit.

NATIONAL 5 ASSESSMENT

Assessment format	Marks available	Time available	Conditions of assessment	Grading
2D Graphic Communication Unit	Pass or Fail	Duration of the course in class time	Open book and in class	Pass or Fail
3D and Pictorial Graphic Communication Unit				
Assignment	60	All work done in class time	Open book Assignment of ten (maximum) A3 size sheets	Marks are combined and graded: A, B, C, Fail
Exam	60	1hr 30m	Under exam conditions	

NATIONAL 4 ASSESSMENT

Assessment format	Marks available	Time available	Conditions of assessment	Grading
2D Graphic Communication Unit	Pass or Fail	Duration of the course in class time	Open book and in class	Pass or Fail
3D and Pictorial Graphic Communication Unit				
Added Value Unit (Assignment)	Pass or Fail	All work done in class time	Open book Assignment of ten (maximum) A3 size sheets	Pass or Fail

STUDYING FOR YOUR EXAM

Start your preparations in good time – there is no sense in trying to do it all in the few weeks before the exam. Your preparations should include:

- learning each topic as it occurs in your class work
- completing any homework that is given to you
- revising the topics covered in this book
- using specimen exam papers to give you a feel for the exam style and content.

If there are aspects of the course that you do not understand, look them up in this book and ask your teacher to go over them with you.

THE EXAM

Be well prepared. It does seem an obvious thing to say but you will not pass the exam if you don't know the topics. Take time beforehand to discuss your weaker areas with your teacher. In the exam you can tackle questions in any order, so do the ones you find easy first. Once you have completed these, go back and spend time on those that you find more difficult.

Look at the marks given for each question. These are a good indicator of the length of answer you should give. For example a 3-mark question will probably mean you should make three points, while a 1-mark question may only require a short answer.

TIME GUIDE

The duration of the exam is 1 hour 30 minute (90 minutes). 60 marks are available and this equates to 1.5 minutes per mark. Check the marks available for each question and use them as a guide to the time you should spend on each one.

SKETCHING

The questions are prepared in such a way that they can be answered in writing. However, some of the questions can be tackled more quickly and effectively if you use annotated sketches to explain your answer. Modelling plans that describe how you would model components are a good example. Make sure your sketches are clear and your annotations correctly explain the process you are describing. This book will show you how.

PREPARING FOR YOUR EXAM 2

EXAM TOPICS AND REVISION GUIDE

The table below lists all seven exam topics that will be covered in every National 5 course exam. These are the topics you need to prepare. The second column lists the best sections in the book to help you study and revise each of the exam topics. The fourth column shows the sections in the book that provide additional information to support your study. Use this table to help focus your exam study.

"VISION IS THE ART OF SEEING WHAT IS INVISIBLE TO OTHERS."

Jonathan Swift

	Exam topic	Best section to study	Page	Relevant information also found in these sections	Page
1	Demonstrate understanding of basic computer-aided design and/or draughting techniques.	Computer graphics Computer illustration 2D CAD and 3D CAD Desktop publishing (DTP)	62–70 96–108 71–74, 75–95 109–130	Course Assignment 3D graphics – Project: sports bottle 2D graphics – Project: Gizmo	183–197 166–176 156–165
2	Explain why graphic items have been used in specific situations.	3Ps Construction drawings Project: graphs and charts	13–17 58–61 149–155	Drawing techniques	22–38, 39–43
3	Explain the advantages and disadvantages of manual and electronic methods.	3Ps Computer graphics Computer illustration Desktop publishing (DTP)	13–17 62–70 96–108 109–130	2D CAD 3D CAD	71–74 75–95
4	Demonstrate spatial awareness by responding to and/or interpreting given sketches and drawings.	Drawing techniques Visualisation Freehand sketching Project: physical modelling	22–38, 39–43 49–52 53–57 177–182	2D CAD 3D CAD Construction drawing	71–74 75–95 58–61
5	Demonstrate knowledge and understanding of drawing standards, protocols and conventions.	Drawing standards Dimensioning Construction drawings Sections, assemblies and exploded views Project: physical modelling	18–21 21 58–61 44–48 177–182	Drawing techniques	22–38, 39–43
6	Define and describe use of colours, layout and presentation techniques.	Design elements and principles Desktop publishing (DTP) Colour	131–141 109–130 142–145	2D graphics – Project: gizmo 3D graphics – Project: sports bottle Project: graphs and charts	156–165 166–176 149–155
7	Comment on graphic communication as it impacts on our environment and society.	DTP (selected pages) 3Ps	109–130 13–17		

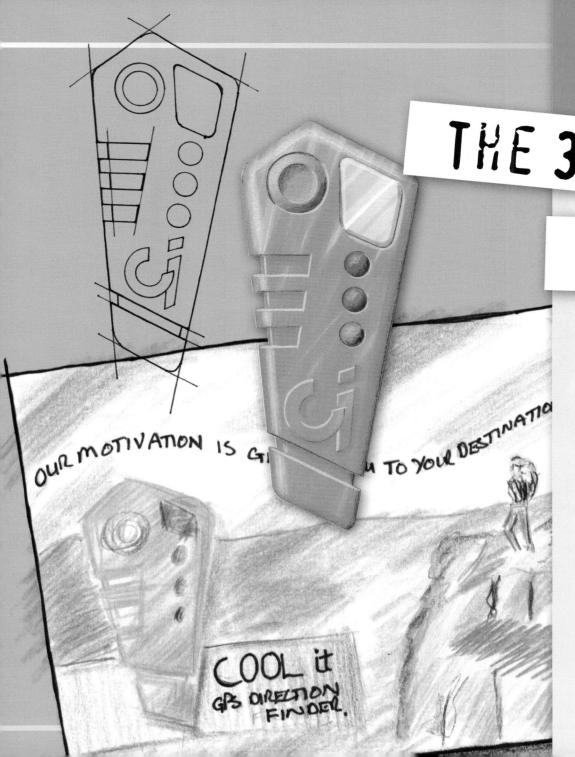

CHAPTER 02

THE 3PS | PRELIMINARY, PRODUCTION AND PROMOTION

Graphics have many purposes and functions. They can be used for entertainment – in video games for example – or they can be decorative, such as in posters and pictures.

Perhaps the most important use of graphics is in industry and construction. The success of these graphics helps determine the success of products we use, the buildings we live and work in, the comfort and entertainment we enjoy and our safety when we are doing these things.

Graphics are a central part of developing new products. Everything, from mobile phones to cars and aeroplanes, requires a range of graphics before it can be designed and built. Construction depends on graphics to ensure buildings are functional, attractive and safe.

The Graphic Communication course looks at the importance of graphics in design, manufacture and construction. It covers the full range of graphic styles, from preliminary design sketches to dimensioned production drawings and the illustrations and publications that we use to promote new products.

Graphic communication has become even more important with increased trade, construction and manufacturing around the world. Graphics help break down language barriers, and international standards have been devised to ensure a common understanding worldwide.

Computer graphics are now central to any modern design and manufacturing process and this topic will be explored fully in this book.

In manufacturing industries, the design, development, manufacturing and marketing of a product follows a cyclic path. The diagram shows a simplified version of the four main stages in the design and manufacture of a product. It highlights the types of graphic that are important at each stage.

We are surrounded by promotional graphics in our daily lives, yet there are sketches, drawings, charts, graphs and computer-generated models that go largely unseen. All of them are vital to industry and construction and an important part of our lives.

Design · Manufacture · Promotion · Market Research

Redesign starts · Preliminary sketches · Manual illustrations · Sketch modelling · Orthographic views · Exploded views · Sectional views · CAD/CAM · Illustrations · Creative layouts · Colour schemes · Publications · Graphs · Charts · Target market data

"IN ORDER TO CARRY A POSITIVE ACTION WE MUST DEVELOP HERE A POSITIVE VISION."

Dalai Lama

Graphic communication is all about communicating information. This may be in the form of a design idea for a new product, or a building plan for a new house, or a poster for use in a marketing campaign.

In industry, there are three main types of graphic that are used to present this information and these are known as the 'three Ps': preliminary, production and promotion. They each have a specific purpose. You will learn about each type below and you will also produce graphics of each type during your course.

PRELIMINARY GRAPHICS

These are sketches, illustrations and thumbnail layouts used at the design stages of new products, new buildings and new publications. Skills in sketching, drawing and rendering are important.

PRELIMINARY DESIGN SKETCHES

PRELIMINARY ILLUSTRATIONS

PRELIMINARY LAYOUTS

PRODUCTION DRAWINGS

These are drawings that include dimensions and technical detail so that products can be made and buildings constructed. Types of production drawings include: dimensioned orthographic views, exploded drawings, sectional views and surface developments. They are normally drawn to scale and always conform to drawing standards.

PRODUCTION DRAWINGS FOR CONSTRUCTION

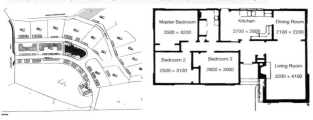

PRODUCTION DRAWINGS FOR MANUFACTURE

EXPLODED VIEW, SECTIONAL VIEW AND SURFACE DEVELOPMENT PRODUCTION DRAWINGS

PROMOTIONAL GRAPHICS

These are graphics and documents that are used in advertising to promote a product. Promotional documents often include an illustration with text and a background. The layout is carefully planned to create visual impact and is designed to appeal to a specific target market. Examples of promotional graphics include: illustrations, posters, brochures, booklets, banners, billboards, graphs and charts, and web pages.

PROMOTIONAL ILLUSTRATIONS

PROMOTIONAL PUBLICATIONS: BROCHURE, POSTER AND GRAPHICS

WHICH TYPE OF GRAPHIC TO USE AND WHEN

PRELIMINARY GRAPHICS

Sketches, illustrations and thumbnail layouts

Benefits

They are: quick to produce.

They are a good way of recording ideas or designs.

They are a good way of developing design ideas.

They can be produced using cheap equipment: pencil and paper.

They can be quickly annotated to add information.

They are useful when communicating ideas to a client or colleague.

They can be easily produced 'on site'.

They form the basis for production drawings or DTP work.

The quality of the graphic is not as important as the clarity of the graphic and the information it conveys.

Disadvantages

They are not normally drawn to scale.

They are not normally dimensionally accurate.

PRODUCTION DRAWINGS

Dimensioned orthographic views, exploded drawings, sectional views and surface developments

Benefits

They are important when component parts are to be manufactured.

They can show how components are assembled.

Technical details can be shown using a number of drawing types.

They can be easily dimensioned.

The drawing standards used are now worldwide standards.

They can be understood by all users, regardless of nationality or language.

They are accurate.

They are drawn to scale.

A library of reuseable parts can be built up.

Electronic production drawings can be used to control manufacturing machinery – computer-aided manufacture (CAM).

They are useful when surface developments are required to make packaging or panels for car bodies, for example.

They can be used in promotional documents and animations to show customers how parts assemble or the floor plan of a new building.

Disadvantages

Training or knowledge is required to produce them: drawing standards have to be learned.

They can be time-consuming to produce.

Costly specialist equipment is required: drawing boards and tools, or computers and appropriate software.

PROMOTIONAL GRAPHICS

Illustrations, posters, brochures, booklets, banners, billboards, graphs and charts, web pages and animations, etc.

Benefits

They can appear 'less technical' than production drawings.

They tend to be more easily understood than production drawings.

They can to be made to look more realistic than production drawings.

They can be used in promotional documents or videos.

They can show the customer what the product or building will look like.

They may be placed in a virtual environment to enhance realism.

They can have materials and lights applied to create visual impact.

They can be animated to create visual appeal.

They can be styled to appeal to a specific target market.

They can be made to look attractive in order to help sell the product.

Disadvantages

They require skill and knowledge to produce.

They can give a false impression of the product.

You can't physically handle a rendered model.

MANUAL OR ELECTRONIC METHODS?

METHODS OF PRODUCING GRAPHICS

The two main methods of producing graphics are:

- manual methods (creating graphics by hand)
- electronic or digital methods (creating graphics using a computer).

Each method has its advantages and disadvantages. You will be asked about these two methods in the course exam. The tables below highlight some of the important differences between the two production methods.

"GOOD DESIGN IS OBVIOUS.
GREAT DESIGN IS TRANSPARENT."

Joe Sparano

Manually produced graphics	
Advantages	**Disadvantages**
They can be produced using **inexpensive equipment**: drawing board, pencil and paper.	Each graphic must to be **drawn separately**.
Manual drawings and designs are not prone to **'hacking' crimes**.	Extensive **modification can be difficult**, resulting in a complete redraw.
Manually produced graphics that are produced 'freehand' are **quick** and **immediate** way of **recording ideas** or **designs**.	They can take up lots of **storage space** compared with electronic methods.
They can be easily produced **'on site'**.	They **cannot be sent electronically** without digitising them.
They are useful when **communicating ideas** to a client or colleague.	It is generally **slower** to produce drawings manually.
There is no risk of loss because of corrupted files or computer crashes.	They **cannot be used to control** manufacturing machinery.
They form the basis for production drawings or DTP work.	**Accuracy** depends on the skill of the drawer: there is no **zoom-in** command to aid accuracy.
	Manual graphics are normally **produced on paper** which makes demands on the environment.

Digitally produced graphics		
Advantages		**Disadvantages**
Drawing Standards can be set in advance to ensure that the correct standards are applied each time.		Initial **investment** in computers and software is required.
CAD drawings are **easily modified**, saving both time and cost.		**Training** is required whenever new software is introduced.
High accuracy is achieved by using the **zoom-in** command.		
Enlarged views can be created without drawing them from scratch.		Computer systems can be a target for **industrial theft**.
The speed of drawing is high because of the **grid** and **snap-to-grid** commands.		A **computer virus** can cause loss of data.
A **CAD library** can be set up so that commonly used parts can be dropped into the drawing without having to be re-drawn each time.		Computer systems require electricity to work: a **power cut** will shut down the system.
CAD drawings can be built up in **layers**, making the drawings easier to understand when they are viewed (see pages 74 and 115).		
Features such as **scales** and **orientation** can be set up and changed easily.		
Drawings stored digitally take up very **little physical storage space**.		
CAD drawings can be used to **control computer numerically controlled (CNC) machines**, making manufacturing quick and accurate.		
CAD files can be emailed to customers and colleagues around the world.		
CAD models can be **realistically rendered** for use in promotions layouts.		
CAD models can be **animated** and used in promotional videos.		
CAD models can be **tested** to ensure the designs work before the physical product is made: this saves time and money.		
Working digitally can help **reduce** the amount of paper used.		

CHAPTER 03

DRAWING STANDARDS

WHAT YOU WILL LEARN

- **British and international standards**
 symbols • conventions • projection method

- **Dimensioning**
 styles • rules • application

- **Exam preparation**
 examples • activity • questions

INTRODUCTION

Symbols and **conventions** are used in order to simplify the drawing process. They make drawings **simpler** and **quicker** to produce and **easier to understand**. They ensure consistent standards in all types of technical drawings, regardless of who produces them. These symbols are understood by all those involved. This is called **standardisation**. The benefits of worldwide drawing standards and conventions are as follows.

- Drawings are simplified because symbols are used in place of complex features.
- Drawings are quicker and cheaper to produce because symbols are used.
- A common standard is established that all users can understand.
- A consistency of drawing layouts and symbols is established.
- A common worldwide language is used: language barriers are eliminated.

Technical drawings are used by:

- people who **produce** drawings – architects, designers and draughtsmen and women
- people who **read and work** from drawings – engineers, builders, electricians, joiners and manufacturers.

STANDARDISATION

The drawing symbols used in Britain have been standardised by the **British Standards Institution** (**BSI**). The BSI publication **BS 8888** sets British and international drawing standards and provides a common language that can be understood around the globe and across the full range of disciplines. This helps eliminate confusion between designers, architects and engineers from different countries. Your teacher should have a shortened version for schools called: **PP 8888 Drawing practice. A guide for schools and colleges to BS 8888, Technical product specification.**

The **BS 8000 series** of books also establishes British Standards for **Structural and Architectural Design**.

DRAWING SYMBOLS

The most common drawing symbols are shown below. You will use them in your coursework drawings. It is important to understand and remember them. Study their use in the design drawings of the Swallow dart shown on page 20.

A thick, continuous line shows **visible outlines** and **visible edges**.

A thin, continuous line is used for **projection lines** and **construction lines**.

A thin, broken line shows **hidden outlines** and **hidden edges**.

A thin chain line shows a **centre line**, e.g. the centres of circles, cylinders and cones. CL or ℄ are common abbreviations.

A thin double dash chain line is used as a **fold line** to indicate where a surface development should be folded.

A thin chain line with thick ends shows where an object is cut through or sectioned. It is known as a **cutting plane**.

Thin 45° **cross-hatching** shows the cut surface produced by a cutting plane.

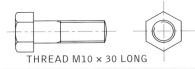

THREAD M10 × 30 LONG

Screw threads are shown as double lines. Notice how the inside circle on the end view of the bolt is broken to indicate an **external screw thread**. 'M10' indicates a **metric** thread of **diameter 10 mm**. The length of the thread is 30 mm.

The **internal screw thread** here is shown as double lines. Note how the outside circle is broken on the end view.

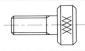

Knurling indicates where a criss-cross pattern is required on a surface to provide a better grip.

Ø Indicates diameter, e.g. Ø60.

R Indicates **radius**, e.g. R30.

☐ Indicates a **square section**, e.g. ☐40.

A/F, A/C Signifies 'across flats' and 'across corners': used when dimensioning hexagons.

ASSY Standard definition for assembly.

PRT Standard definition for part.

The **third angle projection symbol** is added to diagrams to help explain their layout. See page 27 for a full explanation.

The Swallow dart design drawings shown here incorporate most of the common symbols listed on page 19.

GO! ACTIVITY

1. Study the Swallow dart design drawings and answer the following questions. Refer to the list of drawing symbols on page 19.

 a. How many different parts have been assembled to make the complete dart?

 b. Which two parts have screw threads?

 c. Which part has an external screw thread?

 d. What is the diameter of the barrel?

 e. How many folds are required to form the flights?

2. Study the Swallow dart design drawings and answer the following questions. Refer to the list of drawing symbols on page 19.

 a. What type of screw thread is used to assemble the dart and what is the diameter of this screw thread?

 b. Which part of the dart has been knurled?

 c. Which part of the dart is shown with cross-hatching?

 d. Name three types of chain line shown in the drawings.

 e. Which drawing shows construction lines?

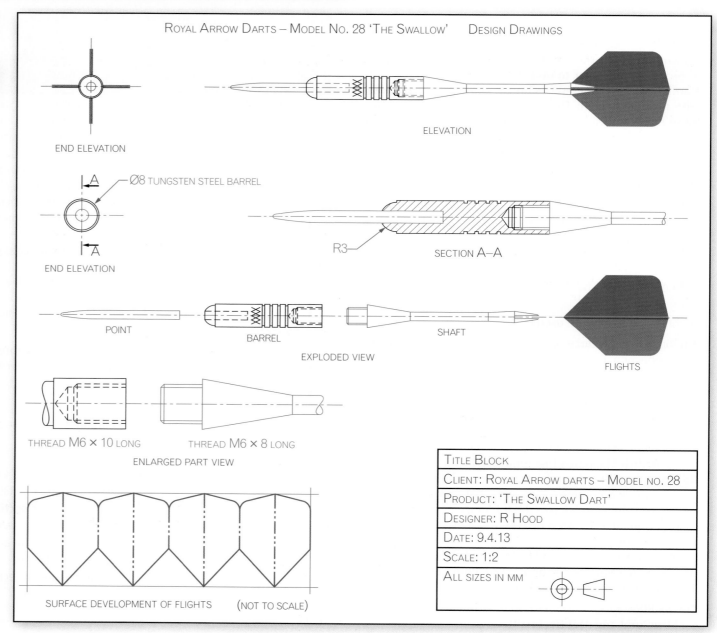

ROYAL ARROW DARTS – MODEL NO. 28 'THE SWALLOW' DESIGN DRAWINGS

END ELEVATION

ELEVATION

Ø8 TUNGSTEN STEEL BARREL

END ELEVATION

R3 SECTION A–A

POINT

BARREL

SHAFT

FLIGHTS

EXPLODED VIEW

THREAD M6 × 10 LONG THREAD M6 × 8 LONG

ENLARGED PART VIEW

SURFACE DEVELOPMENT OF FLIGHTS (NOT TO SCALE)

TITLE BLOCK	
CLIENT: ROYAL ARROW DARTS – MODEL NO. 28	
PRODUCT: 'THE SWALLOW DART'	
DESIGNER: R HOOD	
DATE: 9.4.13	
SCALE: 1:2	
ALL SIZES IN MM	

DIMENSIONING

INTRODUCTION

Dimensions (measurements) are essential on most production drawings because they enable the engineer or builder to manufacture products and construct buildings accurately. The dimensioning system used in Britain is set by the BSI in the book BS 8888 (see page 19).

You will be required to show dimensions on drawings in your unit tasks and course assessment. Learn the conventions and rules of dimensioning shown on this page and practise them in your work.

In most engineering drawings, the basic unit of measurement is the millimetre (mm). However, where larger sizes are required, such as in site plans for houses, the metre (m) is the basic unit used.

DIMENSIONING RULES

- Each dimension should be shown on the drawing only once.
- Place the dimensions on your drawing so that they can be read from either the bottom or the right-hand side of the page.
- Always measure in millimetres unless instructed otherwise.
- Figures should not touch outlines, dimension lines or centre lines.
- Ø before a dimension denotes the diameter of a circle. R denotes radius.
 - On circles, always dimension the diameter, never the radius.
 - On curves, arcs and rounded corners, always show the radius.

Dimension lines
- Where possible, place the dimension lines outside the outline.
- Arrowheads should be small and slim, with the point of the arrowhead touching the projection lines.

Overall dimensions are placed further away from the drawing.

Intermediate dimensions are placed in line. This is known as **chain dimensioning**.

> **GO! TIP**
>
> Centimetres (cm) are not used in engineering drawings. Avoid using cm.

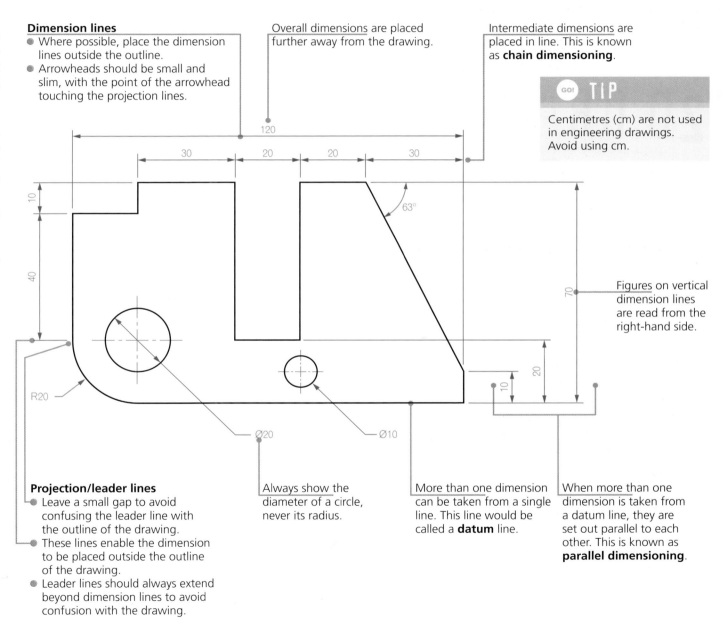

Figures on vertical dimension lines are read from the right-hand side.

Projection/leader lines
- Leave a small gap to avoid confusing the leader line with the outline of the drawing.
- These lines enable the dimension to be placed outside the outline of the drawing.
- Leader lines should always extend beyond dimension lines to avoid confusion with the drawing.

Always show the diameter of a circle, never its radius.

More than one dimension can be taken from a single line. This line would be called a **datum** line.

When more than one dimension is taken from a datum line, they are set out parallel to each other. This is known as **parallel dimensioning**.

CHAPTER 04

2D DRAWING TECHNIQUES

WHAT YOU WILL LEARN

- **Geometry**
 circles • hexagons • octagons • tangency

- **Manual drawing skills**
 cylinders • pyramids • prisms • cones • true shapes

- **Specialised views**
 surface developments • true shapes

- **Projection skills**
 third angle projection • bounce line • half plan

- **3D CAD modelling**
 2D drawing using 3D CAD

DRAWING TECHNIQUES | THE BACKBONE

It will come as no surprise that drawing is an important part of graphic communication! As part of the National 4 and 5 course you will be required to draw a range of geometric forms. These will include elevations, end elevations, plans and surface developments. Your teacher will show you how to draw these forms using both a drawing board and computer-aided design. There are advantages and disadvantages to each method: you will probably find one technique easier and more enjoyable to use, however you should be familiar with both approaches.

Geometric forms are the basis of many products, buildings and designs, and knowing how to draw these is important if you want to be successful in your Graphic Communication course. The skills you will learn here are vital for working in engineering, architecture or design.

During the National 4 and 5 course you will be required to produce drawings that involve prisms, cones, pyramids and cylinders. These may be used as evidence for passing the two course units.

"THE BEST IDEAS COME AS JOKES. MAKE YOUR THINKING AS FUNNY AS POSSIBLE."

David M. Ogilvy

Your Final Added Value Unit (National 4) or Course Assignment (National 5) may require you to draw components that are based on the skills you will learn in this chapter. In the National 5 exam you may be asked questions about geometric forms.

CAD: MAKE A SURFACE DEVELOPMENT

While 3D CAD software is a fantastic tool for producing realistic models and making technical drawings, there are very few 3D CAD applications that can produce surface developments of 3D models.

Some 3D CAD software will allow you to use a 'sheet-metal' or 'folded-metal' mode to create your 3D models – often the modelling techniques that are used in these modes are not the same as those you will learn in your course.

There is nothing wrong with using sheet or folded-metal modes, but they have a specific function for use in the manufacturing industry. You do not need to spend time learning the names of these functions.

However, there is a large range of free or inexpensive software for creating surface developments from even the most complex 3D models. Pepakura Designer is one such program that is available for download from various sites.

MANUAL VERSUS ELECTRONIC – WHICH TO USE?

Both manual and electronic methods are suitable for creating technical drawings and surface developments.

- Manual equipment you will require: a drawing board, tee-square, 45° and 30/60° set square, rule and compass.

- For CAD you will need a suitable computer with the software installed and a printer for producing 'hard copies'.

When producing technical drawings or surface developments using 2D CAD, you will use the same techniques as when creating the drawings manually, except with the added benefit of grid and snap-to-grid available to improve speed and accuracy.

If using 3D CAD, the approach to producing the drawings is slightly different and this is described in this chapter.

Practise with a range of techniques – it can be too easy to stick with one tool or technology and ignore the benefits of the other!

FREEHAND SKETCH

Sketching is a crucial skill to any designer, architect or engineer. You should always produce a quick sketch before using CAD software: it will allow you to focus on the shapes and dimensions you will need when creating an accurate 3D CAD model.

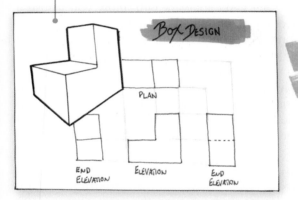

PHYSICAL MODEL

A card model can be produced from the surface development: surface development software can also allow the model to be cut directly on a plotter cutter or laser cutter.

From sketch to model

Technical drawings are used to represent items to be manufactured. 'Surface developments' describe any geometric form that has been 'unfolded' so it can be cut and formed from a single sheet of material. These drawings are called 'nets' in mathematics. Surface developments can be produced manually or using CAD software.

SURFACE DEVELOPMENT

Surface modelling software will allow you to 'unfold' your solid 3D model. However, these applications may not choose the most efficient method of unfolding your model and you may need to edit which edges are joined together to produce your development. Many modern surface modelling applications also automatically add glue tabs, a function which can be switched off if required.

One advantage of using this software is that the surface development can be exported to a DTP package to add graphics before it is printed, cut and assembled.

3D CAD MODEL

3D modelling has revolutionised graphic and product design. You can use 3D CAD to produce models of your sketched designs and almost all 3D CAD software can then generate engineering or technical drawings of the models you have produced. However, to create a surface development of a 3D model you will need to use a specialised application. You will have to 'export' your 3D model from your CAD package and import it into your surface development software.

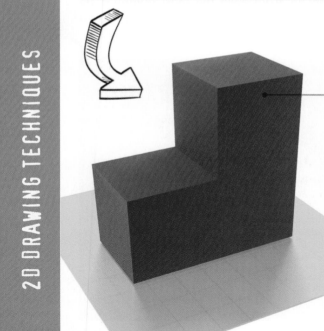

CIRCLES

Circles form part of many everyday products. You need to understand how to construct and divide circles in order to draw geometric forms such as cylinders and cones.

This worked example demonstrates how to draw a circle and then divide it into 12 segments. You will do this again during the course.

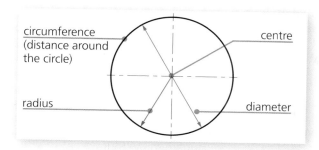

circumference (distance around the circle)

centre

radius

diameter

1. DRAW CENTRE LINES.

Draw two centre lines using your T-square and set square.

2. DRAW THE CIRCLE.

Set your compasses to the required radius and draw the circle.

Ø100

3. DIVIDE THE CIRCLE.

Divide the circle into 12 using your 30/60° set square to draw lines – called generators – from the centre out to the circle. The angle between each generator is 30°.

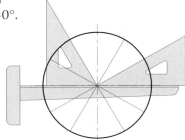

4. ADD NUMBERING.

Number each generator as on a clock face.

CYLINDERS AND CONES

Generators can be projected along the curved surfaces of **cylinders** and **cones**. These **surface generators** give us reference points on the surface that we can project between views. Generators also help us unfold these forms to produce **surface developments**.

TANGENCY

During the course you will draw objects with rounded corners. A rounded corner is known as an **arc**. The arc blends in with the two straight lines that make the corner. Where a straight line blends into a curve, the straight line is at a **tangent** to the curve.

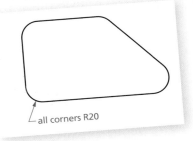

all corners R20

Draw the shape shown here. The stages below show how to find the centre of the corner arcs and draw them. Small arcs, no bigger than R4, are known as fillets – these can be drawn freehand.

1. DRAW THE OUTLINE SHAPE.

Draw the outline shape using straight lines only.

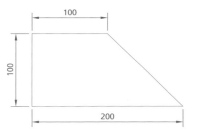

100

100

200

2. FIND THE CENTRE POINTS.

Measure 20 mm (the arc radius) in from each edge and draw centre lines. This gives the centre point for each arc.

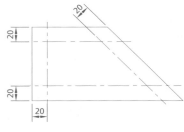

20

20

20

20

3. DRAW THE CORNER ARCS.

Set your compasses to R20 and draw curves from the centres. The straight lines should form tangents to the curves.

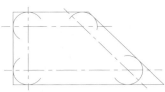

4. COMPLETE THE DRAWING.

Firm in the outline to complete the drawing.

2D DRAWING TECHNIQUES

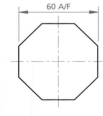

2D DRAWING TECHNIQUES

HEXAGONS AND OCTAGONS

Hexagons and octagons are common geometric shapes. You need to know how to construct them in order to draw hexagonal and octagonal prisms and pyramids.

HEXAGONS

Two methods are used to construct hexagons: **across the corners** and **across the flats**.

ACROSS THE CORNERS

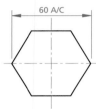

60 A/C

When the size of a hexagon is given **across the corners** (**A/C**), you must draw the hexagon **inside** a circle of the same diameter.

1. DRAW A CIRCLE.

- Draw a circle to the given diameter, in this case Ø60.
- Divide the circle into 12.
- Draw horizontal lines top and bottom where the generators meet the circle.

2. DRAW THE HEXAGON.

- Using a 30/60° set square, draw four sloping lines at 60°.

3. FIRM IN.

- Firm in and tidy up the hexagon.
- Note that the hexagon is drawn **inside** the circle. The size across the corners is the same as the diameter of the circle.

ACROSS THE FLATS

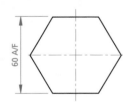

60 A/F

When the size of hexagon is given **across the flats** (**A/F**), you must draw the hexagon **outside** a circle of the same diameter.

If a hexagon is drawn accurately, all sides are the same length.

1. DRAW A CIRCLE.

- Draw a circle to the given diameter, in this case Ø60.
- Draw horizontal lines top and bottom where the centre line meets the circle.

2. DRAW THE HEXAGON.

- Draw four sloping lines at 60°, just touching the circle.
- When a line touches the edge of a circle like this, the line is a tangent to the circle.

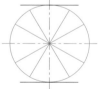

3. FIRM IN.

- Firm in and tidy up.
- Note that the hexagon is drawn **outside** the circle. The size across the flats is the same as the diameter of the circle.

OCTAGONS

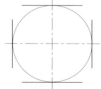

60 A/F

The size of an octagon is generally given **across the flats** and the octagon is drawn **outside** a circle of the same diameter.

1. DRAW A CIRCLE.

- Draw a circle to the given diameter, in this case Ø60.
- Add two horizontal and two vertical lines where the centre lines meet the circle.

2. DRAW THE OCTAGON.

- Using a 45° set square, draw four lines that make tangents to the circle.

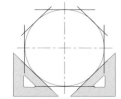

3. FIRM IN.

- Firm in and tidy up.
- All eight sides should be the same length. Check this with your compasses.

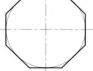

ORTHOGRAPHIC PROJECTION IN 2D

INTRODUCTION

Orthographic projection shows three-dimensional (3D) objects as two-dimensional (2D) drawings.

Before a product is manufactured or a building is constructed, accurate detailed drawings must be produced. These drawings are made using orthographic projection systems that are understood around the world. The most common orthographic projection system is called **third angle projection**.

An object is usually drawn in up to four 2D views:

- the elevation, viewed from the front
- the plan, viewed from the top
- two end elevations, one from each end.

The views are always set out the same way. Step 4 on this page shows how the four orthographic views are set out. This is the standard layout for all third angle projections. Dimensions (lengths, breadths and heights) and other features, for example corners and edges, are projected between views.

The third angle projection symbol is added to drawings to help explain their layout.

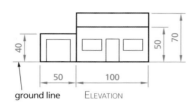

WORKED EXAMPLE

This example shows how to draw and project the four main orthographic views of a house.

1. DRAW THE ELEVATION.

- Draw a ground line across the page.
- Measure the lengths and heights of the house and draw the elevation above the ground line.

2. DRAW THE PLAN.

- Project lines upwards from each corner – this carries the lengths up to the plan. The windows and doors are only flat detail and don't need to be projected.
- Measure the breadths and complete the plan view.

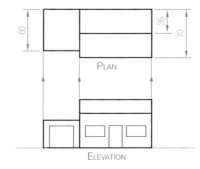

3. PROJECT END ELEVATIONS USING BOUNCE LINES.

- Project the heights across from the elevation, ignoring the doors and windows.
- Draw two 45° bounce lines as shown.
- Project the breadths across from the plan.
- Bounce them vertically downward where they meet the bounce lines.

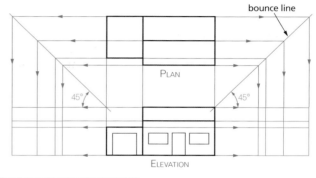

4. COMPLETE THE END ELEVATIONS.

- Follow corners A and B across from the elevation and around from the plan to identify A and B on the end elevations. Each corner can be plotted in this way.
- Number or letter the corners on the elevation and plan. This makes it easier to follow points along the projection lines and on to the end elevations. Put brackets around a label, for example (A), to indicate that the corner is hidden at the back of the object.

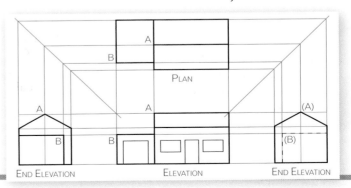

1. DRAW THE GABLE END.

- Draw the left-hand gable of the house on a lateral or side-facing workplane.
- Use constraints to ensure the house is the correct dimensions.

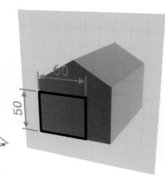

2. EXTRUDE THE PROFILE.

- Use the extrude feature to turn the 2D sketch into a 3D feature. The sketch should be extruded to the correct size.
- Shell the house feature with a wall thickness of 2 mm.

3. CREATE A NEW SKETCH.

- A new sketch should be created on the same workplane as the gable end sketch.
- Draw a rectangle to the correct dimensions.

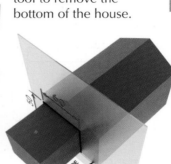

4. EXTRUDE THE GARAGE.

- Extrude the garage to the correct size.
- If you feel confident, you should shell the garage feature to a wall thickness of 2 mm. You may also use the shell tool to remove the bottom of the house.

5. DRAW THE DOOR AND WINDOWS.

- Select the front face of the house and create a new sketch.
- Draw the profile for the front door and windows.

6. COMPLETED MODEL.

- Extrude the profile for the door and the window.
- Ensure you have selected 'subtract' or 'remove' material so the door and window shapes can be cut into the house.
- If you feel confident, try the same for the garage!

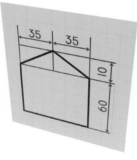

FROM 3D TO ORTHOGRAPHIC: GET IT RIGHT!

Almost all 3D CAD software will allow you to produce a technical drawing from the model you have generated. However, most applications use a different format from the one you should be using (BS 8888), and you will need to ensure that your drawing is properly presented: creating the 3D model is only half the challenge!

While using CAD software may appear easy, you should have a sound understanding of how technical drawings should be drawn and presented. Creating some drawings using manual techniques can be the best way to learn the process – don't always trust the computer!

Views aligned: ensure all your views are neatly aligned in third angle projection. Your drawings should be to an appropriate scale, with 'white space' separating each view.

Views titled: each view must have a title – titles should be neatly aligned too. Use a sensible font, such as 'Technic'. Your text should be no larger than 4 mm in height.

Line weights: outlines should be at 1pt. Any construction, centre or dimension lines should be at 0.5pt

Line types: always use the correct line types. Centre lines, cutting planes, fold lines and hidden detail should be shown properly.

Pictorial view: when introducing a pictorial view, it should not show smoothing edges or hidden detail. Make sure it is titled.

Title box: always have a title box. You must create your own rather than use the standard template provided. Write a key with information about your drawing: see page 174.

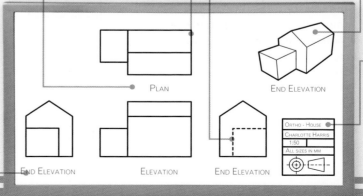

PLAN

END ELEVATION

END ELEVATION

ELEVATION

END ELEVATION

ORTHO - HOUSE
CHARLOTTE HARRIS
1:50
ALL SIZES IN MM

2D DRAWING TECHNIQUES

PRISMS IN 2D

INTRODUCTION

Prisms are common geometric forms used in packaging and counter displays. There are several different types, each taking its name from the shape of its base. During the course you will draw square, rectangular, triangular, hexagonal and octagonal prisms. A hexagonal prism is shown here.

WORKED EXAMPLE

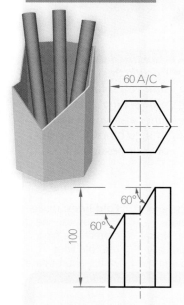

60 A/C

60°

60°

100

A cardboard box to display pencils is being made in the form of a hexagonal prism.

From the information above, draw:

- the plan and elevation
- the end elevation to the left
- the surface development, not including the base.

1. DRAW THE PLAN AND ELEVATION.

- Draw the plan view first. Use the 'across the corners' method.
- Project down to draw the elevation.
- Number the six vertical edges on plan and elevation.

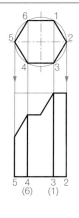

6 1
5 2
4 3

5 4 3 2
(6) (1)

2. DRAW THE LEFT END ELEVATION.

- Draw a 45° bounce line and project the breadths around from the plan.
- Number the vertical edges.

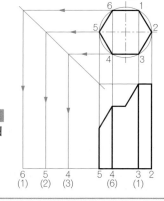

6 1
5 2
4 3

6 5 4 5 4 3 2
(1)(2)(3) (6) (1)

3. COMPLETE THE LEFT END ELEVATION.

- Project the heights across from the elevation. Use the numbers to plot the corners on each edge.

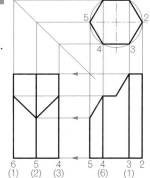

6 1
5 2
4 3

6 5 4 5 4 3 2
(1)(2)(3) (6) (1)

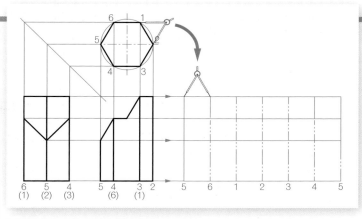

6 1
5 2
4 3

6 5 4 5 4 3 2 5 6 1 2 3 4 5
(1)(2)(3) (6) (1)

4. DRAW THE SURFACE DEVELOPMENT.

- Project the heights along from the elevation.
- Using compasses, step off the length of a side six times.
- Number each vertical fold line starting with the shortest, in this case number 5.

5. COMPLETE THE SURFACE DEVELOPMENT.

- Using the numbers as a guide, plot the top edge of the surface development.
- The corners on the top edge that lie between edges 3 and 4 and edges 1 and 6 need extra construction lines (a and b) to be drawn. Using compasses, step the positions of lines a and b from the elevation.
- You may wish to add a glue tab.
- Firm in the outline and add titles.

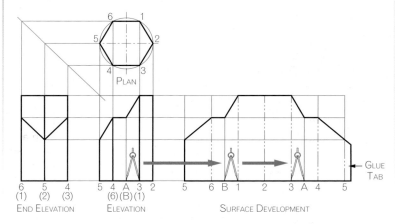

6 1
5 2
4 3
PLAN

GLUE TAB

6 5 4 5 4 A 3 2 5 6 B 1 2 3 A 4 5
(1)(2)(3) (6)(B)(1)
END ELEVATION ELEVATION SURFACE DEVELOPMENT

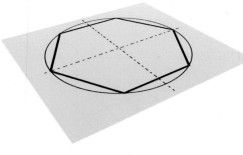

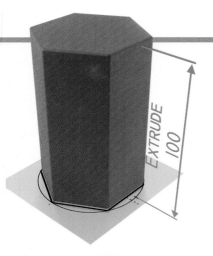

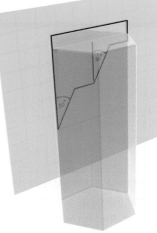

EXTRUDE 100

EXTRUDE SUBTRACT MATERIAL

1. DRAW THE HEXAGON.

- Many 3D CAD applications allow you to draw hexagons directly from a palette and specify the size across corners (A/C).
- If your 3D CAD software does not have a palette, you will need to draw a hexagon using the same techniques as used with manual equipment.

2. EXTRUDE THE HEXAGON TO FORM THE PRISM.

- Select the hexagonal sketch, resize it to 60A/C and extrude to the correct size.
- With some 3D CAD applications you may need to shell your prism.

3. CREATE A SKETCH PERPENDICULAR.

- Create or select a workplane that cuts vertically through the hexagonal prism and create a new sketch.
- Draw the profile that you wish to cut from the hexagonal prism. You will need to add constraints to your profile to ensure you are cutting the correct shape from your prism.

4. CUT THE HEXAGONAL PRISM.

- Extrude the profile. Make sure you select cut or subtract material, otherwise you'll add a strange block to the top of your hexagonal prism!

> "LEARN FROM THE MISTAKES OF OTHERS. YOU CAN'T LIVE LONG ENOUGH TO MAKE THEM ALL YOURSELF."
>
> Eleanor Roosevelt

GO! EXAM TIP

In an exam you may be asked a range of questions on prisms. Possible exam questions include:

- Identify the correct true shape for a prism.
- Identify a particular face on a prism.
- Identify the correct surface development of a prism.

GO! ACTIVITY

1. Challenge your visualisation skills. Once you have printed out your CAD drawing, use numbers to identify each edge on the elevation. Can you put these numbers on the same edge on the end elevation, plan and surface development?

Short edge: it is good practice to have your surface development start from the shortest edge. Not all software will do this automatically for you so you may need to edit it.

Fold lines: make sure you use the correct line type: use fold lines where appropriate.

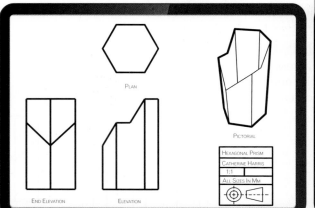

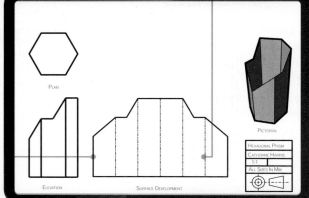

CYLINDERS IN 2D

WORKED EXAMPLE

The label for a plastic shampoo bottle is to be made for a design mock-up of the bottle. From the information given, draw:

- the plan and elevation
- the left end elevation
- the surface development.

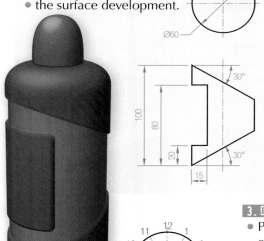

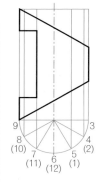

Ø60

100
80
20
15
30°
30°

1. DRAW THE PLAN AND ELEVATION.

- Draw the plan and divide it into 12. (Dividing the plan helps you to visualise the drawing.)
- Draw the complete elevation and add surface generators as shown (the blue lines travelling up the elevation).
- Number each surface generator.
- Draw the outline of the label.

In this example, a bounce line is not used. Instead, semicircles are drawn underneath the elevation and end elevation. The semicircles are divided into six and numbered as shown. Surface generators are projected upwards from the semicircle. These numbered surface generators allow you to draw without a bounce line. However, if you prefer, you can use a bounce line instead.

2. DRAW THE COMPLETE END ELEVATION.

- First draw the centre line.
- Then draw the semicircle.
- Divide the semicircle into six and project the generators upwards.
- Number the generators.
- Project the heights across from the elevation and plot the points.
- Sketch the ellipses freehand.
- Project the window across from the elevation to lines 7 and 11.
- Firm in the outline.

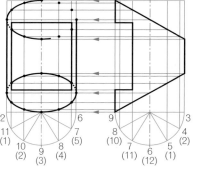

3. DRAW THE SURFACE DEVELOPMENT.

- Project the full height across from the elevation.
- Step off the circumference in 12 steps.
- Draw in surface generators.
- Number the generators 1–12, starting and ending with the shortest edge.

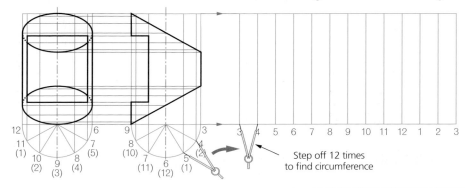

Step off 12 times to find circumference

4. COMPLETE THE SURFACE DEVELOPMENT.

- Project heights across from the elevation to complete the top and bottom edges.
- Project the window outline across from the elevation. Remember to use the numbers to plot the correct points.
- Firm in the outline.

PLAN

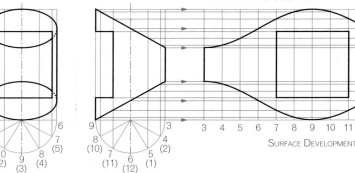

END ELEVATION

ELEVATION

SURFACE DEVELOPMENT

CYLINDERS | USING 3D CAD

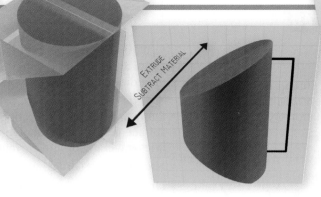
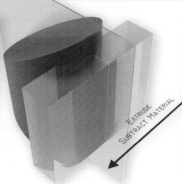

1. DRAW THE CIRCLE.

- Draw a circle on the plan workplane.
- Make sure you use centre lines and dimension the circle.

2. EXTRUDE PROFILE.

- Use the extrude feature to create a cylinder – use the correct distance for the extrusion.
- At this stage you may need to shell your cylinder if your 3D CAD software does not do it automatically.

3. SKETCH TO CUT CYLINDER.

- Select or create a workplane that cuts through the centre of the cylinder.
- Create a new sketch and draw the shape you want to cut from the cylinder.

4. CUT THE CYLINDER.

- Extrude the profile symmetrically through the cylinder.
- Ensure you are subtracting material from the the cylinder.

5. CREATE ANOTHER CUT.

- Create a new sketch on the same workplane.
- Draw a rectangle to the correct size.
- If you are confident with 3D CAD, steps 5 and 6 can be completed within steps 3 and 4 at the same time.

6. EXTRUDE THE CUT.

- Extrude the rectangular sketch symmetrically – again, make sure you are cutting or subtracting material.

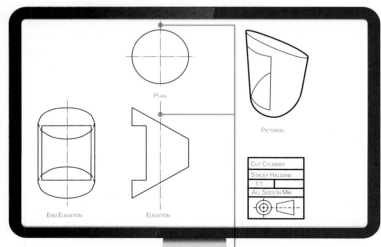

Centre lines: remember to add centre lines to any cylindrical drawing.

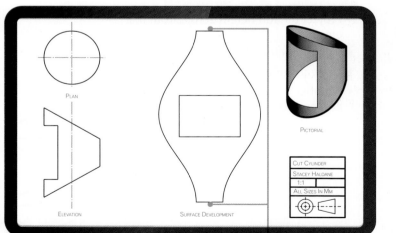

Shortest edge: start your surface development from the shortest edge.

EXAM TIP

Exam questions about cylinders may involve:

1. identifying a correct true shape
2. identifying a correct surface development.

WORKED EXAMPLE

A child's play tent is to be made in the form of a cut-off square pyramid. Draw:

- the elevation and plan
- the end elevation on the left
- the surface development of the four sides
- the true shape of the top of the tent.

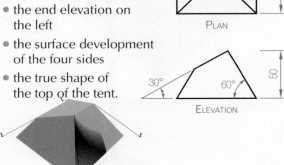

80

80

PLAN

30° 60° 50

ELEVATION

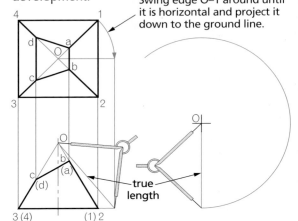

1. DRAW THE ELEVATION AND PLAN.

- Draw the elevation, including the apex 'O'.
- Project upwards and draw the plan.
- Number the four corners and the apex.
- Project points a, b, c and d up to the plan.

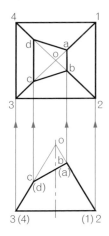

2. DRAW THE END ELEVATION.

- Project heights across from the elevation.
- Use the bounce line to project breadths from the plan.
- Follow the numbers to plot the shape of the end elevation.

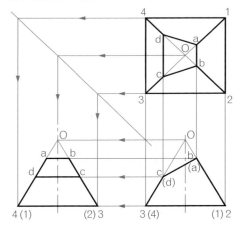

3. FIND THE TRUE LENGTH OF A COMPLETE EDGE.

- On the plan, swing edge O–1 around until it is horizontal.
- Drop this point down to the ground line.
- On the elevation, join this new point to the apex O. This true length becomes the radius for the surface development.

Swing edge O–1 around until it is horizontal and project it down to the ground line.

true length

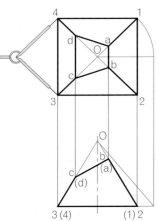

4. STEP OFF THE FOUR SIDES.

- Step the base length around the arc four times.
- Number these points and join them to the centre (point O).

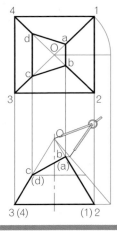

5. COMPLETE THE SURFACE DEVELOPMENT.

- On the elevation, project points a, b, c and d across to the true length.
- Step these sizes onto the surface development.

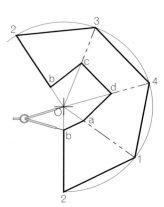

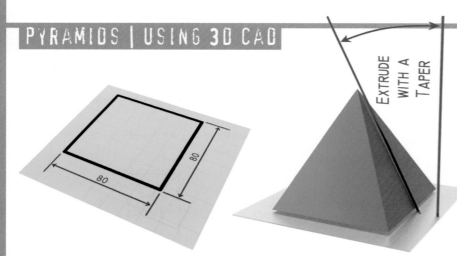

EXTRUDE WITH A TAPER

30°

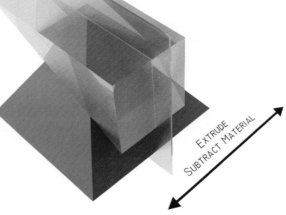

EXTRUDE SUBTRACT MATERIAL

1. DRAW THE ELEVATION.

- Draw a square on the plan workplane.
- Add constraints to the square to ensure the correct size.

2. EXTRUDE THE PROFILE.

- Extrude the profile to the correct height.
- Use the taper feature to turn the cuboid into a pyramid.

3. DRAW THE CUTTING PROFILE.

- Select a workplane that cuts through the pyramid vertically.
- Draw the profile the needs to be cut. You will need to add constraints to set the angle of the cut and the distance of the cut from the base of the pyramid.

4. EXTRUDE THE CUTTING PROFILE.

- Extrude the cutting profile and select subtract or remove material.

"TECHNOLOGY OVER TECHNIQUE PRODUCES EMOTIONLESS DESIGN."

Daniel Mall, graphic designer

GO! ACTIVITY

Surface development software will automatically find the true length – you do not need to do it yourself. However, you should have a good understanding of true length and challenge your knowledge and understanding of the topic.

1. Print out your elevation, end elevation and surface development. Check whether the true length of the elevation matches that used on the surface development by using your manual drawing equipment to draw on your printout.

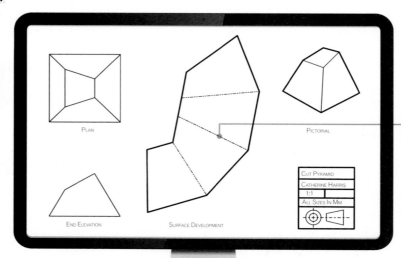

PLAN

PICTORIAL

END ELEVATION

SURFACE DEVELOPMENT

CUT PYRAMID
CATHERINE HARRIS
1:1
ALL SIZES IN MM

Fold lines: ensure you use proper fold lines. Some software may not do it.

GO! EXAM TIP

Exam questions about pyramids may involve identifying:

1. a correct true shape
2. a correct surface development
3. a true length.

1. DRAW THE TRUE SHAPE OF THE TOP.

- Choose the view that shows the sloping surface as a single line (in this example it is the elevation).
- Project at 90° from this surface (this gives the true length of the surface).
- Draw a datum line at 90° to the projection lines. (A datum line is a line from which measurements are taken.)
- Add a horizontal datum line to the plan. This datum line can be anywhere on the plan but it is normal to pass it through the lowest corner of the surface or through the centre of the surface.

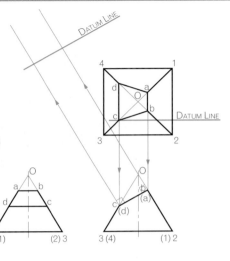

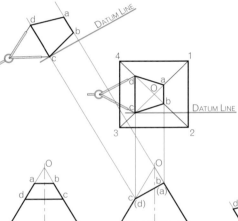

2. COMPLETE THE TRUE SHAPE.

- Take the breadths above the datum line on the plan.
- Step them off above the other datum line.
- Mark and label points a, b, c and d.
- Join them to find the true shape of the top surface.

3. THE FINISHED DRAWING.

Here is the complete drawing showing elevation, plan, end elevation, surface development and true shape.

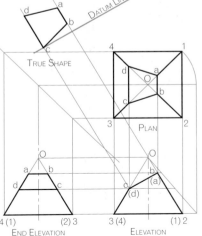

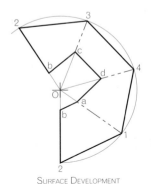

END ELEVATION ELEVATION SURFACE DEVELOPMENT

WORKED EXAMPLE

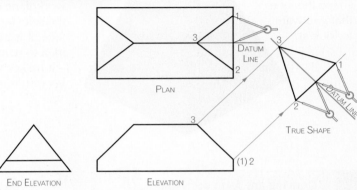

PLAN

END ELEVATION ELEVATION

In the course you can be asked to project a true shape from any straight-sided form, for example a pyramid or a prism. This example shows how to project the true shape of a surface of a prism using the centre line as the datum.

1. Choose the view that shows the surface as a single line.

2. Project at 90° from the surface.

3. Draw a datum line at 90° to the projection lines.

4. Add a horizontal datum line to the plan. In this example, the datum line passes through the centre of the surface.

5. Take the breadths above the datum line on the plan.

6. Step them off on both sides of the other datum line.

7. Mark and label points 1, 2 and 3.

8. Join them to find the true shape of the sloping surface.

2D DRAWING TECHNIQUES

1. SELECT THE CORRECT FACE.

- Select as a true shape the face that you want to look at.

2. CREATE A NEW WORKPLANE.

- Create a new workplane on the selected face. It is a good idea to name this plane – it makes selecting it later on much easier.

3. PROJECT EDGES.

- Project the edges of the face: the straight line tool will snap to the corners of the face. Some 3D CAD software will allow you to instantly turn the face into a valid sketch that can be used as a feature.

Drawing any form of geometric shape can be tricky using either manual drawing equipment or 2D/3D CAD. The most effective way of learning to create and draw various cones, pyramids, cylinders and prisms is simply to practise using a range of techniques.

While you will experience a range of techniques at school, you can easily practise at home too.

This example uses free 3D CAD and surface development software to design and construct a mobile phone charging stand. What else could you design and make at home?

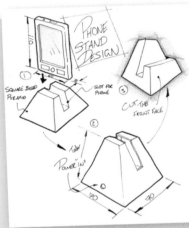

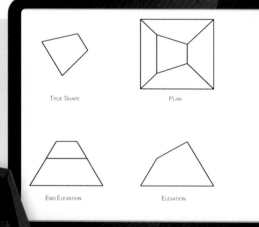

1. Sketch some basic ideas for a phone stand. You will need to measure the size of your phone and ensure any slot is big enough to hold it. You will probably have an A4 printer at home, so don't design a stand that is too big to make from a single sheet of paper.

2. Model your design in a 3D modelling application – your school may be able to supply you with a copy or you can download a free version online. Produce a surface development using a surface development application.

3. Print out your surface development. Some printers may allow you to print on card – this can make your model stronger and look more appealing.

If you can make a model like this on your own, you are achieving several of the outcomes in the 2D Unit.

The design skills and problem-solving skills you learn will be excellent preparation for the Course Assignment.

WORKED EXAMPLE

An air-bed foot pump in the form of a cut-off cone is being designed. Drawings are required so that graphics can be planned. From the elevation given, draw:

- the plan view
- the end elevation on the right
- the surface development
- the true shape of this sloping surface.

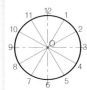

ELEVATION

1. DRAW THE ELEVATION, PLAN AND END ELEVATION.

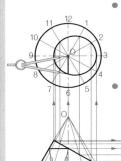

- Complete the elevation of the cone.
- Divide it into 12 using surface generators.
- Number each generator.
 - Draw a complete plan and end elevation.
 - Split each into 12 using surface generators. Be careful to ensure the views are numbered correctly.

2. COMPLETE THE PLAN AND END ELEVATION.

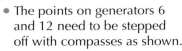

- Where each generator crosses the sloping surface, project across to the end elevation. Mark each point on the end elevation. Use the numbers on both views to check the points are correct.
- Project up from the elevation to the plan. Mark each point.
 - The points on generators 6 and 12 need to be stepped off with compasses as shown.
 - Sketch in the curves on the end elevation and plan.

3. DRAW THE SURFACE DEVELOPMENT.

- Take the true length of the surface generators (down the outside of the elevation, lines 3 or 9).
- Draw an arc using this true length.
- Take the distance between generators at the base and step it off 12 times around the arc.
- Number these points and join them to the apex, O. Start numbering using the shortest generator, in this case number 3.

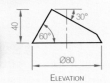

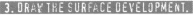

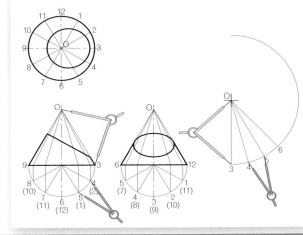

4. COMPLETE THE SURFACE DEVELOPMENT.

- On the elevation, project across from the slope to the true length line. This finds the true length of each point from the apex to the slope.
- Take these sizes from the true length line and step them on generators around the surface development. Work from the apex, O, each time. Use the numbers to avoid mistakes.
- Sketch in the curve.

5. COMPLETE THE TRUE SHAPE.

- Draw the true shape of the sloping surface. (Refer back to page 35 for the procedure for projecting true shapes.)
- Find the view which shows the surface as a straight line.
- Project each point at 90° to this line.
- Add a datum line at 90° to the projection lines.
- Go back to the plan to pick up the breadths.
- Step the breadths to both sides of the datum line.
- Sketch the curve neatly.

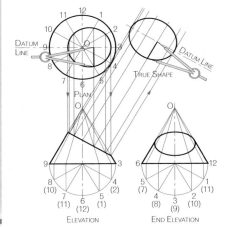

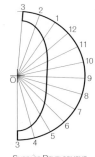

DATUM LINE

DATUM LINE

TRUE SHAPE

PLAN

ELEVATION

END ELEVATION

SURFACE DEVELOPMENT

CONES | USING 3D CAD

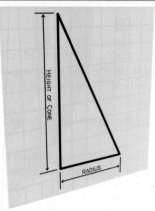
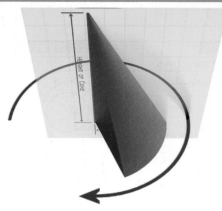
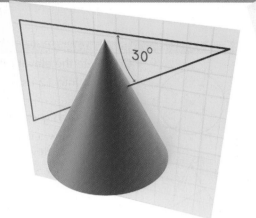

HEIGHT OF CONE
RADIUS

HEIGHT OF CONE

ROTATE AROUND AXIS

30°

EXTRUDE SUBTRACT MATERIAL

1. DRAW HALF THE CONE PROFILE.

- Cones can be created by revolving a profile or by extruding a circle with a taper. In this example, we use the revolve technique.
- Create a sketch on a vertical workplane.
- Draw a triangle, where the base is the radius of the cone and the centre axis is the height of the cone.

2. REVOLVE THE PROFILE.

- Revolve the profile round the centre axis.
- Once you have revolved the cone, you may need to use the shell function.

3. DRAWING THE CUTTING PROFILE.

- Draw the profile that you wish to cut from the cone. You will need to add constraints to your profile to ensure you are cutting the correct shape from your cone.

4. CUT THE CONE.

- Extrude the profile – make sure you select cut or subtract material.

"MAKING THE SIMPLE COMPLICATED IS COMMONPLACE; MAKING THE COMPLICATED SIMPLE, AWESOMELY SIMPLE, THAT'S CREATIVITY."

Charles Mingus, musician

SPEEDY LITTLE CAD ...

The time taken to model the cone in CAD and create an accurate surface development is far less than it takes to draw it manually on a drawing board. CAD also allows us to make quick modifications to the drawings: this is why it is so useful in industry.

Apex Point: show your apex point.

Shortest edge: start your surface development from the shortest edge.

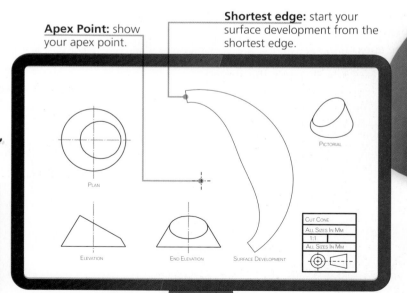

PLAN

ELEVATION

END ELEVATION

SURFACE DEVELOPMENT

PICTORIAL

CUT CONE
ALL SIZES IN MM
1:1
ALL SIZES IN MM

GO! EXAM TIP

Exam questions about cones may involve identifying:

1. a correct true shape
2. a correct surface development.

PICTORIAL DRAWING TECHNIQUES

WHAT YOU WILL LEARN

- **Styles of pictorial drawing**
 isometric • planometric • oblique

- **Skills in pictorial drawing**
 construction methods

INTRODUCTION

Isometric drawing is a method of pictorial drawing where all three dimensions and three surfaces are shown in one view. Isometric means 'having equal measure'. You can produce an isometric drawing more easily by constructing an isometric crate first. You can then draw the object inside the crate.

RULES OF ISOMETRIC PROJECTION

- **Heights are projected vertically upwards.**
- **Lengths and breadths are projected at 30° to the horizontal.**
- **All measurements along the height, length and breadth are full size.**

HOW TO CONSTRUCT AN ISOMETRIC CRATE

1. DRAW THE VERTICAL AXIS.

- Draw in the vertical edge and mark off the overall height.

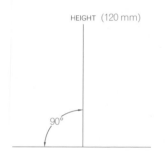

HEIGHT (120 mm)

90°

2. DRAW THE ISOMETRIC AXES.

- Project the 30° lines from the base of the vertical line using a 30/60° set square.

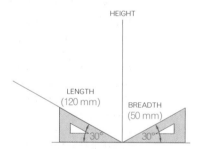

HEIGHT

LENGTH (120 mm) BREADTH (50 mm)

30° 30°

3. ADD DIMENSIONS.

- Measure and mark off the overall length and breadth.
- Draw in remaining verticals and 30° lines to produce a crate (box).

 This is an empty crate. Use this process to construct crates to contain isometric views of objects or buildings.

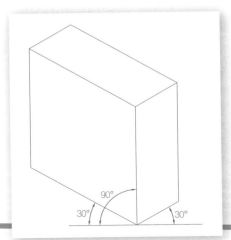

90°

30° 30°

HOW TO DRAW AN ISOMETRIC CIRCLE

1. SLICE UP THE CIRCLE AND ISOMETRIC CRATE.

- Draw the elevation and end elevation of a cylinder. Slice it up equally as shown.
- Draw an isometric crate the same size as the circle and add centre lines.
- Slice up the front of the isometric crate the same way as the elevation.
- Transfer sizes directly from the front elevation onto the corresponding numbered slice on the isometric crate.

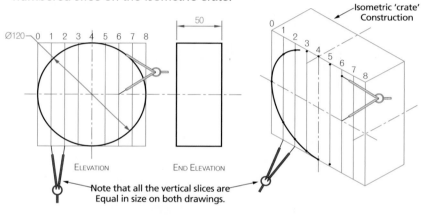

Isometric 'crate' Construction

Ø120 0 1 2 3 4 5 6 7 8

50

0 1 2 3 4 5 6 7 8

ELEVATION END ELEVATION

Note that all the vertical slices are Equal in size on both drawings.

2. ADD BREADTHS.

- Project each point on the isometric circle back at 30°.
- Transfer the breadth from the end elevation to the isometric view using compasses.

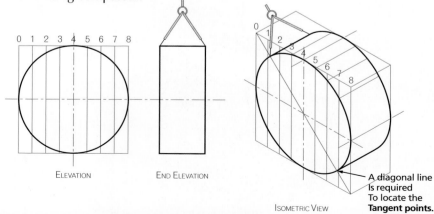

0 1 2 3 4 5 6 7 8

ELEVATION END ELEVATION ISOMETRIC VIEW

A diagonal line Is required To locate the **Tangent points.**

WORKED EXAMPLE

A small display shelf is shown below. From the information given, draw an isometric view of the assembled shelf to a scale of 1:1.

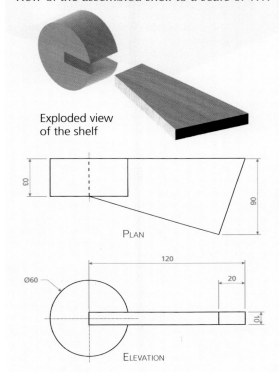

Exploded view of the shelf

PLAN

ELEVATION

120
Ø60
20
10

CONSTRUCTION METHOD

There are two common methods of constructing an isometric circle: the cutting plane or slicing method shown on the previous page and the method shown here. This method involves dividing a circle into generators using your 30/60° set square and plotting these generators on the isometric crate. Try both methods and choose the one that suits you the best.

1. DRAW A Ø60 CIRCLE, DIVIDE IT INTO 12 AND CONSTRUCT AN ISOMETRIC CRATE.

- Draw a Ø60 circle and divide into 12 using generators.
- Number the generators 1–12.
- Construct a 60 × 60 × 30 crate to take the cylinder.

2. DROP VERTICALS ON THE CIRCLE AND STEP THEM OFF ON THE CRATE.

- Use the triangles inside the circle to plot points on the crate.
- Once all 12 points are plotted you can carefully freehand in the isometric ellipse.

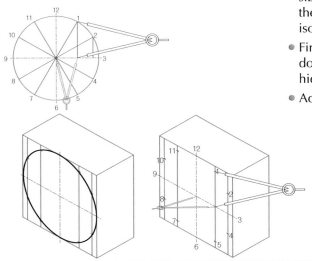

3. COMPLETE THE BACK EDGE OF THE CYLINDER.

- Project generators back along the surface of the cylinder.
- Step off the breadth of the cylinder along each generator.
- Freehand the back curved edge.

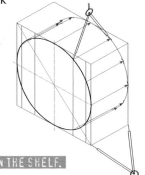

4. DRAW A CRATE TO CONTAIN THE SHELF.

- Start at the centre of the ellipse and draw a crate, size 120 × 60.
- Be sure to work both sides of the centre line.
- Plot the sloping edges: note you cannot transfer angles from an orthographic to an isometric projection. You must measure sizes along the vertical and isometric lines.
- Firm in the outlines: do not show hidden detail.
- Add a title.

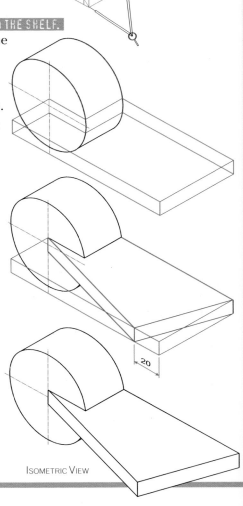

ISOMETRIC VIEW

PICTORIAL DRAWING | PLANOMETRICS

INTRODUCTION

Planometric drawings are used by architects, civil engineers and interior designers. Planometric projection is easy to draw and offers a clear view of interior spaces. It gives a viewing position looking down from above.

RULES OF PLANOMETRICS

1. The base is a true plan view rotated at an angle to the horizontal, usually 30°, 45° or 60°.
2. Planometric projection is achieved by rotating the plan view at an angle: 30°, 45° or 60°.
3. All vertical edges remain vertical and project upwards from the base.
4. All the measurements on the base are true. Vertical measurements (heights) should be full size.

WORKED EXAMPLE

A hair-styling reception room is shown here. It includes a styling counter, sofa and mirrors. From the information given, draw a planometric view of the room.

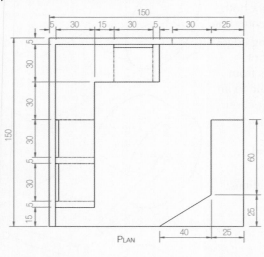

PLAN

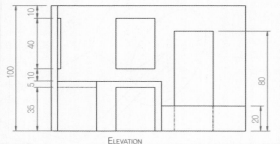

ELEVATION

1. DRAW THE FLOOR
- Draw the floor of the room rotated at 45°.
- The floor may also be drawn at 30° or 60°.

2. PROJECT WALLS
- Project the walls vertically to the full height of the room. You may need to show the thickness of walls.
- Draw the footprint (plan) of the styling counter rotated at 45°.

3. PROJECT BOOTHS
- Project the height of the styling counter vertically.
- Heights are always found on an elevation or end elevation.

4. PROJECT SEAT
- Project the sofa heights vertically and firm in.
- Add legs to the styling counter.

5. ADD WALL MIRRORS
- Transfer the widths and heights of the mirrors and the door from the elevation onto the walls.

6. FIRM IN DRAWING
- Project the mirrors forward to achieve depth. Project the door through the wall and show the thickness.

PICTORIAL DRAWING TECHNIQUES

PICTORIAL DRAWING: OBLIQUE

Oblique drawing is a simple form of pictorial drawing, often used because it shows the true front view of an object and circles can often be drawn with a compass.

RULES OF OBLIQUE DRAWING

1. The front of an object is shown as a true shape.
2. Breadths are projected back at 45°.
3. Breadths are reduced by half actual size to improve realism.

WORKED EXAMPLE

A display shelf is shown below. From the information given, draw an oblique view of the assembled shelf to a scale of 1:1.

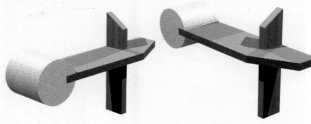

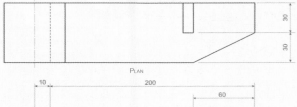

PLAN

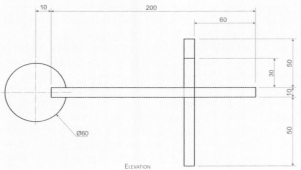

ELEVATION

1. DRAW THE FRONT CIRCLE
- Draw the front circle.
- Project the centre back at 45°.
- Measure the breadth 30 mm (half of 60 mm).
- Draw the centre lines at the back.
- Note that any circle drawn on the front or forward facing surface of an oblique drawing is a true circle and can be drawn using compasses.

2. DRAW THE CIRCLE AT THE BACK.
- Draw the rear circle.
- Project tangent lines at 45° – the red 45° lines will locate the tangent points.

3. ADD THE SHELF.
- Construct an oblique crate at a 45° angle: remember to halve the breadth.
- Measure the angle at the right end, halving the breadth again.
- Heights and lengths are always true sizes.

4. DRAW THE UPRIGHT
- Draw an oblique crate for the upright: remember to halve the breadth.
- Measure and draw the slope at the top.

5. FIRM IN THE DRAWING.
- Remove any extra construction lines.
- Firm in the drawing.
- Do not show hidden detail.
- Add a title.

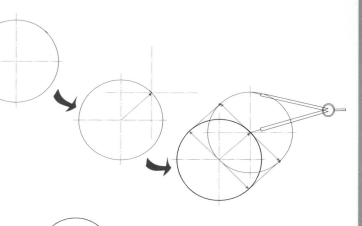

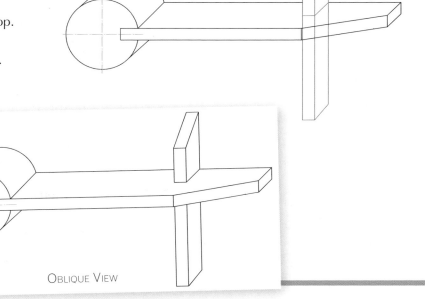

OBLIQUE VIEW

CHAPTER 06

SECTIONS, ASSEMBLIES AND EXPLODED VIEWS

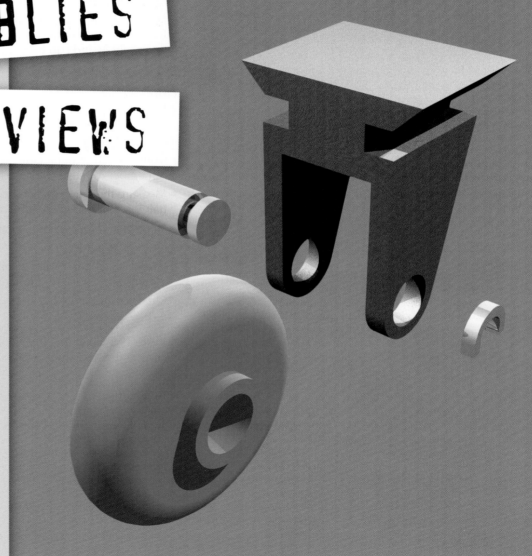

WHAT YOU WILL LEARN

- **Sectioning drawings**
 cutting plane • cross-hatching • conventions and rules

- **2D and 3D CAD sectioning**
 cutting plane • editing the drawing

- **Assembly drawings**
 interpreting component drawings • dimensions • assembly skills

- **2D and 3D CAD assembly**
 assembly constraints

- **2D and 3D CAD exploded views**
 releasing constraints • positioning

ASSEMBLIES AND SECTIONAL VIEWS

INTRODUCTION

Sectional views are used on drawings to show the inside details of objects. Sectional views show the internal construction details, which may not be obvious from a normal drawing or sketch with hidden detail.

Examples of sectional drawings can be found in workshop manuals and other forms of technical illustration. Sales brochures and promotional posters may also make use of sectional views.

CUTTING PLANES

A chain line with thick ends is used to show where the object is sliced through. This line is known as a cutting plane. It has arrows to indicate the direction of viewing and letters to distinguish it from other cutting planes.

In the drawing here, the cutting plane shows where the object is sliced. The direction of viewing is indicated by the arrows.

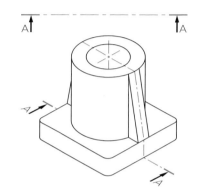

SECTIONAL VIEW

The part of the object behind the arrows is removed and the sectional view is left. Some hidden edges become visible, so they are drawn as outlines.

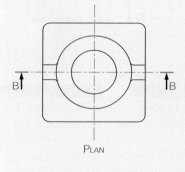

CROSS-HATCHING

The section is cross-hatched at 45°, with the lines approximately 5 mm apart. The sectioned view is titled according to the cutting plane, i.e. section A–A.

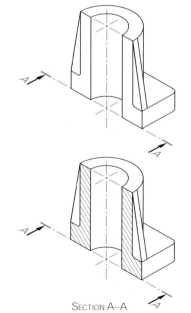

Section A–A

WHEN NOT TO HATCH

Various rules apply to sectional views:

1. Webs (ribs) are used to strengthen or support various engineering components. Webs should not be cross-hatched when they are sectioned lengthways.

2. Sectional elevation B–B demonstrates that you do not cross-hatch a web that is sectioned along its length.

3. Sectional plan C–C shows that you do cross-hatch a web that is sectioned across its length.

4. Drawing conventions also state that you do not show sections through nuts, bolts, washers, screws or shafts (axles) (see pages 46 and 47).

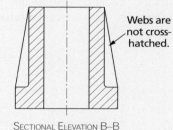

Plan

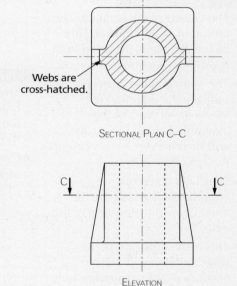

Sectional Plan C–C

Webs are cross-hatched.

Webs are not cross-hatched.

Sectional Elevation B–B

Elevation

HIDDEN DETAIL

Do not show hidden detail on a sectional view. For example, in sectional elevation B–B the upper back edge of the base is not shown.

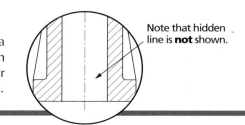

Note that hidden line is **not** shown.

INTRODUCTION

Many products consist of more than one part, called **components**. The type of drawing that shows all the components assembled together is called an **assembly drawing**. The standard abbreviation for assembly is ASSY.

Exploded view of the wheel assembly

1. START THE ASSEMBLY.

- The cutting plane is on the end elevation of the bracket. This means the view projected from it will be a sectional elevation.

- The cutting plane arrows indicate the direction of viewing. All parts of the assembly behind the arrows will be removed: in this case to the left of the arrows.

- Start with a central component: in this case the axle. Draw the elevation of the axle.

- This is the only part of the assembly that will not be sectioned: axles, spindles, nuts and bolts and webs are never cross-sectioned.

WORKED EXAMPLE

Details of all four components of a wheel unit of a roller blade are shown here. Draw the cross-section A–A of the assembled parts.

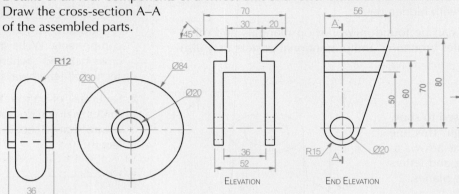

WHEEL — ELEVATION, END ELEVATION

BRACKET — ELEVATION, END ELEVATION

CLIP — ELEVATION, END ELEVATION

AXLE — ELEVATION, END ELEVATION

2. DRAW THE BRACKET.

- The holes in the bracket are Ø20 and the Ø20 axle fits through the holes.

- Construct the bracket around the axle.

3. DRAW THE WHEEL.

- The wheel is 36 mm wide and fits snugly inside the bracket.

- The centre line helps to locate the centre of the wheel.

4. ADD THE CLIP AND CROSS-HATCH THE DRAWING.

- Draw in the top section of the clip: it fits in the space on the right of the axle.

- Add cross-hatching where components have been cut through.

- Show hatching lines at 45° on the bracket, wheel and clip, do not cross-hatch the axle.

- Cross-hatching on adjacent parts should be staggered and run in opposite directions.

- Add a title.

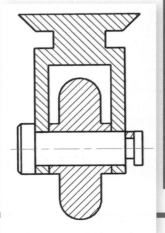

TIPS

- An assembly question will show you all the parts. It may include dimensions or be shown at a scale of 1:1.

- Look for clues as to how the parts can be assembled. Holes often require some other part to fit in them and matching dimensions on different parts may suggest how these parts fit together.

- The exploded pictorial graphic helps you understand how the parts are assembled.

- Look for the cutting plane to show how the assembly is cut through.

SECTIONS, ASSEMBLIES AND EXPLODED VIEWS

CAD offers many advantages, however it is a mistake to rely completely on any software to present drawings correctly. In short, don't trust CAD production drawings – always check that they adhere to drawing standards and conventions.

Before you create a CAD section you should identify where to position the cutting plane. It should slice through a part of the assembly that will show more detail or give more information about the product. Remember, the cutting plane is positioned on one orthographic view (in this case the elevation) and the section is shown on an adjacent view.

WHAT TO SECTION: AND WHAT NOT TO

Certain features should not have cross-hatching lines in a sectional drawing:

- webs
- bolts
- spindles
- nuts
- axles
- bearings.

EDITING THE SECTION

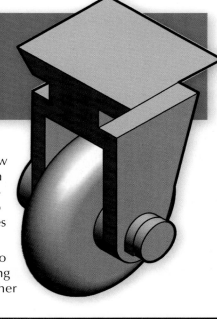

Some 3D CAD software will allow you to remove or edit the cross-hatch from components or faces. The cross-hatching below has been edited to become invisible and four missing lines have been drawn in.

If your software does not allow you to do this, you should edit your drawing using an illustration application. Your teacher will show you how.

The 3D CAD software has not recognised that this assembly includes an axle component. Axles should not be shown as a sectioned part – there should be no cross-hatching. Also some key edges are missing. This sectional view is incorrect and will need to be edited.

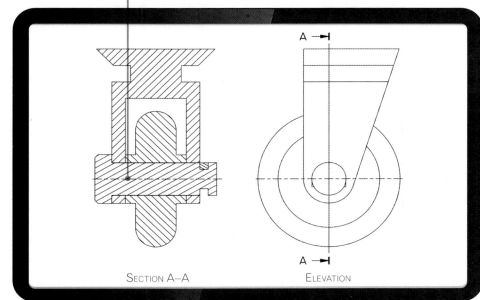

SECTION A–A ELEVATION

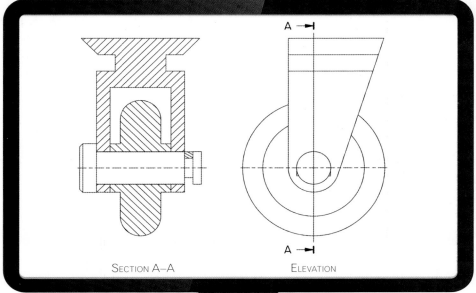

SECTION A–A ELEVATION

An exploded view is a type of assembly drawing in which the parts are assembled but are separated along a connecting axis or plane. Exploded views can be orthographic or pictorial. They are used during manufacture to show how parts of a product assemble. They are sometimes provided in promotional brochures and in instruction manuals when a product needs to be assembled at home.

Like sectional views, exploded views are known as **technical detail.** Marks will be awarded for technical detail in your Course Assignment so it's worth learning these techniques.

A pictorial exploded view is easily created by rotating the exploded assembly. Choose a position that shows each component in its own space without overlapping other parts.

RULES OF EXPLODED VIEWS

1. Parts should be exploded along an axis or plane that connects them when they are fully assembled.

2. There should be clear space between each part.

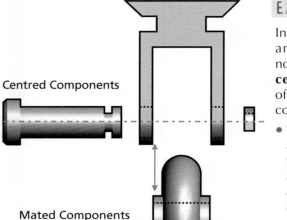

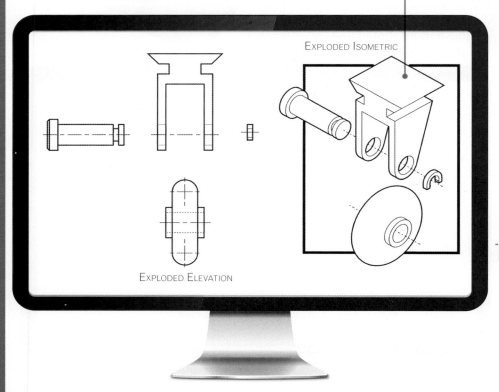

EXPLODED ISOMETRIC

EXPLODED ELEVATION

Centred Components

Mated Components

EXPLODING A CAD ASSEMBLY

In 3D modelling you will produce an assembly drawing with its normal constraints: **align**, **mate** and **centre axis**. By suppressing one of the constraints you can move a component to another position:

- The **axle** and **clip** have each had a mate suppressed to allow them to be moved away from their assembly position. The centre axis is still holding them both along the centre line.

- The **wheel** has the centre axis suppressed but the mate still holds it in line with the bracket.

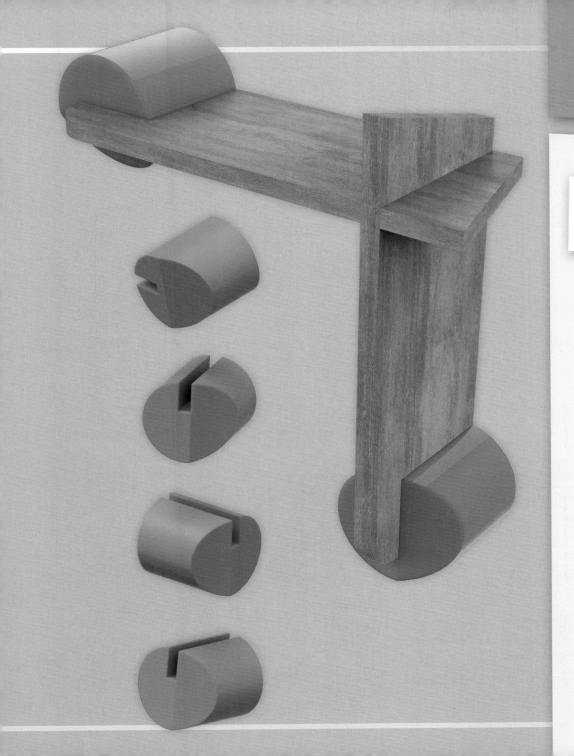

VISUALISATION

WHAT YOU WILL LEARN

- **Exam preparation**
 prepare • interpret • problem solve

- **Specimen questions**
 visualising graphics • drawing standards

You will not have to complete drawings in the exam but you will be asked questions that will enable you to demonstrate your understanding of drawings and how they are created.

A geometric shelf unit is shown. The shelf unit is a self-assembly type. The components slot together and are held in place using glue.

Study the assembly drawings and exploded drawing and answer the questions 1–6.

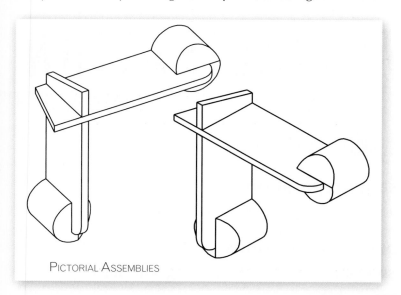

PICTORIAL ASSEMBLIES

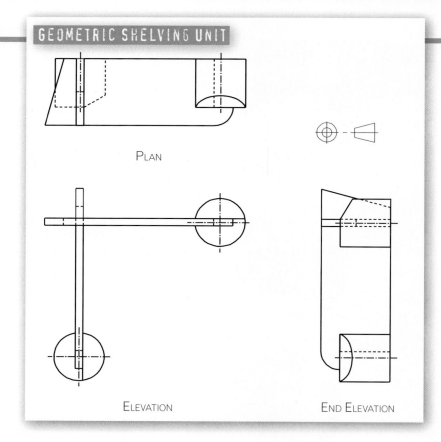

GEOMETRIC SHELVING UNIT

PLAN

ELEVATION

END ELEVATION

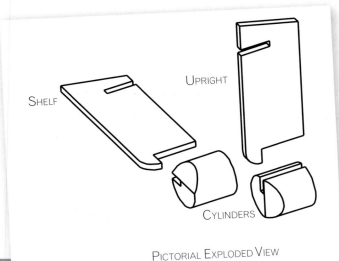

SHELF

UPRIGHT

CYLINDERS

PICTORIAL EXPLODED VIEW

Copy the answer table below and record your answers.

Visualisation answer table	
Component	Match
1 Shelf	
2 Upright	
3 Cylinder	
4 Surface development	

From the parts shown:

1 State the part that matches the shelf used in the shelf unit.

2 State the part that matches the upright used in the shelf unit.

a

b

c

d

3 State the part that matches the cylinder used in the shelf unit.

e **f** **g** **h**

4 The curved surfaces of the cylinders are to be decorated with a wrap-around transfer. Three possible surface developments have been produced for this purpose (i–k, shown on the right).

From the parts shown here, state the surface development that matches the orthographic views of the cylinder. You may use a ruler or compass to help you arrive at a choice.

The designer projected another view, below.

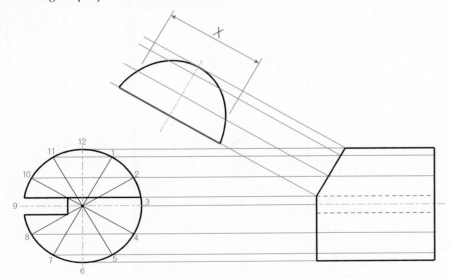

5 State the purpose of this view.

6 Using the numbers provided, state where the size shown at 'X' was found.

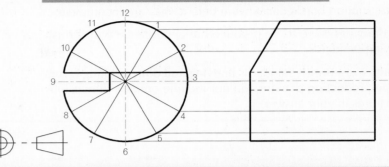

i

j

k

VISUALISATION

1. Dimensioned production drawings for the manufacture of a plastic support bracket are shown below. They are incomplete.

The drawings were to be produced in accordance with British drawing standards.

Identify eight British Standards **drawing and dimensioning errors** on the production drawing (do not include omitted dimensions or features in your answer).

'SURREALISM IS DESTRUCTIVE, BUT IT DESTROYS ONLY WHAT IT CONSIDERS TO BE SHACKLES LIMITING OUR VISION.'

Salvador Dali

Copy out the table, then identify and describe each error as per the example given below.

60

PLAN

30

75 mm

15

R 20

R 15

END ELEVATION

ELEVATION

PLASTIC BRACKET

NOT TO SCALE

ALL SIZES IN MM

Drawing standards errors in the support bracket production drawing		
	Description of the error	**Marks**
1	This line should be a centre line, not a solid line.	1
2		1
3		1
4		1
5		1
6		1
7		1
8		1
9		1

VISUALISATION

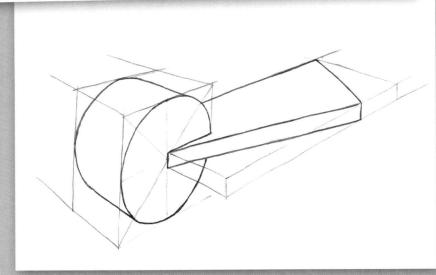

CHAPTER 08

FREEHAND SKETCHING

SKETCHING TECHNIQUES

INTRODUCTION

Sketching is a way of producing graphics quickly. Sketches should be produced freehand, without using drawing instruments. Use a soft (B or 2B) pencil for sketching. It is very important to keep the pencil sharp.

FIND YOUR OWN SKETCHING ANGLE

With a sheet of paper laid square in front of you like a table mat, sketch a series of sloping lines.

- Hold the pencil comfortably.
- Sketch from the bottom up and away from you. If you are left-handed, sketch in the opposite direction.
- Sketch each line in one movement.

This finds your most comfortable sketching angle. From now on you should turn the paper to sketch all straight lines at this angle.

USE BOXES TO BUILD SKETCHES

All sketches, no matter how complex, are built up using boxes. Your first task is to practise sketching boxes.

- Turn the paper so you can sketch all lines at your most comfortable sketching angle.
- Keep the box lines parallel to the edges of the paper.
- Concentrate on keeping all angles at 90°.
- Keep the lines straight and light.

KNOW THE IMPORTANCE OF PROPORTION

Creating the correct proportions is essential. You must train your eye to recognise good proportion. Constructing your sketch in boxes makes this much easier. Try sketches with straight lines first – buildings are ideal. Sketch your own house or school building.

1. TO START:

- Sketch the boxes.
- Box in the elevation. Take great care to get the proportions right.
- Divide it into its main parts.

2. THEN:

- Add detail and end elevation.
- Add sloping lines.
- Project the heights across and construct the end elevation.

MORE COMPLEX SKETCHES

More complex sketches, such as the clock shown right, can be built up using boxes and circles.

- Concentrate on proportion and line quality.
- Keep construction lines straight and light.
- Plot your circles and curves carefully.
- Firm in outlines and add detail.

CIRCLES

Sketching circles is made easier by some simple construction.

1. SKETCH THE BOX.

- Sketch a square.
- Add diagonals to find the centre of the square.

2. ADD CENTRE LINES.

- Sketch in two centre lines.
- Mark four points where the centre lines meet the square.

3. DIVIDE THE DIAGONALS.

- Divide the diagonals, corner to centre, into four equal parts.

4. SKETCH IN THE CIRCLE.

- Sketch in the circle through the outermost eight points.

This method is not exact, but will produce a good circle with practice.

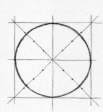

FREEHAND SKETCHING

INTRODUCTION

Sketching in perspective is an important skill for designers, illustrators and architects. Perspective sketches look realistic and are essential when communicating with customers and clients.

During the course you will sketch, freehand, in perspective. The advice given on page 54 is important. To become skilled in perspective sketching you must:

- turn the paper to sketch lines at your most comfortable sketching angle
- use boxes to build up each sketch
- train your eye to recognise good proportion.

HORIZON LINE AND VANISHING POINTS

Perspective sketching often starts with a horizon line. It can be placed high or low on the page, depending on the effect you want to create.

The vanishing points (VPs) always lie on the horizon line.

FORESHORTENING (REDUCING THE LENGTHS AND BREADTHS)

Perspective has the effect of shortening the depths which go back towards the VPs. This kitchen unit has had its length foreshortened. In a row of three identical units, each one is shortened further to create a strong perspective effect. Notice that the height also reduces towards the vanishing point.

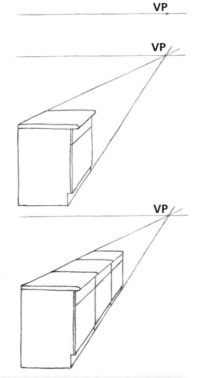

VP

VP

VP

INTERIORS

One-point perspective (using only one vanishing point) is often used to show interiors such as this kitchen design.

As in all styles of sketching, creating the correct proportion is the key to success.

SKETCHING PERSPECTIVE CIRCLES AND CYLINDERS

Use the same construction method as shown for circles on page 54.

1. SKETCH A PERSPECTIVE BOX.

- Mark a vanishing point.
- Sketch a perspective square. Remember to foreshorten the length.
- Join the diagonals to find the centre.

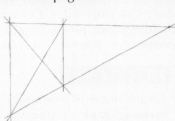

2. ADD TWO CENTRE LINES.

- The first line is a vertical centre line.
- The second line projects back to the vanishing point and then extends forward.
- Mark four points where the centre lines meet the perspective square.
- Mark another four points by dividing the diagonals, from the centre to each corner, into four equal parts.

3. COMPLETE THE CIRCLE.

- Sketch in the circle through each of your eight outermost marks.

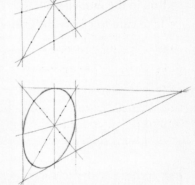

4. SKETCH A CYLINDER.

- Add a second vanishing point along the horizon line.
- Project the top and bottom of the circle back to the new vanishing point.

- Using the first circle as a guide, sketch in the curve at the back of the cylinder.
- Add detail. This cylinder becomes a torch.

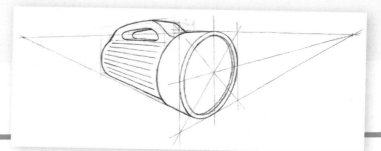

INTRODUCTION

Sketching in perspective is the best way to make your sketches look realistic. Illustrators often use perspective to make the products they draw look impressive. Drawing and sketching in perspective can make buildings and products look bigger than they really are. One-point perspective sketching uses only one vanishing point.

WORKED EXAMPLE

An architect has produced orthographic design drawings for a new leisure pool building. A pictorial sketch is needed to present the design to the client. The architect chooses a one-point perspective sketch. This will be easier for the client to understand and will give a more realistic impression of the building.

1. SKETCH THE ELEVATION OF THE POOL BUILDING.
- Box in the main parts.
- Take care to create the correct proportions.

2. POSITION THE VANISHING POINT CAREFULLY.
- Placing it low down will make the building look big and imposing.
- Add sloping roof lines.
- Project the corners back to the vanishing point.
- Check your proportions against the orthographic drawing.

3. SET THE FRONT WALL BACK UNDER THE ROOF.
- 'Move' the front wall back towards the vanishing point along the projection lines, taking foreshortening into account.
- Add the back edges of the building and the sloping roof.
- Sketch in the curved glass roof at the front and then at the back.

4. SKETCH IN THE CURVED ROOF DETAILS.
- Curves further back should match those at the front but should be smaller.
- Space out the curved roof frames. The spaces between them become narrower the closer they are to the vanishing point.
- Draw the angled roof supports in the same way.

5. COMPLETE THE DETAIL AND FIRM IN THE SKETCH.
- Make a final check of proportions and foreshortening.
- Add thickness to the roof supports.
- Firm in your sketch.

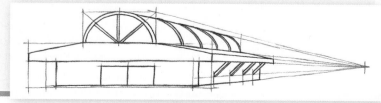

TWO-POINT PERSPECTIVE SKETCHING

CONSTRUCTION METHOD

Freehand sketching in two-point perspective does not always require that you have a horizon line and two VPs visible on the page. These features take up lots of space and can make your sketch too small: see right.

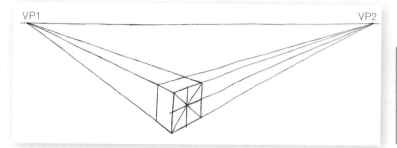

VP1 VP2

Try sketching with **remote VPs**. Imagine the VPs are past the edge of your page. Aiming towards them is enough to guide your line of perspective (see below).

WORKED EXAMPLE

A small display shelf is shown. From the information given, sketch freehand a two-point perspective view of the assembled shelf.

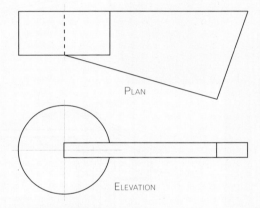

Plan

Elevation

Exploded view of the shelf

1. SKETCH A CRATE USING REMOTE VPS.

- Sketch the front edge of the crate and project vanishing lines towards remote VPs.
- Sketch the height, length and breadth in appropriate proportions.
- Add the construction for a perspective circle on the front.

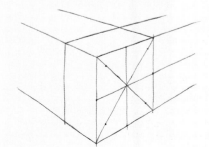

2. SKETCH THE CYLINDER.

- Sketch the perspective circle on the front.
- Project vanishing lines back and add the back of the cylinder.
- Note: use the circle on the front to guide the curve at the back of the cylinder.

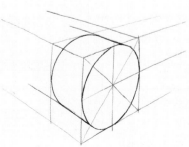

3. CONSTRUCT THE CRATE FOR THE SHELF.

- Position the crate carefully and sketch vanishing lines towards the VPs.
- Add the join line between the cylinder and the shelf.

4. COMPLETE THE SHELF.

- Construct the angles on the shelf, taking care with proportions.
- Firm in the outline of the display shelf.

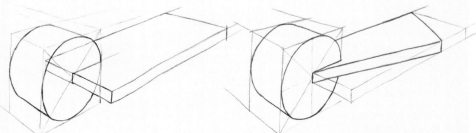

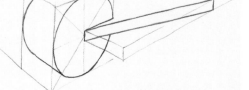

FREEHAND SKETCHING

57

CHAPTER 09

CONSTRUCTION DRAWINGS

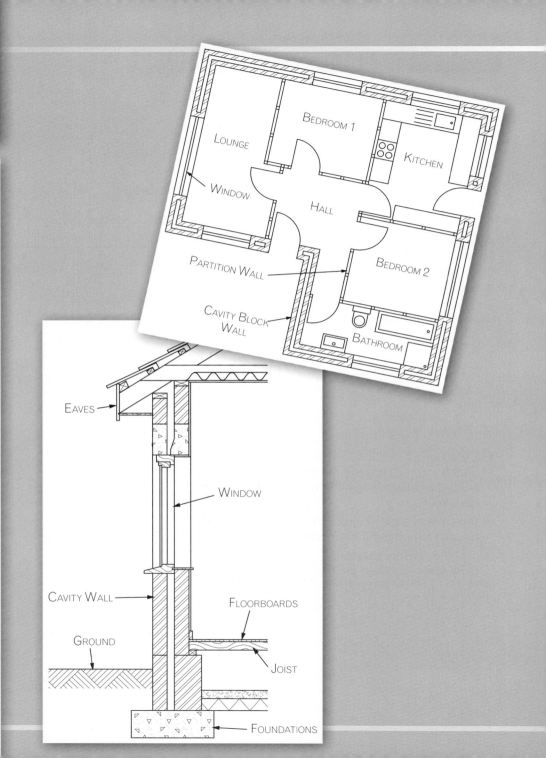

INTRODUCTION

A building or construction project requires a complete set of specialised drawings. These drawings – called a project set – are used by the local planning department and building control, as well as by builders, joiners, plumbers, electricians and water, gas and telephone engineers.

The buildings are designed by an architect with a team of technicians and surveyors to help plan and produce the drawings.

The types of drawings you need to know about are:

- location plans
- site plans
- floor plans
- sectional views
- elevations
- illustrations.

You need to understand these drawings and be prepared to answer exam questions about them. You may also be required to add details and symbols to building drawings but you are not required to complete an entire drawing.

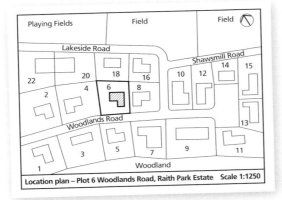

Location plan – Plot 6 Woodlands Road, Raith Park Estate Scale 1:1250

LOCATION PLAN

The location plan is the first drawing in the project set. It identifies the location of the proposed new building within its surroundings. It also helps the builder to plan the layout of a new building scheme and is required by the local government planning officers, who decide whether or not to approve the project.

Neighbouring buildings and their boundaries are shown, as are roads, street names and fields. In the example shown above, the new building is on plot 6 of a large building project. All the plot numbers are shown. The new building and plot are outlined with thick black lines and are sometimes, but not always, cross-hatched.

The direction arrow always shows north.

The scale of the drawing depends on the size of the whole building scheme, but is normally 1:1250.

SITE PLAN

A site plan shows the site boundary and the outline of the new building, which are highlighted in the location plan. Paths, roads and neighbouring plots are also shown. This type of plan enables the builder to mark out the site, lay drainage pipes and build manholes. It is also submitted to the local government planning department for approval.

In this example, two site plans of plot 6 have been drawn – these are shown below.

SITE PLAN 1

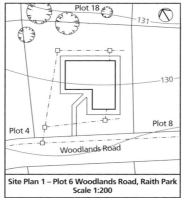

Site Plan 1 – Plot 6 Woodlands Road, Raith Park
Scale 1:200

SITE PLAN 2

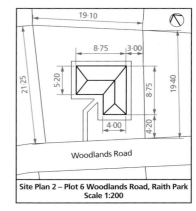

Site Plan 2 – Plot 6 Woodlands Road, Raith Park
Scale 1:200

Site plan 1 shows:

- existing trees
- contour lines, which show that the ground slopes down towards the road (the figures show metres above sea level)
- drainage pipes and manholes, which run from the bathroom and kitchen to the main drain under the road; the pipes always run downhill.

Site plan 2 shows:

- the building outline, including the roof
- the main dimensions of the house and the site in metres
- the position of the house on the site.

The scale of a site plan depends on the size of the building. For houses and small buildings a 1:200 scale is used.

BUILDING CONTROL AND PLANNING DEPARTMENTS

Drawings for new buildings require approval from the building control department and the planning department before construction work can begin. The building control department checks that the quality of design and construction meet British Standards. The planning department assesses whether or not the style and proportions of the proposed building are appropriate for the location.

FLOOR PLAN

A floor plan is a type of sectional view. It represents a plan view of the building with the roof and a few layers of bricks removed to show:

- the arrangement of rooms
- the positions of windows and doors
- the types of internal and external walls; in this drawing, external walls are brick cavity walls and internal walls are partition walls made from timber and plasterboard.

Floor plans are used by builders, plumbers, electricians and joiners to help plan the construction work and to cost the building materials.

The scale of a floor plan depends on the size of the building but for most domestic buildings a scale of 1:50 is used. (Note: the drawings on this page are not to scale.)

SIMPLIFIED FLOOR PLAN

Floor plans can be simplified for speed of drawing. In this plan, the walls are represented by thick lines.

MORE INFO

Other information found on floor plans can include:

- the dimensions of each room and the exact positions of doors and windows
- the layout of water pipes (plumbing)
- the layout of electrical cabling and positions of sockets, switches and fuse boxes.

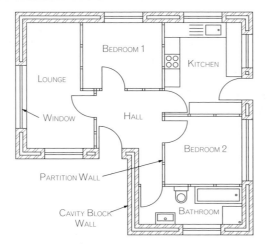

FLOOR PLAN – PLOT 6 WOODLANDS ROAD, RAITH PARK
TYPE: BUNGALOW SCALE: 1:50

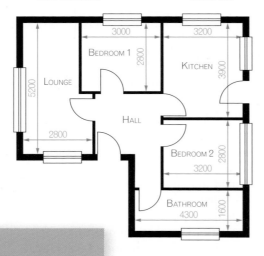

FIXTURES, APPLIANCES AND SYMBOLS

More-detailed floor plans show the layout of kitchens and bathrooms, as these are rooms that have fixtures and appliances. BSI symbols (see page 61) are used to simplify the drawing of common features. The kitchen layout here shows electrical and central heating fittings.

GO! ACTIVITY

1. Using the key to building symbols shown on page 61, identify the common features in the floor plans on this page.

SECTIONAL VIEW

A cross-section showing a slice through the wall gives builders, joiners and roofers information about how the house should be built.

The example shown here provides information about:

- construction of the eaves of the roof
- the type of materials used throughout
- how the window fits into the wall
- the construction of the cavity walls
- the floorboards and joists
- ground levels inside and outside the house
- the design of the foundations.

Sections can be shown through any part of the building and normally a scale of 1:20 is used. The local building control department needs sectional views and floor plans to assess the quality of construction design.

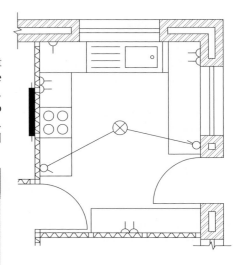

Elevations are orthographic projections of a building produced by the architect or designer. They show:

- the style of the building, for example bungalow or villa
- the external appearance of the building
- the style of roof
- the positions of doors, chimneys and windows.

Elevations are required by the local planning department to assess whether the style and proportions of the proposed building are appropriate for the location. Builders also need a picture of what the house will look like from the outside.

BUILDING SYMBOLS

The most common BSI building symbols are shown below. You must understand and remember them.

Lamp/Light	⊗	Door	
Switch		Sinktop	
Socket		Sink	
Insulation	⟋⟍⟋⟍⟋⟍	Bath	
Brickwork		Wash basin	
Concrete		Shower tray	
Sawn wood		Radiator	
Window		WC	

Selling or renting out the property is an important part of any building project. This often begins before the building work starts. Indeed, it is now common to buy a new house before a brick has been laid.

The process of selling a new building is known as marketing the property. It requires a specialised type of graphic known as an illustration.

Illustrations are normally pictorial graphics, although they can be 2D. They are vital to the marketing plan because:

- they can be drawn in perspective and rendered in colour to make them realistic and attractive to customers
- they promote the property on the market
- they are easily understood by the public because they are not technical graphics
- they can be included in sales brochures for customers
- they can represent the property in pleasant, mature surroundings.

Promotional graphics such as illustrations may be drawn by the architect. However, it is now common to subcontract this work to an illustrator or graphic designer who will produce the illustration and the sales brochure, along with any other promotional materials.

CHAPTER 10

COMPUTER GRAPHICS |
HARDWARE, SOFTWARE
AND SAFETY

WHAT YOU WILL LEARN

- **Benefits of computer graphics**
 specs • uses • types of computer

- **Computer technology**
 hardware • software • applications

- **Keeping safe**
 safety • security • protecting yourself

- **File management**
 good practice

- **Glossary**
 useful terms • understanding the language

DIGITAL GRAPHICS | THE FUTURE

Computer technology has revolutionised almost every industry, but none more so than graphics. Computers are used in the full range of preliminary, production and promotional presentations. In all instances, computers have made the design, editing and production of graphical items quicker, of higher quality and more cost effective. Almost all careers in graphics will require you to understand how to use computer technology to create and share ideas.

In the Graphic Communication course you are expected to use computers to create a range of graphic types. Having a solid understanding of the technology can make this process easier and more enjoyable. You will also be expected to answer questions about computer graphics in the National 5 exam.

COMPUTER SPECS: POWER HUNGRY

Looking for a good computer? Technology is improving all the time, so you should do your research before you buy. Aim for a computer with all these features:

- fast processor
- separate graphics card
- large monitor
- large hard drive
- fast hard drive
- lots of RAM

COMPUTER GRAPHICS: A BEAUTIFUL SYSTEM

Any device can be simplified into what is called a 'systems diagram'. A systems diagram describes any machine in terms of input, process, output (and occasionally 'backing store' and 'feedback').

In the National 5 exam you may be asked whether components are **inputs**, **outputs** or **backing store** devices.

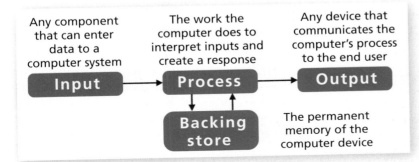

Input	Process	Output
Any component that can enter data to a computer system	The work the computer does to interpret inputs and create a response	Any device that communicates the computer's process to the end user

Backing store — The permanent memory of the computer device

COMPUTING DEVICES: TYPES

LAPTOPS

Laptop computers offer many advantages: they are powerful, have a keyboard for quick and easy typing, are fairly portable and can be connected to a projector for presentations. Laptops come in a wide range of specifications and prices. Cheap, entry-level laptops can sometimes be good value, but don't expect to create or edit complex graphics or 3D renders with them.

DESKTOPS

The desktop computer is the workhorse of the graphics industry: they are very powerful and can handle a wide range of graphic processes – often simultaneously.

Desktop computers are not particularly portable. They are heavy and most components are not integrated into one case. However a graphic designer or CAD engineer will create the majority of their graphics using a desktop computer because of the large display and processing power.

TABLETS

Tablet computers bridge the gap between laptops and mobile phones: a large, clear, touch-screen display enables users to interact intuitively with the device, while wireless technology helps the tablet communicate with Internet routers (or, in some cases, the phone network).

Some tablet computers allow designers to 'sketch' directly onto the display, removing the need for drawing tablets. This allows designers to be more productive, producing preliminary drawings when sitting with clients – these sketches can be firmed up later using a PC or laptop.

MOBILE PHONES

Mobile phones are becoming increasingly powerful, and many models have specifications to rival tablet computers. Mobile phones have the advantage of being connected directly to the cellular network: sharing files and communication is at their core. Most mobile phones also include a high resolution camera. A graphic designer can store lots of work on their handset, take inspirational photographs and organise work and deadlines using calendar features.

CENTRAL PROCESSING UNIT (CPU)

The CPU is the main processor that controls most of a computer's main operations. CPUs can also process graphics, but are not as efficient or quick as a GPU (see below).

MOTHERBOARD

The motherboard connects all the components of a computer. The communication speed of a motherboard has a large impact on the performance of a computer.

RANDOM ACCESS MEMORY (RAM)

RAM is the main temporary memory storage of a computer. RAM is used to run applications and remember any temporary data. This data is lost when there is no electricity.

ETHERNET PORTS

Ethernet ports are high-speed communication ports. These are often used to connect to networks or Internet routers. Some high-speed imaging equipment may also use an ethernet port.

GRAPHICAL PROCESSING UNIT (GPU)

A GPU is a purpose-built processor designed to complete the huge calculations required to display complex graphics quickly. A powerful GPU is essential for 3D illustrations or video editing.

HARD DISK DRIVE (HDD)

A hard disk drive is the internal storage of a computer. HDD are moving disks where data is read, written or deleted magnetically.

GO! EXAM TIP

You don't need to revise the information on this page. It is for background learning only.

UNIVERSAL SERIAL BUS (USB) PORTS

USB (universal serial bus) is a type of communication port found on most computer devices. USB is a common format and can be found on a wide range of devices.

FIREWIRE (IEEE 1394) PORTS

A firewire port is a communication port similar to a USB port but with blisteringly fast transfer rates. Firewire is often used with high-end cameras or external hard drives.

DVD AND BLUERAY REWRITERS

DVD – and now Blueray – drives are an optical read/write system. Data is 'burned' onto or read from the surface of a disc using a laser. DVD and Blueray discs must be kept free from scratches, otherwise the data may become unreadable.

SECURE DIGITAL (SD) CARD READER

Secure digital (SD) cards are a form of storage technology commonly used with digital cameras and mobile phones. SD cards store data even when the power is off. SD cards come in a range of sizes – both for their physical size and their storage capacity.

WIRELESS

Wireless is a networking technology that allows computers and mobile phones to communicate with each other or to access the Internet without wires. This makes using computer technology in different locations much more flexible.

SOLID STATE DRIVE (SSD)

Solid state drives are storage drives similar to HDD but without moving parts. This makes reading and writing data extremely fast. SSD are less prone to damage from being dropped but are more expensive and have a smaller capacity than HDD systems.

2D CAD

2D CAD is very similar to a drawing board and is primarily used to create technical drawings of products or buildings. While 2D CAD is normally used to create 2D drawings, pictorial views can also be created. These pictorial drawings cannot be rotated like 3D CAD models.

3D MODELLING

3D modelling software allows a designer to draw buildings or products in three dimensions. All the component parts can be animated, simulated and rendered to give an accurate impression of how the product will look and function if it is manufactured.

3D RENDERING

3D rendering software allows the designer to apply materials, textures, light sources, shadows and reflections to graphics. This makes the product look more realistic and easier to understand. Some 3D rendering software allows animations.

DESKTOP PUBLISHING

Desktop Publishing (DTP) software allows a designer to present text, graphics and photographs in a visually appealing manner. While DTP is most commonly used with printed graphics, it is becoming more popular in website building and digital visuals.

PHOTO EDITING

Photo editing programs allow graphics artists to modify, enhance or repair images acquired from digital cameras or scanners. A range of artistic tools is available, some of which can make photographs appear hand-painted, pencil-drawn or spray-painted.

SPREADSHEETS

Spreadsheets are commonly used to display information in tables or to make calculations. Spreadsheet software usually has graphical tools that allow you to present information in a range of graphs or pie charts.

VECTOR DRAWING

Vector drawing programs allow you to make graphics that can be scaled to any size without losing quality. This works because graphics are based on coordinates rather than bitmapped pixels. Vector drawing programs can be used to create stunning visuals.

VIDEO EDITING

Video editing applications allow designers to edit, enhance or repair video files from cameras or mobile phones. Video files can be 'stitched' together to make longer films, transition effects added between scenes and audio added to enhance the viewing experience.

WEBSITE BUILDING

Website building software works in a similar way to DTP packages, with the exception that the 'pages' are designed to be uploaded to the Internet. Text, graphics and video can all be added to make the site more visually appealing.

WORD PROCESSING

Word processing software is used to type letters, books and essays. Some word processors may have a few graphics tools, however these are limited compared to proper DTP software. Word processors should not be used for DTP in this course.

COMPUTER GRAPHICS | HARDWARE, SOFTWARE AND SAFETY

You may think that using a computer is fairly harmless. However, there are some important things to think about before you step into the digital world. Here you can learn some vital tips to keep you healthy and safe.

You should follow the advice on this page whether using a desktop computer, laptop, graphics tablet or games console.

HOW TO SIT: POSTURE PERFECT

We all slouch at times, but doing so for a long time can cause serious strain on your back muscles and spine. It is important that you sit in a comfortable chair that provides back support. Avoid using a stool. You should try to keep your back straight and sit back from the monitor. If you are using a computer a lot it is advisable to have a foot rest and wrist support: an ergonomic keyboard and mouse will also help you avoid **repetitive strain injury** (RSI).

Your screen should be placed at eye level or just below to prevent neck strain. You should also take a break at least once an hour and stretch your legs. This will give you some time to clear your head, rest your eyes and take some exercise. Practise your posture: it may not seem natural to begin with, but can save you from a lot of pain later on.

GET A GRIP: ERGONOMIC DEVICES

Human interface devices (HID) allow people to interact with computers. There are a number of such input devices, ranging from mice and keyboards to drawing tablets and touch screens.

The quality and design of HID can have a marked effect on comfort and prevent repetitive strain injury. RSI is a painful straining of muscles that can occur when continually repeating movements. Ergonomically designed devices can reduce the risk of RSI.

LOOK HERE: REST YOUR EYES!

Your eyesight is valuable and you should take good care of your eyes. Frequent use of monitors and TV screens can cause eye-strain, so you should take a number of safety precautions. Never sit too close to any display device or sit in a darkened room while staring at a screen. You should take a 15-minute break for every hour spent looking at a display.

Ensure that your computer has a sensible display resolution so that icons and text are not too small to read.

PERSONAL DATA: IT'S NOT GOOD TO SHARE

Many websites encourage us to share personal information such as full names, date of birth, addresses and family history. This information sharing can appear harmless but, in fact, it contributes to your 'digital footprint'. Information can be gathered by advertising companies wishing to make sales offers, or by more sinister individuals and groups attempting identity theft.

You should avoid putting personal information, photographs or videos online: even with privacy settings set to a high level, there is a risk that this data can be seen or used by others.

If you would not be comfortable pinning the same information on the front door of your home, don't put it online. Once you have put something online, it is permanently public: someone may have saved copies of your documents and reuse or share them without you knowing.

COMMUNICATION

THE INTERNET

The Internet has revolutionised communication around the world. The chances are that you cannot remember a time without the Internet, email or mobile telephones. However, prior to the worldwide web, communication of ideas was far slower, often relying on posting paper copies of documents or sending them via fax machines. Now, with email you can quickly send text, pictures, animations or even programs to anywhere on the planet.

With this almost instant worldwide communication, new problems have been created. Now, more than ever, communicating graphically has become vital.

EMAIL VS FTP: SENDING FILES

There are many ways of sending a file over the Internet and these can be put into two categories: **push-based** or **pull-based**.

Push-based file transfer involves one person sending a file towards another person. This is achieved using email; files are added to messages as 'attachments'. Attachments are often represented by a paperclip icon. Email service providers limit the file size of an attachment and this can be inconvenient, especially when sending images or video files.

File transfer protocol (FTP) requires the person sending the file to upload it to a web-based server. People who want to access the file then have to pull – or download – the file themselves. This stops email inboxes from becoming cluttered, slow and unresponsive.

You should encrypt or password secure sensitive data that you want to send. Remember you have no idea who may see things you send.

FILE MANAGEMENT: KEEP CONTROL

Keeping organised is important in all aspects of your life: a diary, calendar or mobile phone can help you remember important events or tasks. To keep track of your documents and homework, you should have a filing system so that important items don't get lost, damaged or thrown away.

With a computer, it can be easy to lose track of all the files you create. You should take care to use sensible file names and folders – called **directories** – to store all your files.

You should also backup files regularly: saving to a secure online site, external HDD or USB memory stick. Remember to keep your HDD or USB memory stick safe, otherwise you'll lose your files!

On a computer, one directory can be stored within another. This is called a 'hierarchical system' and it allows you to keep your documents organised and accessible.

When completing any CAD or DTP work at school, take care to save your files properly. You don't want to lose your work and have to start from scratch!

Graphic communication

DTP 3D modelling Images

Parts Assemblies

APPLICATION (APP)
Name given to a piece of software that runs on a computer or mobile phone.

ATTACHMENT
The name given to a file sent within an email.

BACKING STORE
Any device used to store files or software.

BLUERAY
The name given to a format of optical storage.

CEOP
Child exploitation and online protection: a branch of the UK police tasked with keeping minors safe from online threats.

CLOUD STORAGE
Storing files or software on an online server through the Internet.

CPU
Central processing unit – the device that completes the processing of data.

DOWNLOAD
Retrieving a file from another computer, server or backing store device. Most commonly used when referring to files on the Internet.

DRAWING TABLET
An input device that relies on a pad and stylus to simulate the use of pen and paper to draw directly into a graphics package.

DVD
Digital versatile disc – an optical storage technology. Discs that can be written to are called DVD-r.

EMAIL
Electronic mail – allows text, images and files to be sent from one computer to another.

ERGONOMICS
The design and manufacture of products to suit the human form reducing the risk of injury from RSI.

ETHERNETS
An ethernet is a high speed communication port. These ports are often used to connect to networks or Internet routers. Some high speed imaging equipment may also use an ethernet port.

EXPORT
Send a file from a software package so that another program can use it.

FTP
File transfer protocol – a method of sending a file from one computer directly to another through a network. Used to send large files securely.

GB
Gigabyte – 1024 megabytes.

GPU
Graphical processing unit – a special processor designed to complete graphical calculations very quickly.

GRAPHICS CARD
A computer device that processes graphics. Contains the GPU and VRAM.

GUI
Graphical user interface – images used on screen to make using a computer easier.

HARD DISK DRIVE (HDD)
A backing storage device that uses moving discs and magnetic fields to read and write data.

HID
Human interface device – an input device that allows a human being to take direct control over a computer.

IMPORT
Load a file from one software package into another.

INPUT
A device that connects to a computer and sends data into the CPU for processing.

INTERNET PROTOCOL
A rule that governs communication over a network such as the Internet.

KB
Kilobyte – 1024 bytes.

LOCAL AREA NETWORK
Computers connected together in a local area so they can share resources such as Internet access, printers and scanners.

MB
Megabyte – 1024 kilobytes.

MONITOR
Output device displaying graphics, text and images.

OPERATING SYSTEM
The software that controls a computer device.

OUTPUT
A device that connects to a computer and presents the results of the CPU for processing via sound, images or movement.

PRINTER
An output device for obtaining a paper hard copy of images, graphics or text.

PROCESS
The title given to the work a computer system completes when making calculations or decisions.

RAM
Random access memory – the memory the computer needs when running software.

REPETITIVE STRAIN INJURY
An injury that can occur when repeatedly making the same motion.

ROM
Read only memory – a hardware device that stores items of code permanently.

SCANNER
An input device in two forms: 2D and 3D. 2D Scanners are used to get paper-based graphics into a computer system. 3D scanners can create 3D models of physical items.

SSD
Solid state drives – backing store devices that read and write data to a memory chip.

TB
Terabyte – 1024 gigabytes.

TWAIN
A protocol that allows scanners and digital cameras to share images with a computer.

UPLOAD
The phrase used when sending a file from one computer to a server, backing store device or another computer. Most commonly used when referring to files on the Internet.

USB
Universal serial bus – an industry standard communication port.

VDU
Visual display unit – see monitor.

VRAM
Video random access memory – a fast type of memory used on graphics cards.

WIRELESS
A short range radio adapter that allows computer devices to access a local network or the Internet.

DIGITAL CAMERA | INPUT

Digital cameras have become very popular as they do not rely on film. Designers can take photographs of products, materials, people and documents, and use this in developing graphic work. Files can be quickly printed or emailed. Some cameras now have the ability to send emails with images without the use of a computer.

DRAWING TABLET | INPUT

Drawing tablets allow designers to sketch ideas to the computer. These digital drawings can then be used to create vector graphics. Tablets use a stylus (pen), which makes sketching on the computer more natural.

HAND-HELD SCANNER | INPUT

Hand-held scanners give a quick way of digitising sketched graphics. These scanners scan an image and convert it into a JPG file in a similar way to a digital camera. While the resolution tends to be lower, they are a quick, inexpensive and portable scanning solution.

3D SCANNER | INPUT

3D scanners allow objects to be digitally scanned by either a laser or small needle-like probe. This is a quick way of getting 3D CAD data without using 3D modelling software. Scanned models can be used in illustrations, for prototype testing or altered to make new designs.

OPTICAL MOUSE | INPUT

An optical mouse is an important component of any computer system, allowing the user to control the cursor to select various GUI on-screen options. Optical mice are more accurate and easier to maintain than their opto-tracker ball equivalent, which frequently become clogged with dust.

FLATBED SCANNER | INPUT

Flatbed scanners come in a range of sizes and offer high quality capture of images compared to hand-held scanners. They are not very portable, but offer very accurate results. Images can also be altered digitally before the file is captured and sent to the computer.

KEYBOARD | INPUT

Keyboards are essential to computers – many won't start without one! They allow designers and engineers to enter alphanumeric data (letters, numbers and symbols) in to the computer.

TABLET COMPUTER | PROCESS

Tablet computers have touch-screen technology and sometimes come with a stylus, which allows the user to draw directly onto the screen. These hand-held computers can connect to the Internet and some have digital cameras built in. Although not as powerful as a desktop or laptop machine, tablet computers are very portable.

LAPTOP/BASE UNIT | PROCESS

The heart of CAD – powerful computers make the difference when running graphics processing software.

A dedicated graphics card and high spec multicore processor are essential to run most CAD software.

EXTERNAL HDD | BACKING STORE

The size of files created by programs can be huge. External hard drives are used to store large files or act as a backup of important work. External hard drives with over 2TB (2000 GB) capacity are becoming more common.

USB MEMORY | BACKING STORE

USB memory drives are inexpensive and portable storage devices that come in a range of capacities, from 256 MB to 60 GB. These memory sticks allow a designer to move large files – but should not be used for confidential material in case they are lost or stolen.

CLOUD STORAGE | BACKING STORE

Cloud storage is a facility for Internet storage of files. These websites use file transfer protocol (FTP) so you can upload or download your files from any computer, smart phone or tablet. However, cloud storage requires an Internet connection and the speed of that connection affects how quickly files are loaded or saved.

LASER PRINTER | OUTPUT

Laser printers use toner dust that is fused to the paper using static electricity or heat, depending on the model. Laser printers come in a range of format sizes from A5 to A3. These printers offer quick, low cost prints. However, many people feel they do not produce as good a colour output as inkjet or wide format printers.

INKJET PRINTER | OUTPUT

Inkjet is the most common format of printer and they come in a range of sizes, from A5 photographic to A3 poster printers. The inks used are expensive to replace and the printers tend to be slower than laser or wide format. The quality of print from inkjet is considerably better than other formats.

WIDE FORMAT PRINTER | OUTPUT

A printer is an essential piece of equipment, allowing designers to see hard copies of drawings or graphics. Wide format printer plotters have the ability to print in wide, long continuous sheets and will also cut graphic images for sign making, vehicle wrapping or packaging manufacture. Wide format printers are costly to operate.

MONITOR | OUTPUT

CAD monitors differ from standard visual display units (VDU) in terms of size, resolution, refresh rate and colour depth. In all aspects, CAD monitors tend to be sharper, with better colour richness and are quick to redraw images. These are important for the eyesight of CAD engineers who spend a lot of time using the computer.

3D PRINTER | OUTPUT

3D printers physically manufacture 3D CAD models and are a form of computer-aided manufacture (CAM). There are different forms of 3D printers with a range of capabilities. 'Prints' are often made from plastic but some other 3D printers can make things in wax, metal or even chocolate!

DRUM PLOTTER/CUTTER | OUTPUT

Plotters print line drawings using pens, or cut thin material using a small knife.

Plotters move the pen or knife in a sideways motion, while rolling the paper or material back and forward. This process allows the plotter to draw or cut straight or curved shapes accurately.

DIGITAL PROJECTOR | OUTPUT

Digital projectors allow designers to display the screen of their laptop, PC, or tablet computer on a wall or pop-up screen: ideal for presentations. Some projectors can also be used with 3D glasses so 3D models appear in perspective. This can make it easier to show designs, illustrations or animations to large groups of people.

LASER CUTTER | OUTPUT

Laser cutters are a form of computer-aided manufacture. A 2D CAD drawing is used to guide a laser as it cuts a sheet of material. Images can also be 'etched' on the surface of the material. Laser cutters are very accurate at cutting the shapes drawn on a computer and are extensively used in sign making.

CHAPTER 11

2D COMPUTER-AIDED DESIGN

- **2D CAD**
 applications • who uses it

- **Drawing method**
 grid and snap • layers • drawing tools • editing commands

2D computer-aided draughting is the electronic equivalent of traditional drawing and can be used to create a full range of production drawings.

Production drawings from 2D CAD can be printed or sent directly to manufacturing equipment to produce component parts.

2D CAD software is useful when generating accurate surface developments or true shapes of individual faces.

While 2D CAD often relies on a mouse as an input device, many new applications are using graphics tablets or touch screen technology to make the drawing process easier and more natural for the designer.

You may use 2D CAD software to complete elements of your coursework or Course Assignment.

2D CAD is a digital drawing board – many of the manual drawing techniques you learn on the drawing board are used to generate 2D CAD drawings.

2D DRAUGHTING VERSUS 3D MODELLING

Knowing how to use 2D CAD is very important as all 3D CAD software uses a range of 2D drawing tools. These allow the designer to draw the flat shape or 'profile' that they want to make into 3D.

It is wrong to assume that 2D CAD has been fully replaced by 3D CAD. 3D CAD can appear more glamorous and exciting, but there are many types of production and architectural drawings that require the fine drawing skills and techniques only provided by 2D CAD software.

In industry, technical drawings produced in 3D CAD are imported into a 2D CAD application for further refinement.

Architecture
Product design
Electronics
Civil engineer
Civil planning
Production engineering

DIGITAL DRAWING BOARD: SAME SKILLS BUT NEW TOOLS

The principles and skills of creating production drawings using a drawing board are also used with 2D CAD software.

Most CAD technicians learn the basics of draughtsmanship using a drawing board. However, 2D CAD has a number of advantages over traditional drawing techniques, such as allowing greater drawing accuracy with the use of grid and snap, providing CAD libraries of common parts and the ability to email drawing files instantly to anywhere in the world.

You should familiarise yourself with manual drawing techniques before progressing to 2D CAD – otherwise you may find it difficult to understand how production drawings are created.

Architects, civil engineers, civic planners and production engineers use 2D CAD software extensively – more than 3D CAD.

There are two reasons for this:

1. The key information on these drawings types is best expressed in orthographic views.
2. Speed of production is often very important: regular users of 2D CAD software can produce drawings at incredible speed.

2D COMPUTER-AIDED DESIGN

GRID | STICK TO THE POINT

'Grid' and 'snap-to-grid' are key features of 2D CAD software. Grid and snap-to-grid tools ensure graphics are produced quickly and accurately, by controlling where the cursor and drawing tools are on the paper.

Grid and snap-to-grid are also used with DTP software: if you learn to use these features, you will find using DTP and 2D CAD far easier!

The spacing or pitch of the grid can be set to the most suitable size.

A suitable scale can be used if the object you are drawing is too big to fit on the screen or too small to be seen clearly.

The 'grid' can be displayed as an array of squares, crosses or dots, depending on the software you are using.

When using 2D CAD, DTP software and even some 3D CAD applications, you should set your grid size first, as changing the size of the grid later can cause graphics to change size or scale.

Some 2D CAD software will allow you to set pictorial grids, such as isometric. This can improve the speed and accuracy of producing pictorial drawings.

GRID: SNAPPY GRAPHICS

Orthographic grid

2D CAD: TAKE COMMAND

PAN
Move the view point of an object without zooming out.

ARRAY
Repeat a graphic in a square or circular pattern.

COPY AND PASTE
Make identical copies of graphics.

CONSTRAINT
Lock or force a graphic to be a certain size or angle.

GRID
Regularly spaced lines and dots which improve speed and accuracy.

ZOOM
Magnify in or out from a graphical item.

GRID LOCK/SNAP
Force a cursor or line to attach to the grid.

MIRROR
Make a symmetrical copy of a graphic.

PERPENDICULAR
Force a line to be at 90° to another line.

EXTEND
Make a line longer until it touches another line.

TRIM
Cut or remove part of a line that crosses another line.

ROTATE
Turn a graphic round a centre point.

MOVE
Reposition a graphic on the page.

half (1:2)
Full (1:1)
Quarter (1:4)

SCALE
Increase or decrease the size of a graphical item.

TANGENT
Force a line to touch a circle or arc at one point.

GROUP
Lock a selection of graphics together.

2D CAD software enables designers, architects and engineers to create production drawings on a computer-generated 'paper'. The size of this paper can be set by the user of the software – most likely to the paper size that the drawing will be printed on (probably A3 or A4).

A wide range of drawing tools is available. The full range depends on the software being used.

2D CAD software can be used to create orthographic drawings or 2.5D pictorial views, such as isometric, oblique or planometric. 2.5D can be a confusing term: while pictorial drawings created using 2D CAD may appear three-dimensional, they are not true 3D as they cannot be rotated or viewed at any angle like the models produced in 3D CAD software. In these instances, the pictorial views are referred to as 2.5D.

Creating pictorial graphics using 2D CAD has a number of advantages, for example creating accurate perspective drawings.

Using different line types can be very important. CAD technicians often colour construction lines and 'outlines' black. The thickness or **weight** of the lines can also be changed. Hairline is used for construction and 1pt for outlines.

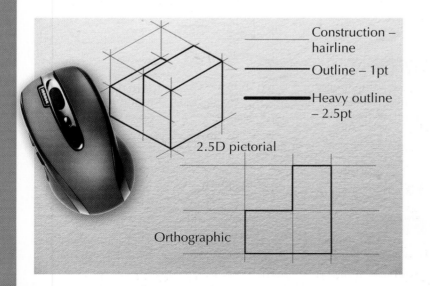

Construction – hairline

Outline – 1pt

Heavy outline – 2.5pt

2.5D pictorial

Orthographic

COORDINATES: ABSOLUTE RELATIVITY

2D CAD software allows designers to draw items very precisely. There are many forms of mathematical coordinate system and some of these are used in 2D CAD applications.

Two of the most common systems are **relative** and **absolute**. Relative coordinates refer to the angle and size of one line in relation to another. Absolute coordinates measure the length and angle of a line against a set point on the drawing, sometimes called the **datum**, **origin** or **zero-zero** point.

FILL OR FILL EFFECTS

Outline graphics can have a range of fill effects applied – depending on the software you use – to improve the visual impact or clarity of the drawing work produced.

DRAWN GRAPHIC

2D CAD software is mostly used to produce line graphics, such as those made on a drawing board. A full range of line types is available.

GRID

A grid can be used – and set to be visible or invisible. The cursor and graphics will 'snap' to the regular intervals of the grid.

DRAWING LAYER

The drawing layer acts as paper, where the graphics can be drawn. The size of this paper may be changed.

LIBRARY: COMMON SHAPES

A CAD library contains a wide range of commonly used shapes or drawings, sometimes called icons, that a designer may use as many times as necessary. These drawings or shapes may be imported or dragged onto a page, then manipulated if required.

CAD libraries save designers from drawing a similar item repeatedly – a task that can be time-consuming and frustrating! CAD libraries are also used when particular drawing standards are critical. A library-drawn item will be drawn to conform to the proper drawing standard.

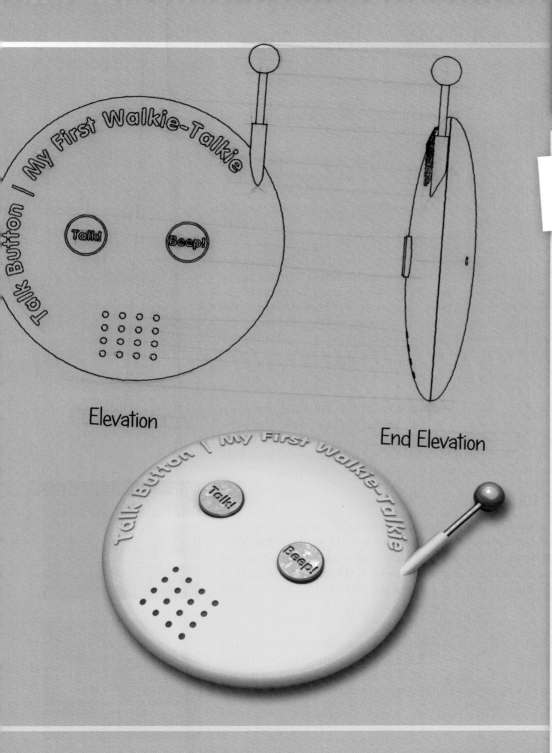

My First Walkie-Talkie

Talk Button

Talk!

Beep!

Elevation

End Elevation

My First Walkie-Talkie

Talk Button

Talk!

Beep!

3D CAD

WHAT YOU WILL LEARN

- **CAD in industry**
 applications • manufacturing • testing • illustration

- **3D modelling**
 extrude • revolve • shell • array • chamfer • fillet

- **Glossary**
 useful terms • tools • editing commands

- **Assemblies**
 components • constraints

- **Advanced 3D modelling**
 helices • tapers • lofts

- **Exam preparation**
 problem solving • skills • knowledge

3D CAD is only one of many tools used by an engineer, designer or architect. There is a range of functions that come after the CAD stage – these include manufacturing and marketing, also known as **production** and **promotion**.

SKETCHED IDEAS

Sketched ideas are still the basis of designing products, buildings and graphics. The more detail there is in the initial sketches, the easier it is for a CAD engineer to create a 3D model. Some of these freehand drawings may be scanned into the computer and the sketch used to generate a 3D model.

3D CAD MODELLING

3D CAD modelling is a time-saving process. The 3D model can be used for several functions once it is made.

Accuracy is the key to success.

Every CAD package has a large selection of features that can make producing your model easier.

Files should be saved regularly, with sensible file names. Keep all files together in one directory. Backing up your files to cloud storage, USB memory or external HDD is good practice.

"DESIGN IS INEVITABLE: THE ALTERNATIVE TO GOOD DESIGN IS BAD DESIGN, NOT NO DESIGN AT ALL."

Douglas Martin, author

MANUFACTURING

Computer-aided manufacture (CAM) allows 2D or 3D graphics to control computer-numerically controlled (CNC) machines to produce physical objects. Some 3D CAD software simulates (tests) the manufacture process prior to machining. CAD/CAM has had major social implications: many factories have replaced workers with automated CNC machines and this has caused unemployment.

PRODUCTION DRAWINGS

Most 3D CAD software can create technical drawings of the 3D model. This allows the designer or engineer to produce orthographic, pictorial, sectional, detailed and exploded views. It is a time-saving feature, removing the need to produce the engineering drawings on traditional drawing boards or 2D CAD software.

3D PROTOTYPE PRINTING

Models are exported as standard tessellation language (STL) files and imported into 3D model machines. The model is then digitally 'sliced' into thin horizontal layers. These layers can be printed. 3D printed prototypes help the designer to evaluate aesthetics and functions.

SIMULATION

Simulation allows testing of products, training of people or predicting real-world events. 3D simulations have preloaded physical data about materials, temperature and environments. Simulation using CAD reduces the costs of producing products and is a safer method for training staff.

3D ILLUSTRATION

Illustration (or visualisation) software improves the visual impact of a 3D model. Some illustration software allows the user to animate the model. Most CAD software has illustration capabilities included but stand-alone applications are available.

3D CAD MODELLING SOFTWARE

3D CAD modelling is a relatively new way of drawing products or buildings on a computer. It enables the designer to view objects from any angle, illustrate models to look photo-realistic or send them directly to manufacturing equipment to produce a finished item.

This has increased the productivity of designers, engineers and architects: models can be quickly produced, altered and sent to clients round the world within minutes. Multiple people can work on one design simultaneously and it can even be illustrated as the graphics are produced.

This technology has led to a growing demand for employees to have a solid understanding of CAD.

3D CAD often requires more powerful computers, but the level of detail and ease of understanding make it worthwhile.

Computer-aided design (CAD) uses computer technology to enable designers, engineers and graphic artists to model ideas in 2D and 3D. This electronic method has many advantages over the more traditional approaches to drawing.

The history of CAD software can be traced back to 1963 and the invention of 'SketchPad' by Ivan Sutherland. This technology was very limited and only allowed engineers to 'draw' onto a square screen using an electronic stylus.

By the turn of the millennium, most companies had almost completely moved to CAD for the creation of **production** and **promotional** graphics.

Now designers can use CAD to **illustrate**, **simulate**, **animate** and even **manufacture** items from home or the workplace.

During the Graphic Communication course you will experience how to use CAD software in your coursework. You will need to understand how to use CAD software for the N5 exam.

SO MANY CHOICES: WHAT PLATFORM?

There are many different CAD applications on the market. Software companies are in competition to develop their programs so that they offer more features, are easier to use and can create increasingly complex models. Your school will have a suitable software package for you to complete any unit, Added Value or Assignment work.

There are many free programs (freeware) available to download that will allow you to meet the standards of the coursework. You could download and install software at home that will help you develop your skills.

You should try to experience a wide range of software platforms if you want to pursue a career that involves CAD modelling. Most software will allow you to **export** and **import** file types to share graphics.

CAD commands and features are used in all CAD software and form the basis of 3D modelling.

"DON'T EXPECT A CREATIVE IDEA TO POP OUT OF YOUR COMPUTER." George Lois

3D CAD

WORK PLANES

Workplanes can be thought of as digital paper – it is here you can create 2D sketches.

Most 3D CAD programs give you three workplanes to start with. These represent the **elevation**, **end elevation** and **plan** views.

You can also create your own workplanes. You should consider which workplane to use before creating a sketch.

SKETCHES

Sketches are the 2D drawings from which 3D features are made.

When you choose to make a sketch the range of drawing and dimension tools will become available. These include line, circle and rectangle, and probably many more.

From these 2D drawings you will be able to create 3D features. The shape drawn on a sketch is called a **profile.** It is this profile that will become a 3D model.

CONSTRAINTS

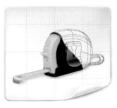

Constraints are used to control profiles. They fix lengths, angles, radii, diameters and can force lines to be locked, parallel, perpendicular or at a tangent to other lines or edges.

Constraints are very important when drawing profiles and should always be used.

Most CAD software will also allow you to draw centre lines and construction lines.

FEATURES

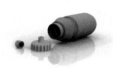

A **feature** is the name given to types of 3D work, such as **extrusion**, **revolve solid** and **shell**.

Features are mostly created from the profiles drawn in sketches, but some like **fillet** and **chamfer** are made by selecting the edge of a 3D feature and modifying it.

When a feature is created, the original sketch is considered 'used'. If you edit the sketch, your 3D feature will be altered too.

MODELLING TREE

All 3D CAD programs use a **modelling tree**. This tree will show you workplanes, sketches and features.

The order of the sketches and features will have an effect on the 3D model. The computer processes the sketches and features in order from top to bottom.

Each workplane, sketch and feature can be given a name. Naming these items as you work is considered good practice because it can make editing your work simpler.

COMPONENTS

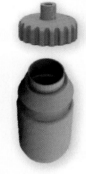

3D models are used to design or draw products or buildings that will be manufactured, simulated or illustrated. Real products and buildings are made of many individual parts. 3D CAD reflects this reality and so models are made of individual parts. Each part is called a **component**.

Components should be saved with a sensible name that describes the function of the part.

ASSEMBLIES

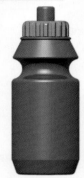

Assembly is the name given to the 3D CAD model that combines all the components in the correct positions.

An assembly allows you to look at a complete product. Changes made to component files will affect the assembly.

Larger 3D models may use **sub-assemblies**, which are smaller assemblies of components added to one larger, completed assembly.

3D MODELLING | KEY FEATURES

You will need to understand seven key 3D modelling CAD commands.

1. Extrusion
2. Revolved solid
3. Shell
4. Subtraction
5. Union
6. Fillet
7. Chamfer
8. Array

You may need to use 3D CAD to produce parts of your N4 Added Value Unit or N5 Course Assignment.

The bottle product on this page uses all the modelling techniques you will need to know for a National 5 exam. The CAD modelling commands used to create the bottle are highlighted.

On most 3D models these CAD commands are used more than once.

All 3D CAD software uses these commands and you can use this book to guide your understanding of these features.

Your teacher will explain how to navigate the 3D CAD package that you use.

"DON'T WORRY ABOUT PEOPLE STEALING YOUR DESIGN WORK. WORRY ABOUT THE DAY THEY STOP."

Jeffrey Zeldman

Extrusion

Fillet

Revolved solid

Shell

Union

Chamfer

Subtract

Array

Revolving is a powerful tool in 3D CAD modelling. It is used to produce models that are **cylindrical** or **conical**.

To use the revolve command you need two items:

1. a **2D profile** that will be revolved into a 3D model

2. an **axis** for the profile to rotate around.

All 3D modelling packages contain a revolve feature. It is one of the most commonly used commands.

An understanding of the revolve command, and where it can be used, is important for answering questions in the National 5 exam.

Creating the 2D profile is the most important but difficult aspect of using the revolve command.

Remember that you should draw half the object you wish to revolve. Some designers find it easier to draw the full shape and use the trim tool to cut it in half later. This half is called a **radius**.

The axis of the revolved model is important to the final shape. The axis does not have to be part of the profile. The axis can even be at an angle. This can make some very interesting designs!

REVOLVE: PROFILE AXIS

The three steps below give an overview of the revolve command. Revolved profiles do not have to go a full 360° – you can choose the angle.

Almost all 3D CAD software will give you a preview of the revolved feature before you commit.

1. Draw a profile.

2. Select an axis.

3. Complete the revolve.

REVOLVE: OFFSET AXIS

An offset axis is not part of the profile. The axis may be another line drawn in the sketch, or may be part of another 3D feature.

It is important to remember that the radius of the feature is measured from the centre axis. This can allow you to create hollow pipe-like sections or hoops.

Profiles can be revolved around an axis or another 3D feature.

When creating a revolved feature with an offset axis, most CAD software expects the axis line to be drawn as a construction or centre line. You may need your teacher to show you this feature on the software you use.

When creating an offset axis revolved feature, there will be an **inside diameter** and an **outside diameter**.

Radius

Outside diameter ⌀

Full revolve

Partial revolve

Extrude is the most basic command in 3D modelling. It allows a designer to sketch a 2D shape and **pull** it into a 3D feature.

All 3D modelling packages contain an extrude command. In some software this may be called a **protrusion** or **pull**: this is the same as extrude.

The extrude command needs a **valid profile** that can be pulled to the correct distance.

Profiles may be as complex as required but you should remember that it is sometimes easier to draw items as separate sketches and create a number of features.

You will need to understand the extrude command for your National 5 exam.

UP OR DOWN? FROM FLAT TO 3D

Sketches are drawn on 2D workplanes. Workplanes are the computer equivalent of paper.

Once a sketch is complete, the profile can be extruded to form the 3D feature.

Sketches can be extruded a set distance or until the model touches another 3D model.

Profiles can be extruded in three directions.

1. above the workplane

2. below the workplane

3. symmetrically through the workplane.

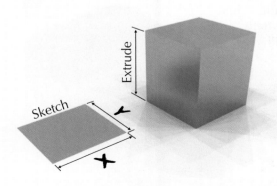

ABOVE

An extrusion created above a workplane

BELOW

An extrusion created below a workplane

SYMMETRIC

An extrusion created where half the feature is above the workplane and the other half is below.

The most challenging aspect of 3D CAD is drawing **valid profiles**. A valid profile is a **closed shape** with **no lines crossing** or **spare, unconnected lines**.

Some software will alert you to invalid profiles and suggest fixes. Otherwise, careful use of the drawing tools is essential.

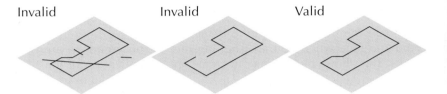

Invalid Invalid Valid

SURFACE SKETCH: ADD OR SUBTRACT?

All 3D CAD software will allow you to select the flat faces of 3D features. On these faces you can choose to make a new sketch. This is called a **surface sketch**. In some software, surface sketches will create a new workplane on the selected surface.

A profile drawn on a surface sketch can be extruded, but you will have the option to **add** material (**union**) or **remove** material (**subtract**).

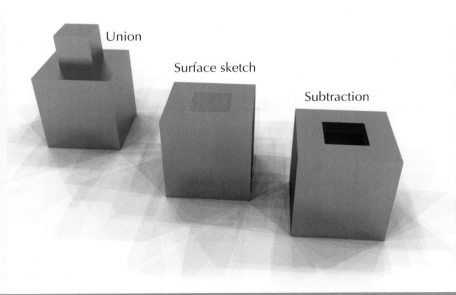

Union

Surface sketch

Subtraction

The **shell solid** command in 3D modelling software is a tool designed to remove the inside material of a model and leave only a 'wall' thickness.

This is a useful option when making packaging, cases or containers for products.

Some software may allow you to delete or remove a face when you are shelling the model. This allows the designer to create an opening.

All 3D CAD software has some form of shell solid tool: in some applications it may be called **hollow**. It is important that you apply any fillets or chamfers to the model **before** using the shell solid.

If you apply a fillet or chamfer after the using the shell solid command you may inadvertently 'cut open' your model.

Some shell solid commands will allow you to change the thickness of different faces. Designers use this to make some faces thicker and stronger.

You need to understand the use and application of the shell solid tool for your National 5 exam.

SHELL: WHO IS THE BOSS?

The shell tool is a quick, easy command for creating hollow boxes or casings.

These hollow components are often used to create casings by 'injection moulding' plastics – a process you can learn more about in Design and Manufacture courses.

Students often wonder how to make hollow cases that can join to other components.

A clever modelling trick can allow you to create a raised hole for a screw – called a **boss**. These bosses form a common way of joining plastic parts together. A thread is often added to the holes in the boss for screws.

In this example, a small box has been extruded. Four circular holes have been subtracted from the body.

Chamfers have been added to the outside holes (see page 83). These chamfers act as 'counter-sinks' for the heads of the screws.

By modelling the case with screw holes, then applying a shell solid, you can create a component with bosses pre-made. This works because the shell command leaves a **wall thickness**.

The circular holes force the shell feature into leaving a wall around the holes and create very useful bosses!

Shell with no face removed
Shell with top face removed
Wall thickness

The first two bottles are sectioned so you can see inside! This will not happen when you use the shell solid command.

Chamfer (countersink)

Remove top face when applying shell

Boss

FILLET AND CHAMFER | LIFE ON THE EDGE

Fillet and **chamfer** tools are features that allow you to modify the edge of a 3D object. Edges can be modified to improve the aesthetics, function or safety.

To use either the fillet or chamfer tools you need to select the edge of a 3D model. More than one edge may be selected at a time.

You need to understand the use and application of the fillet and chamfer tools for your National 5 exam.

ALL AT ONCE: FACES RATHER THAN EDGES

While the fillet and chamfer commands are usually activated by selecting edges, some CAD software may allow you to select an entire face and round all the edges in one operation. This can save a lot of time! The radius of the fillet or the size of the chamfer can be adjusted easily.

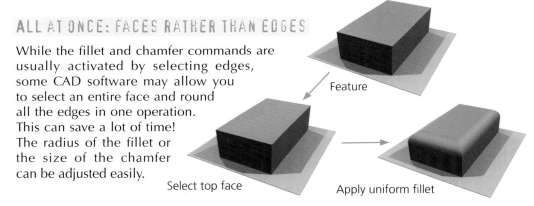

Feature

Select top face

Apply uniform fillet

KEEP IT SIMPLE: UNIFORM

The standard fillet or chamfer tool will allow you to set a **uniform** size.

A uniform fillet or chamfer keeps the size of the feature the same along the selected edge.

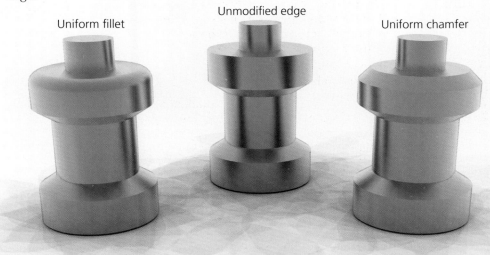

Uniform fillet

Unmodified edge

Uniform chamfer

STANDING OUT: NON-UNIFORM

A non-uniform fillet or chamfer gives you greater control over the tool. With an non-uniform fillet, some parts of the edge can be rounded more than other parts. A non-uniform chamfer allows the angles of taper to be different.

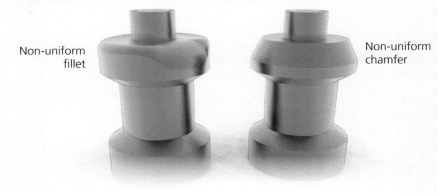

Non-uniform fillet

Non-uniform chamfer

SKETCH OR FEATURE? CHOICES?

Both fillets and chamfers can be created during the sketch stage to minimise the number of features in the modelling tree. This can improve the performance of your computer – especially with complex 3D models.

However, changing the size of the fillet or chamfer becomes more difficult as you will need to edit the sketch. Both approaches are acceptable.

As a sketch

Modify

Feature

First feature

Applied chamfer

3D CAD

83

An **array** is the command that allows you to repeat profiles or features without redrawing them. Some CAD software may refer to an array as a **pattern**.

There are two types of array:

1. a box (square) array

2. a circular (ring) array.

There are also two ways to use the array tools:

1. an array of a sketched profile

2. an array of completed 3D features.

Using an array can save a lot of time redrawing profiles and features.

Because you don't have to redraw profiles, it enables greater accuracy in modelling (arraying) complex features.

Two elements are needed to complete an array.

1. a feature or profile to be arrayed

2. a edge or lines to control direction.

You need to understand the use and application of the array tools for your National 5 exam.

When using an array command to repeat a profile or a feature, it is important to select how the array will be **patterned**.

This can be completed in two ways:

1. using the edge of 3D features

2. using a sketch with geometry for the array to follow.

Either method can be used to control the array.

TYPES OF ARRAY: BOX OR RING?

Some CAD software may have more array options – **box array** and **ring array** are the two basic forms used.

Feature hole in cube

Box array of the hole

Ring array of the hole

"YOU'RE AT YOUR HAPPIEST WHEN YOU'RE CREATING."

Anon

TAPER | STRAIGHT TO THE POINT

Taper is a useful command for creating sloping faces without using the chamfer tool. Taper is a command that most commonly appears in **extrusion** and **helix** features.

The taper is controlled by setting an angle (in degrees). The angle will determine how much the sides slope. If the angle of the taper is too large then the height of extrusion will be reduced and the feature will end in a sharp point.

This is due to trigonometry – a field of geometrical science you will learn in mathematics.

You DO NOT need to understand the use and application of the taper tool for your National 5 **exam**, although it can help you create 3D models in your coursework.

POSITIVE

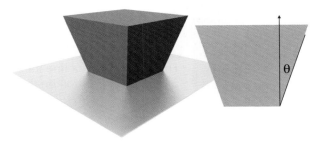

A positive taper angle θ will see the 3D feature appear wider towards the top of the extrusion.

NEGATIVE

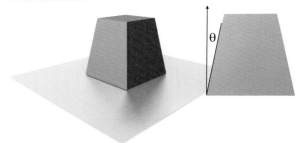

A negative taper angle θ will see the 3D feature appear narrower toward the top of the extrusion.

DRAFT ANGLE: PATTERNS THAT FALL OUT

The taper command is often used to create a **draft angle**. A draft angle is a taper that appears on the moulds used for manufacturing products. A draft angle helps remove the product from the mould during manufacture.

These are processes you can learn about in Design and Manufacture courses.

Some CAD software has a draft angle command: all sides on a model will be given taper.

CAD modelling and the manufacture of products are closely related to each other. Knowing how to create a product in CAD is a valuable skill for a product designer.

Moulds with tapered sides

SPRING: A TAPERED HELIX

Commonly requested CAD features are coiled springs or helix features for screws.

To create such features involves combining the helix command with a taper. The taper angle on a helix works in a similar way to an extrusion, with a positive or negative angle controlling whether the feature will get narrow or wider.

If the angle of the taper is too large, the coil will be reduced in length and end in a sharp point. This can also cause a messy and deformed twist at the end of the feature. You should try to avoid this.

Axis

Pitch

θ

Angle

Profile

SKETCHING: DRAWING CONCLUSIONS

THE GOOD

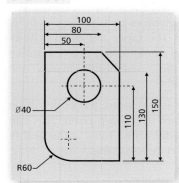

A good sketch will be neatly drawn with constraints added to control all the sizes.

Circles will have centre lines (some CAD software will show these as construction lines). Circles will be dimensioned with a diameter constraint. Fillets will be constrained with a radius.

This sketch is ready to be used.

THE BAD

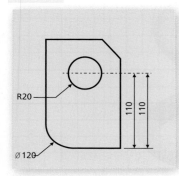

A poor sketch may be functional but lack key constraints or some parts may be constrained twice. Some constraint types may be wrong.

Such sketches will still be in a flexible state and could be altered by accident. You could use this profile to create a feature, but it is bad practice.

THE UGLY

An unclosed profile, lines crossing and other errors will prevent a 3D profile from being converted into a feature. It may be lacking dimensions, construction or centre lines.

A profile like this example needs a lot of work before it can be used by any feature command.

SKETCHING: THE DIGITAL PENCIL

CIRCLE
Draw a circle. Start with the centre point and extend to choose diameter.

ELLIPSE
Draw an ellipse. Start with the centre point.

ARC/FILLET
Draw an arc or fillet between two lines.

LINE
A straight line with no other features.

POLYLINE
A series of straight lines that can be edited and that stay connected.

RECTANGLE
Draw a rectangle by selecting two points. Can also make squares.

SPLINE
Special line. Control nodes on the line allow you to make a series of smooth compound curves.

TANGENT CIRCLE
A circle with edges tangent to three other graphics.

TRIM/CUT
Allows you to remove unnecessary lines. Removes the lines beyond the intersect.

CONSTRAIN: ALL LOCKED DOWN

GENERAL DIMENSION
A general tool for applying linear, radius, angular or diameter dimensions.

CONCENTRIC CIRCLE/ARC
Force two or more circles or arcs to share the same centre point.

GENERAL LOCK
Lock or fix a line in its current position.

LOCK/FORCE HORIZONTAL
Force, lock or fix a line into a horizontal position on the workplane.

LOCK/FORCE VERTICAL
Force, lock or fix a line into a vertical position on the workplane.

PARALLEL
Force two or more lines to be parallel.

PERPENDICULAR
Force a line to be 90° to another line.

FORCE TANGENT
Force a circle or arc to be tangent to another line, circle or arc.

MIRROR
Copy and reflect a line or profile over an axis.

You don't need to know about these CAD commands for National 4 or 5 but they may come in useful for Higher and Advanced Higher. However, using these commands in your Added Value Unit or Assignment can improve your 3D modelling.

LOFTING PROFILES: THE BIG TRANSITION

Lofting profiles is an advanced method of creating features. It creates what is called a **transition piece**. This involves changing the shape of a prism over a set distance.

For the loft command to work it requires two workplanes, a set distance apart. More workplanes can be created. A sketch is drawn on each workplane.

The profiles can be any shape. In most CAD software you will be given options regarding which corners of a loft to join.

Lofts – or transition pieces – create smooth shape change. The profiles on each workplane do not have to be aligned: this will allow you to design swooping, curved components.

Some 3D CAD software will allow you to shell the lofted feature in a single command.

If you edit or delete either the sketches or workplanes used in a loft command, the lofted feature will be affected too.

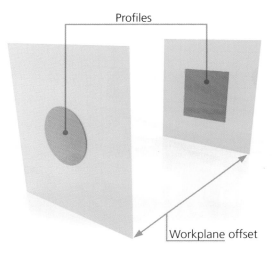

Profiles

Workplane offset

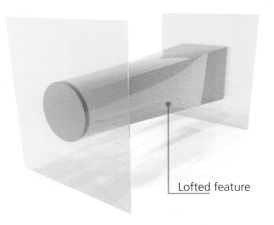

Lofted feature

"A COMMON **MISTAKE** THAT PEOPLE MAKE WHEN TRYING TO DESIGN SOMETHING COMPLETELY **FOOL-PROOF** IS TO UNDERESTIMATE THE INGENUITY OF COMPLETE FOOLS."

Douglas Adams in *The Hitch Hiker's Guide to the Galaxy*

HELIX: GETTING YOUR HEAD IN A SPIN

A **helix** is a CAD command that creates **spring-like** features. This is a useful tool in graphic communication for creating moulded threads in products. It can also be used to create aesthetic designs on parts.

All CAD software includes some form of helix command. Helix commands work in a similar way to the rotate command discussed earlier. A helix requires a valid profile and an axis to rotate around.

Once you have selected both the profile and axis, you will be asked how many rotations to complete round the axis, the pitch of the rotation and whether to complete a clockwise or counter-clockwise helix.

If adding a thread to a bottle, the centre axis will be in the centre of the opening.

Remember, the lid will also need a thread. Ensure you are removing material so both parts can fit together!

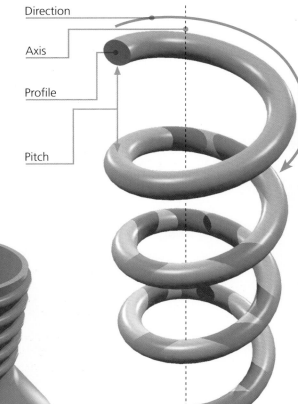

Direction

Axis

Profile

Pitch

Assembly is the name given to completed 3D models made from more than one component part.

Most 3D models involve multiple **components** – just like real products – and these need to be 'put together' or assembled into the final product.

3D models are assembled using **constraints**. Constraints lock one component to another using an assembly command.

In the following example you will learn the most useful assembly commands.

There are six forms of assembly constraints:

- Align
- Concentric (centre axis)
- Mate
- Offset
- Orientate
- Tangent

Your National 4 Added Value Unit and your National 5 Assignment may require you to model a product with more than one component. Understanding how to assemble your 3D model will make the experience far easier.

GO! ACTIVITY

1. Test yourself! Identify the modelling techniques used to create the components of this torch and describe how to model each of them. If you can do this, you are on course to succeed in your National 5 exam!

"ALL THE COMPUTERS IN THE WORLD ARE MEANINGLESS WITHOUT AN IDEA."

George Lois

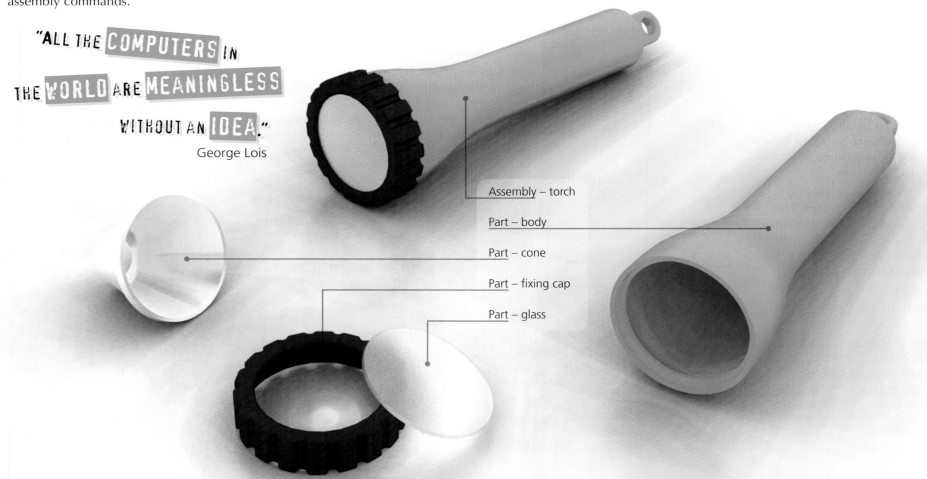

Assembly – torch

Part – body

Part – cone

Part – fixing cap

Part – glass

Assemblies work by fixing or attaching one component to another. These components will obey any rule you give them. Just remember – if you are using CAD to manufacture an item, you need to have proper methods of fixing things together!

ALIGN | FACES ALL IN LINE

An **alignment** command will allow you to force the face of one object to be in line with the face another object.

The alignment command typically works with flat faces.

OFFSET | SET A DISTANCE

The **offset** tool is used in conjunction with mate, align or tangent commands. Basically this tool will allow you to set a distance between the face or edge of two objects. The two 3D models will not move closer or further apart from than the distance you set.

ORIENTATE | GETTING THE ANGLE

Some assemblies may have one component set at an angle to another component. This angle is often referred to as an **orientation**.

An orientation is an angle set in degrees. The face or edge of one component can be angled to the edge or face of another component.

MATE | LET'S STICK TOGETHER

The **mate** command joins the face of two objects together. These faces will be **fused** and unable to separate, although the faces can slide around each other.

TANGENT | STICKY CIRCLES

Tangent is a term used to describe a line that touches the perimeter of a circle at only one point. The tangent assembly constraint will lock the round face of a cylinder to the face of another object.

CENTRE AXIS | FALLING IN LINE

The **centre axis** (or **concentric**) command will allow cylindrical geometry to be centred with other cylindrical shapes.

Some CAD software will allow you to select a radius or rounded corner and automatically find the centre

TRAINING

The graphics used in training devices replicate situations that people may need to experience in real life. This technology is usually interactive, meaning that people can react to and engage with the graphics on the screen. The choices or decisions people make will affect the outcome of the training simulation.

Common uses of graphics in training include flight simulators, surgery equipment and race car emulators.

Training simulators are very expensive but have many advantages over other teaching methods, such as increased safety, repeatability and accurate feedback.

Using simulators can reduce the cost of training large numbers of staff.

TESTING

Products can be tested on a computer prior to manufacture. This can reduce production costs by fault finding at an early design stage.

Some software simulates forces, momentum and material properties.

- 3D models can be tested to calculate elasticity, strength, mass and centre of gravity. This enables designers to alter designs to be more efficient, stronger or lighter.

- Other software – commonly known as a virtual wind tunnel – tests 3D models for their fluid and aerodynamic properties. This is particularly useful when designing everything from cars and aeroplanes to submarines and race cycling helmets.

After the test simulation the computer calculates the results and these may be shown as an animation.

PREDICTING

Computer graphics are often used to communicate data that may predict future events.

Sensors and input devices are used to gather data. This is then processed by a computer – often a mainframe super computer – and results are shown in a graphical format.

Prediction simulators are most commonly seen in weather forecasting. The graphics displayed are based on the predictions of computers and weather forecasters. The graphics are designed to help people understand those predictions.

Other forms of predication simulators include animal migration, solar flares and even stock market activity. The graphics used to present these predictions help communicate large amounts of complex data quickly.

FILMS AND ANIMATION

The film industry has used computer graphics since the early 1970s. The film *Futureworld* (1976) was the first to use 3D computer graphics where primitive wireframe and flat shaded models featured in a few scenes. *Toystory* (1995) was the first feature film made entirely from **computer-generated imagery** (CGI).

Films and animations are not bound by any physical rules: models can move and react in any manner desired by the graphics artist.

CGI animations have many advantages over traditional cartoons. A 3D model needs only to be drawn once, after which it can be moved, positioned and animated in countless ways. 3D models can also have advantages over live actors – characters can do any form of special effect or stunt, and they do not require rest. Scenes can be reworked limitlessly until an artist is satisfied.

PRODUCT VISUALISATION

Product visualisation involves rendering a 3D model so it looks photo-realistic. Product designers use this technology to share ideas about their product prior to manufacture, or to create specific graphics for advertisements.

These visualisations make use of textures, materials, decals, light, reflection and shadow, to create graphics that are visually appealing. Materials, textures and decals are 'mapped' to the surface of the 3D models. Light sources can then be added to cast highlights and shadows over the model.

After rendering 3D models, the graphics are often used in desktop publishing (DTP) software to create promotional materials.

Product visualisation is discussed in detail later in this book (see pages 49–52).

VIDEO

Video games have come a long way since the first digital computer game 'Spacewar!' in 1961. Modern video games commonly use 3D models to create characters, vehicles and scenery. These models use similar technology to product visualisation, including textures, materials and lights, to create visually appealing scenes.

Many of the graphics in video games react to the player. Some graphics may change shape, texture, colour or light depending on how the player interacts with them.

3D models are created in a CAD package and textures, materials and decals are created in a vector-drawing application. These are loaded into game-creating software, after which software engineers code how the graphics work in the game.

2.5D

A reference to flat drawings that are used to produce 3D parts using CAM or the use of 2D software to draw pictorial graphics.

2D

An orthographic drawing showing only two of the three dimensions.

3D

The drawing or modelling of an object where the width, breadth and depth of an object are displayed.

3D PRINTER

An output device that can print solid objects from a 3D model.

ALIGN

An assembly command, whereby two faces line up with each other.

ANIMATION

Recorded or controlled graphical movements of a model for visual impact.

ARRAY

Repeating a profile or feature in a selected pattern.

ASSEMBLY

The combination of parts to make a complete product.

AXIS

A line in a single direction that objects can be revolved around.

CAD

Computer-aided design.

CAM

Computer-aided manufacture equipment that can physically produce the item that has been drawn.

CENTRE AXIS

See Concentric.

CHAMFER

The command that allows an edge to be replaced by an angled face.

COMPONENT

An individual 3D model. Components are individual parts used in assemblies.

CONCENTRIC

Cylindrical or curved items that align through their centre points.

CONSTRAINT

A command used to control the shape and size of lines used in sketches or component parts within assemblies.

CONSTRUCTION

A method of using sketch tools to draw geometry that helps to produce profiles.

CNC

Computer numerical control used to control CAM equipment.

EXTRUDE

A 3D CAD feature that allows 2D profiles to be pulled into 3D shapes.

FEATURE

An element of 3D work created by adding or subtracting material.

FILLET

The command that allows a sharp edge to be replaced with a curve.

HELIX

A spiral form created by revolving a 3D feature round an axis with a change in pitch.

ILLUSTRATION

A computer graphic that has colour, material, light, shadow and reflection added to improve the visual impact.

LOFT

A 3D feature created by joining profiles sketched on separated workplanes.

MATE

An assembly command, whereby two faces join each other.

MODEL TREE

The structure or series of operations used to create a 3D model. All 3D CAD software uses a form of model tree.

OFFSET

An assembly constraint that can be used with mate or align, but sets a distance between the faces.

ORIENT

Assembly command used to set an angle between two faces.

POLYLINE

A series of connected straight lines.

PROFILE

A 2D shape used to create 3D features.

PROJECTION

Used to grab geometry from a feature or sketch to assist in the production of another sketch.

PROTRUSION

See Extrude.

PULL

See Extrude.

REVOLVE

Rotate a profile around an axis to create a 3D feature.

SHELL

A command that allows you to remove the interior of a 3D feature – hollowing it out.

SIMULATION

A method of using CAD to test products, train people or predict outcomes.

SKETCH

The term used when creating a profile. Sketches are drawn on workplanes and/or the surfaces of 3D models.

SOLID MODEL

A method of creating 3D models.

SPLINE

Special line – a line with control nodes that can allow smooth curves to be drawn or modified.

SUBTRACT

A 3D feature that is used to remove material from another feature.

SURFACE MODELLING

A modelling technique that represents the surfaces of models only, with no wall thickness or internal material.

SURFACE SKETCH

A sketch that is drawn on a 3D model to make further features.

UNION

A 3D feature joined to another feature to create a new shape.

WIREFRAME

A 3D model where only the edges are displayed as a series of lines.

WORKPLANES

The drawing surfaces for sketches.

3D MODELLING: MAKE THIS!

You will be expected to answer a range of questions about 3D modelling. You should use sketches and annotations to illustrate your answers.

You will be shown a sketch, drawing or 3D model and asked to describe how particular features were created or how they could be modified.

Before answering any 3D modelling or CAD question, you should look at the drawing or model carefully. List any modelling techniques that are apparent. If there is more than one way of completing a feature, try to identify the simplest way of modelling the component. If you are given particular dimensions, ensure that you reference these in your answer.

You should practise sketching modelling plans – this will help you to answer questions confidently during your exam.

CAD: QUESTION TIME

1. State the name of **three** input devices.

2. State the name of **three** output devices.

3. Describe three advantages of CAD over manual drawing techniques.

4. Describe what is meant by the following terms:
 - Pan
 - Rotate
 - Array
 - Constrain:

5. Read the information given about the walkie-talkie and study the pictures. Then, describe, in the proper order, the 3D modelling techniques used to create the bottom of the case. Make reference to the dimensions in the preliminary sketch.

A toy manufacturer is planning to produce a walkie-talkie for young children.

They have sketched a preliminary design and given this to a CAD technician to create a 3D model.

Elevation

End Elevation

The bottom of the case was the first component to be 3D modelled. The CAD technician made a dimensioned preliminary sketch before making a modelling plan.

Ø120

37 37

Ø5

Plan

Pictorial

All wall thickness 2mm

Not to scale
All dimensions are in mm

15

Elevation

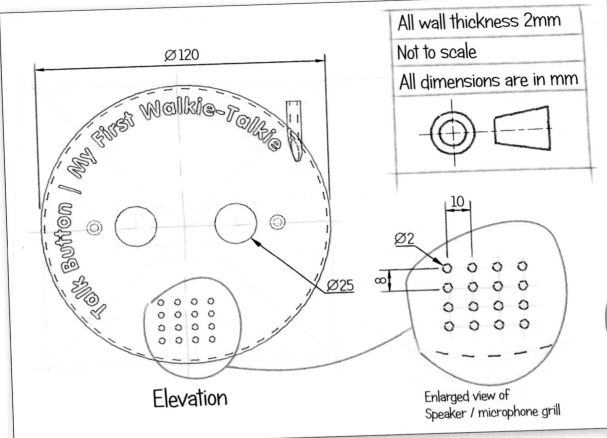

All wall thickness 2mm

Not to scale

All dimensions are in mm

Ø120

My First Walkie-Talkie

Talk Button |

Ø25

Elevation

10

Ø2

8

Enlarged view of
Speaker / microphone grill

6. Describe, in the proper order, the 3D modelling techniques used to create the speaker/
microphone grill. Make reference to the dimensions in the preliminary sketch.

The CAD technician used the extrude command to cut the 16 speaker holes into the case.

7. State how far the circles must be extruded to create the holes on the case.

The CAD technician used 3D modelling assembly commands to join the two component
parts of the case.

8. Describe how the two components were assembled using 3D modelling software.
Refer to both the preliminary sketches to assist with your answer.

In the exam you will probably be given a starting point for creating the 3D model.

You should always look at how many marks are allocated to the question. This will give you an indication of how many steps the marker will be looking for to award full marks.

Always make use of sketches in these answers. It can clarify what you are trying to communicate. Colour pencils may help you add detail to your answer, but do not spend a long time rendering sketches – you will not get marks for that.

Always use the generic CAD terms – do not mention any special names that your CAD package may use.

Modelling the bottom case

Draw an ellipse to the dimensions on the sketch.

Draw horizontal and vertical lines to divide the ellipse into a quarter, Use the trim line tool to remove excess lines.

Use the revolve command and revolve the profile 360°. Use the vertical line as the axis to revolve the profile around.

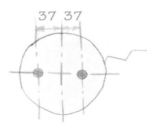

Draw circles at a diameter of 5 mm. The circles must be drawn on the horizontal centre line and 37 mm from the centre. Extrude the circles all the way through the model.

Set wall thickness to 2 mm.

Use the shell command and remove the top face.

Modelling the speaker/microphone grill

Start a new sketch and draw the first circle.

Ø2

Array 10 mm and repeat four times.

Array 8 mm and repeat four times.

Extrude all 16 circles through the component from the bottom face to the top face and subtract the material from the case.

Assembling the case

Centre the axis of the screw bosses 1 to 1 and 2 to 2

Mate the faces of the two flat rims.

Bottom case

Top case

CHAPTER 13

COMPUTER
ILLUSTRATION

WHAT YOU WILL LEARN

- **Why illustration matters**
 applications • who does it?

- **Resolution**
 pixels • bitmaps • raster • vectors

- **Illustration features**
 materials • colours • lights • decals

- **Glossary**
 useful terms

- **2D CAD Illustration**
 tools • effects • layers

ILLUSTRATION | MAKE THE ILLUSION REAL

Computer illustration, sometimes called computer-generated imagery (CGI), is the technology used to create visually appealing or realistic-looking graphics.

During your course you will be required to make illustration graphics for units and your Course Assignment.

ILLUSTRATOR | DIGITAL BEAUTY THERAPIST

Computer illustration has surpassed manual methods of illustration in most industries because of the many advantages it offers.

Computer-illustrated images do not rely on the designer having traditional manual skills with artistic tools. These skills are replaced by the imagination and creativity to produce images that have visual impact.

New technologies – from the Internet and phone applications to video games and architecture – rely on illustrators to create the graphics and images that will appeal to the target audience. The public are continually bombarded with graphics from a variety of sources and, while good graphics may go unnoticed, poor quality graphics stand out and cause a negative impact.

It is the job of a computer illustrator to make models, graphics and images look better. Some illustrations may need to have maximum visual impact while others only require small tweaks to enhance the quality.

A wide range of industries now use professional computer illustrators.

2D OR 3D | CAN YOU SEE IT?

Computer illustration falls broadly into two categories: 3D rendering, and 2D and photographic production. A computer illustrator will work between the two platforms. Often illustrations are a combination of 2D and 3D graphics.

Creating computer illustrations does not just rely on CAD skills but also on the designer's understanding of colour theory, design elements and principals, and desktop publishing techniques and features.

Most illustrations will be used in conjunction with other graphical tools, techniques and software packages.

"EVERY CHILD IS AN ARTIST. THE PROBLEM IS STAYING AN ARTIST WHEN YOU GROW UP."

Pablo Picasso

Architecture

Sign making

Video games

Website design

Graphic design

DTP documents

Advertising

Computer art

TV and cinema

Images can be printed as hard copy or displayed on screens. Both require a suitable quality or 'resolution' of the graphic.

Printers and screens both display their graphics as a series of dots. Unsurprisingly, the way the resolution is worked out for screens and printers is different.

SCREEN OR PRINT?

Electronic screens display images in a series of picture elements or 'pixels'. The quality of the screen and graphics card determines how many pixels can be displayed. This is often referred to as **pixels per inch** (PPI).

Although inkjet and laser printers work differently, the quality of a printed graphic is referred to as **dots per inch**, or DPI.

Your illustration software will allow you to set the resolution you would like to render. Be careful! High resolutions take longer for the computer to process and the files become huge.

IMAGE SIZES | DPI AND PPI

8 × 8 pixels	**50 × 50 pixels**	**100 × 100 pixels**	**1000 × 1000 pixels**
64 pixels	**2500 pixels**	**10,000 pixels**	**1,000,000 pixels**
		(0.01 megapixel)	**(1 megapixel)**

Higher resolutions are only required when enlarging an image. If the image is small, you can use a lower resolution.

HIGH RESOLUTION RENDER

A high resolution render will display all the detail that you have created, along with realistic shadows and reflections.

LOW RESOLUTION RENDER

A low resolution image will be quicker for the computer to render and the file size will be smaller. These renders should be used for checking aspects of work during production. If the image is blocky and individual pixels are visible, the image is described as **pixelated**.

Switch to a high resolution before printing a graphic!

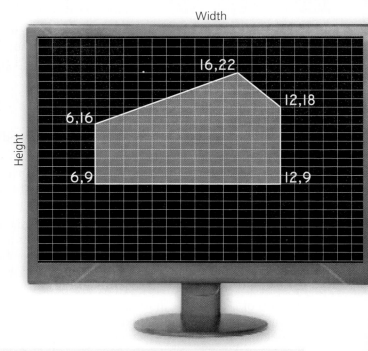

RASTER VERSUS VECTOR: BUT BOTH WITH PIXELS?

There are two forms of computer graphic: vector and raster. Vector graphics are controlled by coordinates, with lines connecting these coordinates to draw a picture. Although the display is still using pixels, information is not saved as individual pixels – only the coordinates are saved. Vector images can be scaled to any size, as the coordinates are controlled mathematically: vector images cannot pixelate. Because vector images are based on lines and curves, they are not suitable for photographs.

Raster graphics are created by allocating each pixel a specific colour. This data is saved in the file. If you need to scale up a raster image, the computer has to 'invent' new pixels. This makes the graphic look pixelated. The resolution – or number of pixels – is very important in a raster graphic as this determines how large you can scale an image before it looks pixelated.

3D ILLUSTRATION | MODEL MAGIC

3D CAD modelling has become a powerful tool for the graphic designer, architect or engineer. However, creating a 3D model is only part of the journey – CAD illustrators can now make photo-realistic images from 3D models for use in promotions and presentations. A 3D model may also be placed in a 'scene' to give it context and improve the visual impact.

Most 3D CAD software contains its own illustration application. However, there are purpose-built applications for rendering models. Your teacher will guide you to the most suitable software for your course.

MATERIALS | TEXTURE IT

3D models can be given a realistic appearance by attaching the image of a material to the surface of the model. For example, a wood (or wood grain) image can be attached to the surface of a chair.

LIGHTS | BRIGHT STUFF

Lights are used to illuminate the model so it can be seen. There are two types of light: global illumination and focused illumination. **Global illumination** lights the whole scene (like the 'sun'), while **focused illumination** acts like a torch or spotlight on a particular feature. Carefully applied, light can add 'drama' to a scene.

REFLECTIONS | LOOKING BACK

Reflections are used to bounce light, surface materials and models from the surface of other models. This makes this graphic more visually appealing and realistic.

SHADOWS | THE DARK SIDE

Shadows create a sense of depth, by allowing the model to cast a shadow on a surface or another model.

TEXTURES | TOUCH AND FEEL

Texture is an effect applied to a material to make it appear more realistic. In most cases this may make the surface look rough or pitted, like the real material.

COMPUTER ILLUSTRATION

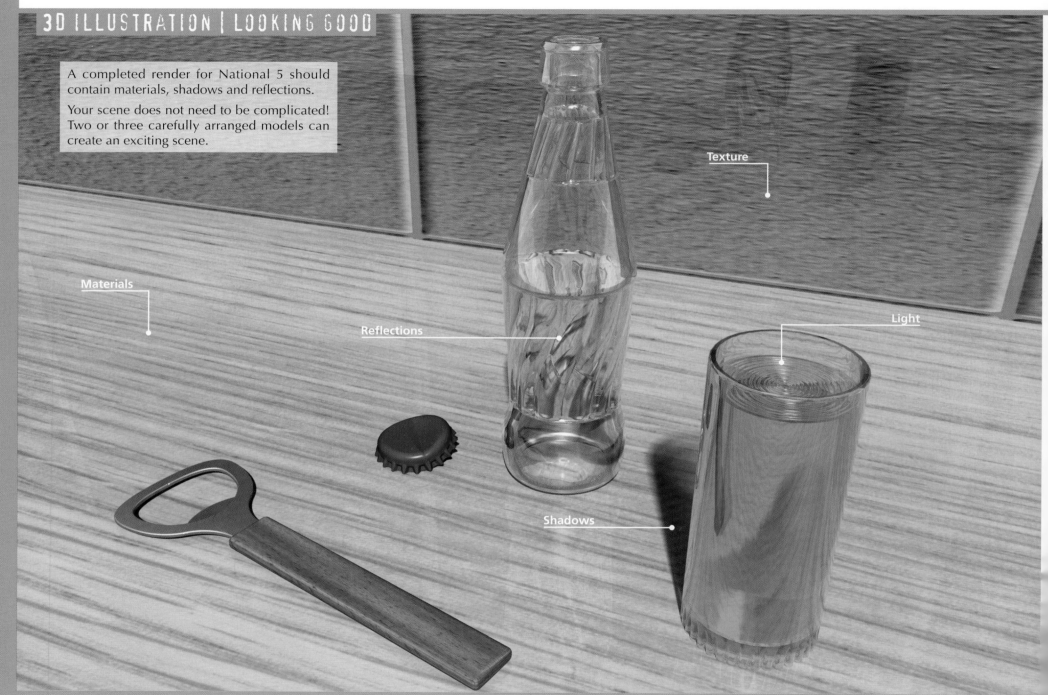

A completed render for National 5 should contain materials, shadows and reflections.

Your scene does not need to be complicated! Two or three carefully arranged models can create an exciting scene.

Texture

Materials

Reflections

Light

Shadows

The appearance of 3D models can be improved by making them appear like real materials. 3D CAD software and illustration applications have a range of preloaded materials and textures.

During this stage, shadows and lighting levels can be set. Materials and textures can be complex and take time for computers to process, so the lighting, shadows and position of 3D models should be set before materials are added.

Materials are 2D graphics that are wrapped around a 3D object. These materials can be either vector or raster graphics, drawn in a 2D illustration package or scanned in. These materials images represent the colour, tone and pattern of real materials.

Textures give the surface of objects a rough look and make the graphic appear more realistic. This technique is useful with 3D models that you want to look like wood, fabric or plastic with a textured surface.

DECALS | STICK ON GRAPHICS

Many products display stickers or surface graphics. This can be recreated by adding decals to 3D models using illustration software.

Like real stickers, decal graphics start life as a 2D image. These images are then 'wrapped' to the surface of the 3D model. If you have cropped the 2D graphic to remove the background, the material and texture of the 3D model will show through the transparent areas of the decal.

A simple raster image created in a 2D illustration application.

The image is 'wrapped' to the surface of a 3D model.
This can include angled and cylindrical surfaces.

3D illustration software has a range of preloaded materials that can be applied to the surfaces of 3D models. These materials make models appear visually appealing and realistic. Don't be afraid to experiment with different materials – if it looks good, go with it!

LIFE LIKE | GRAB MATERIALS

A hand scanner will allow you capture the surface of a real material. This scanned image is stored and can then be applied to the surface of a 3D model.

When using a scanner it is important to remember that you may need to repeat or scale the image to fit on a surface. Scan more rather than less of a material so that you won't run short. It's better to have too much than not enough.

Hand scanner

Scanned texture

Flat shaded 3D model

Texture rendered 3D model

Changing materials can have a dramatic effect on the look of a product. This technique is often used by product designers. As an illustrator, you are looking for materials that have the most effective visual impact, realism or both.

Perspective describes how objects appear to get smaller the further away they are. Using perspective with illustration software can make graphics appear more realistic and improve their visual impact.

If you want to use perspective in a 2D CAD package, you must create the perspective effect yourself, but 3D illustration software has these options built into the program.

MODELS ONLY | GET RID OF THE BACKGROUND

3D illustrated models are often used in DTP documents – particularly for promotional graphics and advertisements.

Many DTP designs contain a creative background image or graphic to add a sense of depth and drama to a document: you can learn more about this in layout elements and principles on page 138.

Cropping a 3D model from an image can be challenging if the background colour is similar to colours used on the 3D model. To make this process simpler, you should make the background colour of the 3D CAD illustration contrast significantly with the colours used on the CAD model.

This high contrast technique is similar to the 'green screen' technology used by the movie industry to place actors in unbelievable locations!

free MEM
find some calming space

FORCED PERSPECTIVE | POINTS OF VIEW

Forced perspective is a clever technique for making items appear larger or smaller than they actually are. This is a form of optical illusion that is commonly used in advertisements, architecture and photography.

Objects that are far away from a person or camera appear smaller than they actually are. Forced perspective works by arranging objects in the background and foreground to interact with each other. In this image, the girl in the foreground appears to be holding the girl in the background.

While this technique is often used to create funny or unrealistic scenarios, it can also be used to add a sense of depth and visual impact to graphics. Forced perspective can combine various forms of illustration: photography, 2D illustration and 3D renders.

VIEW TYPES | LOOKING DIFFERENT

WIREFRAME

Wireframe graphics display no surface texture, light or shadow information. They are easy for the computer to process and allow a designer to position models easily.

FLAT SHADE

Flat shaded graphics contain no material or texture data, but display light and shadow. Flat shaded graphics appear less 'cluttered' and it is easier to see how light and shadow will affect each model.

TEXTURE MAPPED

Texture mapped illustrations have materials, textures, light, reflections and shadows turned on. This can slow down the performance of the computer. It is best to set up your illustration before you attempt a full render.

You will be required to create an illustrated scene for the Assignment. Scenes do not need to be complicated, but you may have the opportunity to make an illustration with real visual impact.

SETTING THE SCENES | TELL A STORY

A scene is designed to improve the visual impact of an illustrated graphic. Some scenes can be 'in context', which means assembling or combining the model with other models that place it in a realistic environment. For example, the bottle model here has been surrounded by products that could be associated with it.

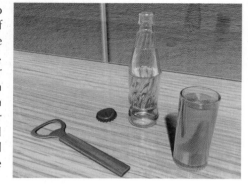

Don't worry, this is more complex than you will need to create!

A simple, but effective scene involves surrounding a 3D model with three flat planes where light, shadow and reflections can interact. This improves the visual impact of the model. The render below is a suitable National 5 scene.

Scene set-up

Completed scene

MEDIATED REALITY | MERGING WORLDS

Mediated reality is the name given to combining computer-generated graphics and photography after both are created.

Choosing an appropriate photograph is important when planning a mediated reality image. You may want to take your own photograph – ensure you have planned where you intend to put your 3D model in the scene.

When a mediated reality image is completed it should be hard to identify the 3D model. Care should be taken to place shadows and reflections in the correct places. Mediated reality images are quick ways to create realistic scenes.

Forced perspective is the most commonly use technique when creating mediated reality scenes. Positioning the photograph and 3D model is the most challenging task.

Original image

Mediated image

Behind-the-scenes!

CAD illustration

Image

COMPUTER ILLUSTRATION

2D illustration software is very versatile and is used to create decals or materials for 3D models, backgrounds for DTP documents, or stand-alone illustrations of products, people, animals or buildings.

Most computers have a simple illustration software installed, such as a paint program, but more powerful software is available for free.

Illustration software has a range of drawing tools that simulate manual graphic equipment. Drawing tablets are also commonly used so that graphic designers can sketch directly onto the screen using digital tools such as pens, pencils, brushes and spray cans – all with the same stylus.

2D illustrated graphics have many advantages over manual techniques. They can be printed, edited or sent via the Internet with ease.

ILLUSTRATION | ART?

2D illustration software is used extensively to create graphic designs with visual impact.

Many popular modern cartoon animations and video games rely on high-quality 2D graphics.

Creating people, animals and plants with 2D software is often far easier than with modelling packages.

Both the image of the person and the headphones on this page have been created using 2D illustration software and were constructed in overlapping layers of graphics.

ILLUSTRATION | PRODUCT VISUALISATION?

While using 2D software to produce product illustrations has become less popular with the advent of 3D CAD, some graphics artists still use it to great effect.

The range of tools allows a graphic designer to create graphics without the need to build complex 3D models. It can also be easier to apply particular visual effects to a 2D graphic than to a 3D model: the designer has complete control over lights, shadows and reflections because they are all manually drawn.

2D illustration software comes with a wide range of tools, and there are similar commands in all packages.

Remember, you will not be asked questions about 2D illustration software, but you may use it for your unit and Assignment work.

FROM SIMPLE SHAPES TO COMPLEX FORMS

Complex shapes can be created using simple overlapping geometry and adding, subtracting, or intersecting the shapes. This is called Boolean graphics – a feature of all 2D illustration software.

Two simple shapes have been drawn so they overlap one another.

The circle has been **subtracted** from the rectangle.

The circle has been **added** to the rectangle.

The area where the two shapes overlapped is left behind – this called an **intersection**.

KNOW YOUR NODES | SUBTLE CONTROL

Lines on 2D illustration software are controlled by nodes. Nodes are points that the line passes through and are the control points for curves or bends.

Where a smooth curve is created, smaller nodes will appear connected by a line to the main node. This is called the **bow-tie**. It allows the graphic designer to control the angle and size of the curve.

Node

Bow-tie

Colour transitions, also know as gradients, are tools that allow the colour fill of a shape to change from one colour to another. This is particularly useful when trying to create highlights or shadows on objects.

There is a wide range of transition options, varying according to the software being used. Two that are available in all packages are radial fills and linear fills.

Radial fill Linear fill

TRANSPARENCY | CAN YOU SEE IT?

Transparency is a tool that allows a graphic to become 'see-through'. This allows a designer to layer colours and shapes to build an image. There is a range of transparency tools, depending on the illustration software used.

No transparency

Linear transparency

Radial transparency

Double transparency

2D illustration software can also be used to manipulate text to create graphics with high visual impact.

A font has been chosen to represent a design company, but needs to be altered.

The text has been converted to nodes and the letter C has been extended.

A highlight and shadow have been added to create 3D impact.

SENSE OF DEPTH | SEEING THE LIGHT

Light and shadow can be easily simulated, in a similar way to using a white and black pencil with spirit markers. In this example a rectangle with radii corners is drawn in a cool blue colour.

Assume the light is shining from the top left. To draw a screen, black lines are added to the top and left edges: the screen appears to sink in. The raised circular buttons get the opposite treatment: black lines at bottom-right.

A white line is drawn to create the illusion of reflected light. This is added opposite the black lines. The middle button has a black and white line added to make it appear like a raised ring.

Further details are added using the same technique. Black lines to the left and top when an item is sunk into the body, while reversing the lines make a raised feature.

Finally, a blue rectangle is added with some diagonal white lines to highlight a glass screen. A simple black bar and a highlight to the top and left ensures the graphic is given depth.

BUILDING PICTURES | LAYERED IMAGES

2D illustration software can be used to improve quick manual sketches.

In this example, a rough two-point perspective sketch of a personal music player has been scanned into a 2D illustration application.

Parts of the image are 'traced' using illustration tools. A flat fill colour is used.

Each tracing is completed on a separate layer.

You can see the illustration as separate components if you pull apart each of the layers.

Highlight, shadow and reflection can be created by applying graduated fills to each of the traced layers. The manual sketch can then be removed.

ADD

A Boolean operation where one shape is added to another to create a new shape.

BOOLEAN

The mathematical name given to the process behind adding, subtracting or intersecting graphics.

BOW-TIE

A control handle used to control the length and pitch of a curve.

COLOUR GRADIENT

See Transition.

DPI

Dots per inch – used in reference to printer resolution.

DECAL

An image, similar to a sticker, added to the surface of a 3D model.

ELLIPTICAL FILL

A colour fill that changes from one colour to another in the form of an oval.

INTERSECT

A Boolean operation where the overlapping parts of two shapes is the only part visible.

LAYERS

A CAD and illustration technique where one graphic can be drawn on one layer, and another graphic drawn on a separate layer. The user can control which layers are visible at any time.

LIGHT

An illustration technique that is used to illuminate a 3D model.

MATERIAL

An illustration technique, used to make a 3D CAD model appear like a real material.

MEDIATED REALITY

A mixture of computer illustrations and photographic images.

NODE

A control point at the end of a line or along a spline that allows you to change the position of the graphic.

PERSPECTIVE

Term used to describe objects that appear smaller the further away they are.

PPI

Pixels per inch – used in reference to screen resolution.

RADIAL FILL

A colour fill that changes from one colour to another in the form of a circle.

RASTER

A form of image that is saved as an array of pixels. Used for photographic images.

REFLECTION

A technique used in illustration to create a mirror-like response behind or below a model.

RESOLUTION

The term used to describe the quality or size of an image on screen or print. Related to DPI and PPI.

SCALE

Scale in illustration refers to either the size of a texture applied to a 3D model, or the size of an illustration in relation to other graphics.

SCENE

A 3D model that is presented in an environment. Often includes reflections, shadows and objects that complement the 3D model in context.

SEAMLESS

The term used to describe a material image that can be arrayed continually without a visible join.

SHADE

A colour with black added to make the colour appear darker.

SHADOW

A dark region where light is blocked by an object. Shadows add depth and drama to a scene.

SPLINE

Special line – a line with control nodes that can allow smooth curves to be drawn or modified.

SUBTRACT

A Boolean operation where one shape is subtracted from another to create a new shape.

SWATCHES

A series of block colour fills. Swatches can usually be arranged into descriptive groups such as cold, warm or exciting.

TESSELLATION

A pattern, material or texture that can be infinitely repeated.

TEXTURE

The appearance of a textured surface applied to a material on a 3D model. Texture can make the material appear 'rough' and realistic.

TINT

A colour with white added to make the colour appear lighter.

TRANSITION

A colour fill gradient that changes from one colour to another, or from one shade or tint to another.

TRANSPARENCY

An illustration effect that allows one graphic to appear slightly see-through.

VECTOR

An image that is saved as a series of coordinates. Used to display simple, non-photographic images.

WIREFRAME

A method of presenting a 3D model where only the edges are presented as a series of connected lines. No surfaces, textures or shadows are visible.

PIXEL

A 'picture element' – a single point of light displayed on a screen.

CHAPTER 14

DESKTOP PUBLISHING

DESKTOP PUBLISHING

Desktop publishing (DTP) is the process of using software to create publications such as magazines, newspapers, books, leaflets and posters on a desktop computer or laptop. In short, it enables the production of documents that combine text and graphics.

The industry that creates these documents is the **publishing** industry, while the physical paper documents are produced by the **printing** industry. The publication is designed by a **graphic designer**.

Typical DTP interface

THE DESIGN TEAM

The graphic designer usually works as part of a larger publishing team. Team structures vary widely depending on the size of a company and the type of publications they produce. Roughly speaking, the publications team comprises:

- Managing, Creative or Art Director – managerial responsibility and overall creative direction.
- Publishers – responsible for working with authors to produce manuscripts.
- Graphic design team – responsible for creative layout and design work.
- Editorial or copywriting team – preparing text for books or magazines, or pulling together text for advertising campaigns.
- Production team – responsible for pre-press work, print preparation, print buying and other aspects of production.
- Illustrators – creating 2D or 3D images.
- Sales and Marketing Team – responsible for marketing and selling the published work, may include selling advertising space and dealing with customer contracts.
- In smaller companies some employees might perform multiple roles, while in bigger companies there might be separate web and print publishing departments.

Increasingly in the publishing industry, many functions are outsourced to specialist companies or to self-employed individuals. For example, a freelance designer or specialist design studio may design the concept for a book and a typesetter may lay out the pages according to the design template. Editors or designers may commission illustrations from freelance graphic artists.

Publishing team

BENEFITS OF DTP TO THE GRAPHIC DESIGNER

Graphic designers can work for a publishing company, a magazine or newspaper or work freelance, selling their skills to clients on a job-by-job basis. Modern work flow methods, using affordable and high quality computers, PDFs, email and other Internet facilities, mean that outsourcing design work is easier than ever and freelancing a very common job role.

The style of graphic layout a designer produces depends on what the **client** wants. The key consideration is the **target audience** who will read or view the publication.

Modern electronic methods of graphic design use a desktop computer, laptop or tablet computer. DTP software enables the graphic designer to create exciting and high quality publications quickly and easily. You will use a DTP package in your coursework.

Some benefits of DTP software to the graphic designer:

- Layouts can be created on a grid using the snap-to-grid and guidelines functions for speed and accuracy.
- Images can be edited and manipulated easily: colour, size, cropping and shaping can all be edited creatively.
- Visuals can be sent electronically to the client for approval, saving time.
- The client's and editor's modifications can be made quickly and easily.
- Graphic designers can work from home, saving travel costs and reducing their carbon foot print.
- Communication between the graphic designer, client and print company is easily done via email.

BENEFITS OF DTP TO THE GRAPHICS INDUSTRIES

Electronic methods of design and production bring advantages to the publishing, printing and graphics industries.

Newspapers are produced daily and magazines weekly or monthly. With so much competition on newsagent and supermarket shelves, the challenge for each publication is to have an edge over its competitors. Publication deadlines, sales figures and quality of content and layout are common market pressures.

Promotional graphics don't only appear in magazines and newspapers. Sign making, vehicle wrapping, advertising hoardings and digital media all make use of DTP technologies.

DTP software brings the publishing, printing and graphics industries many **benefits**:

- Text and graphics can be imported electronically from remote locations around the world.
- The time it takes to design and publish a document (the lead time) is greatly reduced.
- Modifications can be made quickly and easily using DTP editing tools.
- Layouts can be constructed accurately using grid, guideline, snap, align, scale, rotate and crop functions.
- Files can be sent electronically using email to the editor or client for approval.
- Once approved, the final layout can be sent directly for publication.
- Templates with common features are used to reduce the time and cost required to produce page layouts.
- DTP software can be used to control some forms of computer-aided manufacturing equipment used in sign making.

Printers at work

Modern offset-litho printing press

BENEFITS OF MODERN PRINTING METHODS TO THE INDUSTRY AND SOCIETY

In the recent past, printing, publishing and sign making for a mass market were very labour intensive processes that depended on large machines operated by a very large workforce. The printing and paper industries were also responsible for significant forms of pollution to our environment.

This has changed with DTP production, digital printing methods and computer-aided manufacture (CAM). Modern printing methods bring a number of benefits to the industry and our society:

- The quantities of paper and inks can be controlled digitally to minimise waste.
- Printing inks are becoming 'greener'. Sustainable, eco-friendly inks based on vegetable oils are beginning to replace petroleum-based inks.
- Modern printing technology can use paper that is 100% re-cycled without loss of quality. This reduces the environmental impact of paper production.
- Electronic newspapers and news feeds further reduce the use of paper.
- Modern printing technologies are more energy efficient than previous methods.
- The printing and publishing industries create many thousands of skilled jobs in Britain.

DESKTOP PUBLISHING

UNDERSTANDING PAGE LAYOUT FEATURES

Before creating your own page layouts it is useful to know about the main DTP layout features. The sample page here shows a typical layout with each feature labelled.

These terms are understood by graphic designers the world over and are used daily in the production of books, magazines and newspapers.

You may be asked questions about them in the course exam so it's important that you learn the correct terms. You can do this by using these features in your DTP work. You will discuss them with your teacher when you talk about your own DTP layouts.

The layout features described on this page are used in conjunction with DTP techniques. These DTP features and techniques will be explained more fully throughout this section.

Layout features can be separated into two main categories: **page structure** and **page contents.**

PAGE STRUCTURE

Page structure is the unseen arrangement of the page that is set up on a grid before any content is added. Page structure includes:

- header space
- heading or title space
- margins
- footer space
- columns
- gutter space

PAGE CONTENTS

The **contents** are the visible features applied onto the page structure. These include:

- header
- headline or title
- sub-heads
- body text
- graphics and pictures
- captions
- footer
- colour fills
- pull quotes
- lines, shapes and boxes

Alignment – the title, sub-head and column are all lined up accurately

Header

Header space

Heading, headline or title

Sub-heading

Drop capital

Body text

Gutter

Left margin

Column

Clip art

Cropped graphic

Bleed

Text wrap

White space

Right margin

Drop shadow

Footer space

Column width

Caption

Footer or Folio

Focus on BEES

www.wildlifeinyourgarden.org.uk

The humble Bumble

Not many of us are aware just how crucial Bees are to our lives. There are over 250 specices of bee in Britain, and it is quite possible that 20 or more visits your garden. Of these, there is just the one honey bee, and 22 bumblebees.

So what are all the rest? Well, there are mining bees, mason bees, leaf-cutter bees and wool carder bees. Some are rather small and hairless, but many are stripy of furry and rather similar to honey bees. They all need nectar and pollen, but often require different flowers to the deep cups favoured by many bumblebees.

What can you do to help our bees? Offer a range of flowers to satisfy all comers, inluding open-faced flowers such as daisy, inula and knautia.

Wildlife Fact
There are over 250 species of bee in Britain

INULA DAISY KNAUTIA

page 4

GLOSSARY | DTP TERMS

BITMAP
An image file comprised of pixels. These tend to be large files.

BLEED
A extension of a graphic or block of colour beyond the trimmed edge of the page.

BODY TEXT OR BODY COPY
The main blocks of text on the page.

CAPTION
A brief description that accompanies a photograph, graphic or table.

CLIP-ART
Ready-made graphics and photos stored in a gallery.

COLUMN
The width of the frame of the body text. It shortens the line length, making the text easier to read.

CROPPING
Trimming excess material from a photograph or graphic.

DROP CAPITAL
The first letter (upper case) in an article or paragraph that is enlarged and dropped below the line. Identifies the start of an article.

DROP SHADOW
A shadow created behind an object or text to create depth and emphasis.

EYE-DROPPER/COLOUR PICKER
A DTP tool that enables exact colour matching of one colour to another.

FLOW TEXT ALONG A PATH
Text that travels in the same direction as a line or curve.

FOOTER/FOLIO
Information, often a page number (folio) in the footer space at the bottom.

FOOTER SPACE
The space at the foot of the page.

FONTS AND TYPEFACE
The styles of text lettering used in a document. Font styles can be chosen and sized to suit their target audience and purpose.

FRAMES
Non-printing boxes that contain text or graphic items. These can be moved, resized or rotated.

GRAPHIC
An illustration or art work produced for use in the publication.

GRID
A square grid of lines or dots that aids accurate positioning.

GUIDELINES
Lines dragged in from top and side to help construct a layout.

GUTTER
The narrow space between columns of text.

HANDLES
These are attached to frames to allow manipulation.

HEADER
Information that appears in the header space at the top of the page in a publication.

HEADER SPACE
The space above the title or heading.

HEADLINE/HEADING/TITLE
Text that introduces the article or subject; usually a large font.

IMPORT/EXPORT
The process of sending digital files (graphics or text).

JPEG
A common image file type used for photographs. File sizes are relatively small.

MARGINS
The white space and borders around the page.

MIRROR/REFLECTION
Creating a symmetrical or opposite image.

PAGE FORMATTING
The orientation of the page: portrait or landscape.

PAGE SIZES
The physical size of a document: for example A5, A4, A3.

PORTABLE NETWORK GRAPHIC (PNG)
A file type that allows the background to be transparent.

POINT SIZE
Text size is measured in points.
This font size is 10pt
this one 16pt.

REVERSE
A reverse is when the text colour is changed from black to white on a dark background. It creates contrast.

SNAP
Cursor attaches to grid or guides to improve speed and accuracy.

SUB-HEADING
An intermediate level of heading, having a size between that of the heading and body text.

TEXT ALIGNMENT OR JUSTIFICATION
The way text lines are arranged in a frame: aligned left, right, centred or fully justified. Not to be confused with lining up items on the page.

TEXT WRAP
When text follows the outline of a graphic.

TRANSPARENCY
Making fills and images partially see-through.

VECTOR GRAPHIC
A scalable computer graphic made of shapes, lines and fills.

DTP FEATURES AND EFFECTS

Graphic layouts can be made more exciting by using software features and effects to create exciting layouts that have visual impact. You need to understand these DTP features in preparation for the course exam. You should also use them to good effect in your unit work and in the Course Assignment. Remember, the best way to learn is to do it!

You should become familiar with these functions:

- grid and snap-to-grid
- guideline and snap-to-guideline
- frame
- colour fill
- fonts
- crop
- text wrap
- flow text along a path
- bleed
- transparency
- drop shadow
- reverse
- mirror
- rotate
- import/export

We will look at each feature in turn and learn how to use it in layout design. It is important that you understand what each feature brings to a layout.

There are other DTP techniques that are useful when you are designing layouts. We will explain these later in this section.

SOME IMPORTANT DTP TERMS

TEXT ALIGN OR JUSTIFICATION

The way text is positioned in a frame is called text alignment. Text can be aligned left, right, centred or fully justified. This is not to be confused with lining up items on the page which is called simply **alignment**.

PAGE FORMATTING

The orientation of a page can make a difference to the impact of the layout. Sometimes the format or orientation is specified in the brief from the client, because the layout needs to fit a particular space. There are two formats: portrait and landscape.

COLUMNS

When extended text or body copy appears in a document it is often arranged in columns. These columns make the text easier to read by shortening the length of each line. Columns also help make the layout visually pleasing. When a text box is created it can be split into columns. The gap between columns is called the 'gutter'.

WHITE SPACE

When blank space is left on a layout it is done so deliberately. It may be to give the reader breathing space, if the layout is busy. It may be to create emphasis: leaving white space around a heading or a graphic can make it stand out. Oh, and white space doesn't have to be white!

REVERSE

Changing the text colour to white on a dark background is a reverse: it creates contrast.

Aligned left

The quick red fox jumped over the lazy brown dog. The quick red fox jumped over the lazy brown dog. The quick red fox jumped over the lazy brown dog.

Aligned right

The quick red fox jumped over the lazy brown dog. The quick red fox jumped over the lazy brown dog. The quick red fox jumped over the lazy brown dog.

Centred

The quick red fox jumped over the lazy brown dog. The quick red fox jumped over the lazy brown dog. The quick red fox jumped over the lazy brown dog.

J u s t i f i e d

The quick red fox jumped over the lazy brown dog. The quick red fox jumped over the lazy brown dog. The quick red fox jumped over the lazy brown dog.

Portrait

Landscape

Three column structure

Single column structure

BLUE stick — Reverse

The new range of high capacity storage sticks from Blue IT

White space

114

SETTING UP A MASTER PAGE AND GRID STRUCTURE

This page explains how to set up a master page for your DTP work. The master page here was set up for the bumblebee layout.

You should always set up a master page when you produce layouts, even when they are single-page layouts. The master page is important because it establishes a structure for text and graphics. It is flexible and can be modified and moulded once text and graphics are added.

Follow this guide when setting up your own layouts.

1. LAYERS

Layers allow the graphic designer to control separate parts of the layout. Headers, footers and margins may be stored on one layer, text on a second, images on a third layer and colour fills on another.

The use of layers is especially useful in materials for an international market. Different languages can be stored on separate layers and added to different versions as required. Your teacher will show you how to use layers on your DTP software. Locking layers can also prevent accidental editing errors. This is useful when constructing a complex layout.

2. GRID

Before adding text or graphics to the page, the layout should be prepared on a grid. For most A4 pages a 5 mm grid can be used.

Activating the **snap-to-grid** option means that features such as guidelines, text frames and graphics can be positioned quickly and accurately on top of the grid.

3. GUIDELINES

Guidelines (the blue lines shown here) can be pulled in from the side and top rulers. Activating **snap-to-guidelines** ensures accurate positioning.

Other important features set out on the master page include: header space, footer space, margins, columns and gutter widths.

DESKTOP PUBLISHING

SETTING UP A MASTER PAGE AND GRID STRUCTURE (CONTINUED)

4. TEXT FRAMES AND COLUMNS

Add the text frame. All the items that make up a page layout are contained in rectangular, non-printing frames. Each frame has eight handles that can be pulled or shrunk to reposition, resize or rotate the frame.

When you create a text frame you have the option to split it into columns. The bumblebee layout fits a three-column structure, although only two columns of text have been used. It is normal to set columns across the full page.

The gutter space and margins will also be set in the text frame.

handle

5. HEADERS AND FOOTERS

Headers and footers can now be added onto a new layer. Try to include headers and footers in your own promotional layouts.

If the document was more than a single page the header and footer would run through the whole publication.

www.wildlifeinyourgarden.org.uk

page 4

6. ADDING TEXT AND GRAPHICS

Once the grid and guidelines are positioned, text frames can be added. Remember to prepare your text on word processing software (Microsoft Word) and import it into the DTP layout where it can be added to the text frames.

A selection of graphics may already have been saved in a folder and these can be imported and used in the layout. They will need to be positioned accurately using **snap-to-grid** and **snap-to-guidelines**.

www.wildlifeinyourgarden.org.uk

page 4

7. FINE TUNING

Colour fills and detail, such as captions and the tilted images, can be added, scaled and positioned.

Fine tuning the layout is important. It will ensure the layout is just right before printing. You will learn more about this later and it will become a feature of your work when you produce your own promotional graphics.

www.wildlifeinyourgarden.org.uk

Focus on BEES

The humble Bumble

Not many of us are aware just how crucial Bees are to our lives. There are over 250 species of bee in Britain, and it is quite possible that 20 or more visits your garden. Of these, there is just the one honey bee, and 22 bumblebees.

So what are all the rest? Well, there are mining bees, mason bees, leaf-cutter bees and wool carder bees. Some are rather small and hairless, but many are stripy of furry and rather similar to honey bees. They all need nectar and pollen, but often require different flowers to the deep cups favoured by many bumblebees.

What can you do to help our bees? Offer a range of flowers to satisfy all comers, inluding open-faced flowers such as daisy, inula and knautia.

Wildlife Fact
There are over 250 species of bee in Britain

INULA DAISY KNAUTIA

page 4

LINES AND SHAPES

DTP software comes with simple drawing tools. These include tools for creating lines, circles, rectangles and a number of other geometric shapes. A gallery of lines and shapes is useful when designing layouts.

LINES

Lines can help the graphic designer to **separate** or **connect** items in a layout. Different line styles can also bring movement or flair to a layout and can **emphasise** or **underline** an item.

Line is one of the most important **design elements** and you should try to use line in at least one of your promotional layouts. Promotional layouts shown later in this book will give you ideas for using the line tool creatively.

> "**CREATIVITY** is allowing yourself to make **MISTAKES. DESIGN** is knowing which ones to **KEEP.**"
> **Scott Adams**

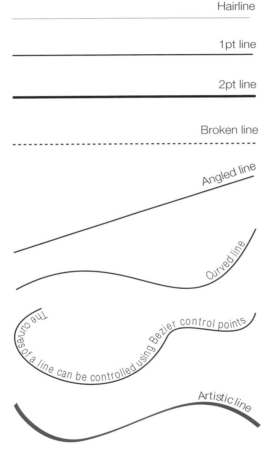

Hairline

1pt line

2pt line

Broken line

Angled line

Curved line

The curves of a line can be controlled using Bezier control points

Artistic line

SHAPES

Standard shapes can be an important feature in a layout. They can reinforce the structure of a layout: sometimes they can create contrast or harmony.

Some standard shapes can contain information or other graphics.

Shapes comprise an outline with a colour fill: either one can be removed and both can be edited.

Shapes need to be used creatively. Think about your target audience and the effect you want to create before using standard shapes in your layouts.

You can also use drawing tools to create your own shapes.

Letters are also shapes with a colour fill and sometimes an outline. The impact of a strong heading or title is as much about the bold visual statement as it is about the meaning of the text.

Letters are shapes with colour fills

FILLS AND TEXTURES

Filing shapes with colours, tones and textures can lift a layout if it is done creatively. Used in flashbars and backdrops, coloured and textured fills can support the message of the layout and help the designer to connect with the target audience.

The **colour palette** in any DTP program is extensive and offers designers a wide range of tones, tints and shades. Care must be taken because a clumsy or clashing colour fill can dominate a layout and ruin it.

COLOUR MIXERS

As well as providing an extensive colour and tonal palette, DTP software allows colour mixing. This is especially important if the designer needs to create an exact colour match of corporate colours for a client, for example.

The common colour mixing methods are discussed here.

RGB

RGB creates colours using mixes of **red**, **green** and **blue.** This colouring system is often used to create on-screen colours and colours for websites.

CMYK

CMYK creates colours by mixing **cyan**, **magenta, yellow** and **black** (known as the key colour). CMYK

mixes are used when a layout is to be printed. It is the common commercial printing format. Inside your inkjet or laser printer there will be four cartridges: C, M, Y and K.

FILL STYLES – COLOURS

PLAIN OR SOLID FILL WITH OUTLINE VISIBLE/REMOVED

Remember to remove the line when you use colour fills in your layouts. Leaving the outline in place can be clumsy and lacks subtlety.

LINEAR GRADIENT FILLS

Gradient fills can provide a more subtle backdrop, especially when fading to white.

RADIAL FILLS

TWO-COLOUR GRADIENT FILL

This is generally to be avoided in graphic layouts. When used badly it can create colour clashes and dominate a layout.

FILL STYLES – TEXTURE

A variety of textured fills, including materials, are available in a DTP textures palette. These can be useful when creating textured backgrounds for layouts. Wood grains, metals and stone textures are available to enhance a layout but they must be used carefully to support the layout, not dominate it.

TIP

If you find a texture fill that you like but it is too dominant, try using a transparency or colour intensity adjustment.

TEXTURED FILL

VARIOUS OTHER FILL STYLES AND TEXTURES

FILL STYLES CAN BE APPLIED TO TEXT

Text Fills

COLOUR SAMPLING AND MATCHING: EYE-DROPPER TOOL

The eye-dropper tool samples the colour in a graphic and allows an exact match to be produced in another area.

Matching
Sampling
Text

CHOOSING FONTS FOR YOUR LAYOUTS

The choice of fonts in a layout can be vital in making a connection with the target audience. It is the people who read your layout (the target audience) that will determine your choice of font.

Fonts fall into two main groups: serif fonts and sans serif fonts.

SERIF FONTS

Serif flick

Serif

Serif fonts are based on an old typeface and this gives them a very **traditional** or **formal** look. However, the serif flicks also make these fonts very readable when they are used in blocks or columns of body copy. You may want to try a serif font for your body copy.

Typical serif fonts include:

Bookman Old Style
Garamond
Lucida Bright
Rockwell
Times New Roman

SANS SERIF FONTS

Sans Serif

These are fonts without flicks on the ends of strokes: sans means **without** in French.

Sans serif fonts are modern in style and were designed to be used in advertising to sell modern products. They can bring impact to headings and titles but can also be used in body copy where a simple, modern or elegant look is required.

There are thousands of sans serif styles and, if you choose carefully, you can select one to connect with a particular age group, gender and interest range.

Typical Sans serif fonts include:

Basic Sans Light SF
Calibri
Geometric212
Goudita Sans light
Helvetica Neue LT
Verdana

DISPLAY OR SLAB FONTS

These fonts are used for short, bold or eye-catching headings. They are often, but not always, sans serif in style and chunkier than the narrow sans serif fonts. Good for posters, advertising and web page headings.

Super Black SF
Folio Xbd BT
Gill Sans Bold

SCRIPT FONTS

These can be elaborate font styles designed to imitate handwriting or simpler like the Comic Sans font. Script styles can suggest moods from formal, flowery and female to youthful and fun.

Ancestry SF
Lucida Handwriting
Freestyle Script

NOVELTY OR FUN FONTS

Novelty fonts are used when humour or stylising is a feature of the layout. They can bring impact and support a fun mood or style, especially to a younger audience.

Fluffy Snacks BTN
Bolts SF
Darlin BTN

CHOOSING FONTS

There are rules that you can apply when choosing fonts for your layouts but the best plan is to consider the rules to be no more than advice. Try several font styles before choosing the one that works best. But do your research first.

RESEARCH

Answering the following questions will help you select a suitable font for a promotional layout.

1. What are you promoting?

2. Who is the layout aimed at?
- What gender?
- What age?
- What interests do they have?
- What is the message you need to get across? Serious? Fun? Sophisticated? Reliable? Modern? Stylish? Good value? A bargain? Safe?
- This research will help steer you towards a style of font and will narrow your choices.

TIPS

- Always ensure text is legible.
- Try not to use more than two font styles in a layout: three max.
- Don't use two very similar fonts: use just one, or two very different fonts.
- Don't over-do elaborate font styles.
- Choose a typeface (font) you like.

When you choose fonts for your promotional layouts, look closely at successful market brands and the fonts they use.

- What do they sell?
- Who do they sell it to?
- What font styles have they chosen to connect with their target audience?
- Think about the target audience and what is being promoted:
 - How old are the audience members?
 - What is their gender?
 - What are their interests?
 - What message is being promoted?

1. Match these moods, feelings and ideals to the company logos, all of which include text. What you know or can find out about the companies will help you make a match. The same process applies to choosing fonts and designing logos or product names for your own layouts. Selecting fonts is about knowing your target audience and the product you are promoting, and making a connection between them.

MOODS, FEELINGS AND IDEALS

Reliable

Risky

Exciting

Teenage

Stylish

Safe

Edgy

Serious

Expensive

Sophisticated

Powerful

Technological

Eco-friendly

Middle-aged

Youthful

Static

Moving

Masculine

Feminine

COMPANY LOGOS

CREATIVE HEADINGS AND LOGOS | WORD POWER

Text is an important part of your promotional layouts. Text can be manipulated for visual impact, as well as to communicate information. This is especially useful in headings and logos, which need to be visual. Remember to consider the function of the text. It should be readable and it should connect with the target audience. This page will help you to experiment with font styles, colours and effects.

OUTLINES AND FILLS

Text is often constructed using an outline and a colour fill. Both can be active or invisible.

Type in a product name and copy and paste.

Learn how to activate and change both the outline colour and the colour fill.

Choose colours and overlap the words by tucking one in behind the other.

Add a backdrop and a fill style.

TILTING AND COLOUR

Aqua-J is a fruit juice aimed at children.

Type each letter into a separate text frame.

Choose a font style that will appeal to the target market.

Rotate each letter to create a wobbly style.

Choose colours and add a backdrop.

REFLECT AND FADE

A-frame is a construction company that needs a logo.

Choose a font style.

Copy and paste the name.

Mirror or flip the lower one and align it carefully. Add a line to act as a reflective surface.

Choose a colour and apply a transparency to the lower text to create a reflection.

CROPPING/POWER CLIP

SKYblu is a design company and they need a logo that is modern and illustrates their name.

Remove the fill but leave the line.

Source a photographic background

Slide the SKYblu company name on top of the photograph.

Use the DTP effect that can crop the photograph inside the shape of the text.

TRANSPARENCY

A transparency can make a graphic or colour fill see-through. It can be a useful feature when balancing tones in a layout.

The first **Aqua-J** background here is too strong: it dominates the layout and needs to be toned down. The second one has been subdued by applying a transparency that fades the background image and allows the bottle to be seen more clearly.

Editing the brightness, contrast or colour intensity can also achieve these results.

A transparency can be controlled to make it less or more transparent. Uniform transparencies can be created, as well as gradient transparencies. The graphic below demonstrates some transparency options.

COLOUR MATCHING

The colour matching tool allows you to sample a colour and create an exact match in another area. In this case the orange lid is colour-matched to the **Aqua-J** brand name.

A mirrored image of the bottle is used with a transparency applied to create the reflection.

CREATIVE USE OF TRANSPARENCY

The slogan 'Style and the purity of nature' in the fashion advert needs to be legible. The designer uses a box with a **plain colour fill** to improve legibility on the busy background.

The text stands out but the colour fill obscures part of the girl and breaks the backdrop. It looks clumsy.

However, when a **transparency** is applied to the colour fill (bottom layout) the girl and the backdrop are visible all the way down the page. It improves the visibility of the text on the busy background and it maintains continuity of the background image. It is also a subtle effect.

ADVANTAGES OF A TRANSPARENCY

- It can help improve legibility of text.
- It can maintain the continuity of an image or background.
- It can improve visual impact.
- It is subtle: it enhances the layout without being noticeable.

COLOUR MATCHING

The colour matching tool is used here to sample the blue in the girls dress. This is then applied to the colour fill at the top of the poster. Colour matching creates unity in the layout.

Plain colour fill

Transparency

DROP SHADOWS

Creating emphasis by making an image stand out in a layout is an important feature of graphic design. It is especially important when a product is being advertised in a promotional layout. Using a drop shadow is a common method for achieving this.

ADVANTAGES OF USING A DROP SHADOW

- It creates visual impact and emphasis.
- It lifts the image off the page.
- It gives the impression of depth in a layout.
- It is subtle: it enhances the layout without being noticeable.

The top Zee Stik layout is without drop shadows.

In the second example, drop shadows have been applied to the image and the title. The intensity, depth, position and colour of a drop shadow can be adjusted.

The drop shadows here have been coloured blue to match the background.

The shadows appear to be cast onto the background and lift the items out of the page, giving the layout depth.

The effects here are subtle: you don't notice the shadow as much as the depth it creates.

Zee Stik
New from BUZZ-IT

Technology with style - Technology with style
Technology with style - Technology with style
Technology with style - Technology with style

Zee Stik
New from BUZZ-IT

Technology with style - Technology with style
Technology with style - Technology with style
Technology with style - Technology with style

FLOW TEXT ALONG A PATH

Text can be made to flow along a line. The line is called a path. This can add contrast to a rectangular or linear layout.

The process is simple:

1. Draw a curved line. Your software may require that you select the 'Curved path text tool' command. Other software allows you to draw a line and then select 'Flow text along a path.'

2. Activate the flow text command and type along the line.
 Flow text along a path – flow text along

3. You may need to make the line invisible. This happens automatically in some DTP packages.

4. The line can be manipulated at any stage to form a different curve.
 Flow text along a path – flow text along

The top Zee Stik layout is on a rectangular page and the backdrop is linear (straight). Curved lines have been added to create contrast and bring a flowing and informal feel to the layout.

The lower Zee Stik layout uses flow text along a path. It adds visual interest and contrast to the layout. Note, the drop shadows have been edited and are now white in colour.

ADVANTAGES OF USING FLOW TEXT ALONG A PATH

- It creates visual interest.
- It brings contrast to a rectangular layout.
- It suggests a relaxed informality.
- Curves can suggest movement on a page.

Zee Stik
New from BUZZ-IT

Zee Stik
New from BUZZ-IT

Technology with style

Technology with style

Graphics are normally produced in a rectangular format. Photographs are rectangular; CAD illustrations and scanned images are also this shape. This suits rectangular print media like magazine pages, posters and printing paper. It also matches electronic output from computers, mobile phones or TV screens.

Often we need to cut away part of the background (partial or square cropping) or all of the background from a graphic (full cropping).

THE BENEFITS OF FULL CROPPING

1. It removes a background that may compete with the image.

2. It can introduce curves that contrast with the rectangular shapes in a layout.

3. It can enhance visual impact by focusing the eye on the image.

The photo of the tennis player is sharp but shows movement and balance. It is perfect for a promotional poster.

However, the background is out of focus and competes with the tennis player. It needs to be removed. DTP software can do this automatically by tracing round the image.

PARTIAL OR SQUARE CROPPING

Partial cropping or square cropping involves cropping the outer parts of the graphic, retaining its rectangular shape.

Original photograph

The square crop tool looks like this.

You can grab a handle on a frame with this and crop rectangular areas from the graphic by sliding it inwards.

The crop tool grabs a handle and removes a rectangular area by sliding it inwards.

Partial cropping: some of the background has been cropped from the right and top.

FULL CROPPING OR CUT-OUT

A different process is used for full cropping of an image.

DTP software often comes in a bundle with **photo-editing software**. With this, a graphic designer or photographer can crop images, remove red eye or apply a number of graphic effects. The image is imported into the photo-editor and an editing tool is chosen. This tool can remove a uniform background. Alternatively, you can trace around the part you wish to keep.

The photo-editing tool allows you to select the background and remove it pixel by pixel if necessary.

In the above example the tennis player is selected before removing the background.

The preview shows the image with the background replaced by a chequered 'alpha channel'. This disappears when the image is pasted into the DTP page.

Fully cropped image with the background removed entirely

TEXT WRAPPING

Wrapping text around a graphic can achieve three things in a graphic layout:

- It can create flowing, curved shapes that contrast with the rectangular shapes in the layout.
- It connects the text closely with the object it is wrapped around and creates unity.
- It can create more space in a busy layout.

It is an easy technique to perform:

1. Crop the background from your graphic to leave only the image.

2. Prepare your text and align it to the same side as the curves you want to match. In this case the left.

3. Depending on your software and the file type, the text may not wrap around the image but wrap only around the frame that the image is in. You may need to draw a simple closed shape around the image.

4. Trace around the cropped image with a line tool to make a closed shape. It is this shape that the text will wrap around. Position the text over the image and the shape.

5. Activate text wrap. You can adjust the space between the text and the image.

6. Finally, make the lines in the wrap shape invisible.

1

2

The mind of the tennis player is incredible. He requires poise, strength and technique. This only comes with dedication, repetition, stamina and self-belief.

3

4

The mind of the tennis player is incredible. He requires poise, strength and technique. This only comes with dedication, repetition, stamina and self-belief.

5

The mind of the tennis player is incredible. He requires poise, strength and technique. This only comes with dedication, repetition, stamina and self-belief.

6

TENNIS

The mind of the tennis player is incredible. He requires poise, strength and technique. This only comes with dedication, repetition, stamina and self-belief.

BLEED

Most printing equipment cannot print right to the edge of the paper. These gaps at the edge are called **margins**. However, graphic designers want to create exciting, modern layouts which include graphics that run to the edge of the page (edge-to-edge printing). The **bleed** is a technique that was developed to accomplish this.

The bleed is a relatively recent technique. It requires the use of larger printing paper which is trimmed or cropped after printing. A4 layouts are printed on paper a little larger than A4, known as OSA4.

To produce a bleed, the graphic is positioned to overlap the edge of the trimmed page. DTP software has a bleed setting that specifies how big this bleed size (overlap) should be.

The example on this page demonstrates the impact a bleed can have on a layout and the work that is done to create the bleed.

THE BRIEF

A promotional layout for a skin care company is being produced. The photograph (right) has been selected. Two methods of cropping the image have been shown (far right). Partial cropping removes some of the image on both the left and right. The fully cropped version removes the background entirely and cuts away the right side of the model.

Original image

Square cropped | Fully cropped

WITHOUT A BLEED

The layout on the left does not use a bleed. The white margins enclose the entire graphic. This creates a formal and traditional look.

WITH A BLEED

The finished graphic, below, shows the visual impact of the bleed. Both the cropped photograph and the background bleed off the page. The image of the girl is dominant and there is more depth. The effect is less contained, less formal and visually more dynamic.

You can create bleeds on an A4 layout by printing it on A3 paper and cropping the paper after printing. Or by printing tight to the margin on A4 paper and cropping it a little smaller.

HYDROCLEAR

Skin care from Invigorate

Crop marks | The edge of the page

Crop marks will be shown on the non-printing area to guide the trimming of the graphic after printing.

Bleed area is set to run past the edge of the page. The size of the bleed overlap will be set on the DTP software.

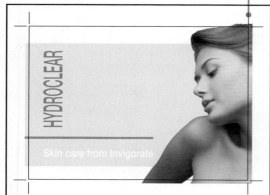

HYDROCLEAR

Skin care from Invigorate

The bleed area | **Oversize printing paper**

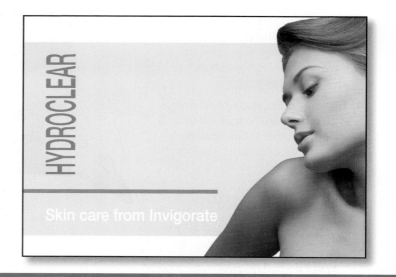

HYDROCLEAR

Skin care from Invigorate

Text and graphics are stored on computers as files. There are many different types of computer file and you are likely to use three or four types.

VECTOR GRAPHICS

The DTP software that you use in school will have drawing tools that enable you to create drawings and illustrations. These drawings and illustrations are called **vector graphics.**

The important things to understand about vector graphics are that:

- they can be scaled up or down without loss of quality
- they look like drawings, as opposed to photographs of real objects
- the quality ranges from cartoon-like to more realistic illustrations (see the vector camera graphics below)
- most clip-art images are vector graphics.

Vector images scale without loss of quality

BMP

Bitmap images (.bmp) are made up of pixels arranged in a grid. Pixels are tiny dots of individual colour. These tiny dots of colour come together to form the images you see.

If you drag the handles to increase the size of a bitmap image (scaling) you will see blurring, especially around the edges. This will look even worse when it is printed. If you drag the handles and scale it down it will also lose clarity.

It's not possible to increase or decrease their size of a bitmap without losing image quality. Bitmaps also have a comparatively large file size.

The small photograph of athlete Mo Farah looks sharp and clear but when it is scaled up the pixelated outline and loss of quality is clear. You can see individual pixels if you look closely.

You may need to source photographs and other images for your coursework. Always search for large images and ensure you check that the resolution is at least 300 dpi.

JPEG

JPEGs (.jpg) are the most common type of file for photographs because they can deal with millions of colours and still have relatively small file sizes.

When you download a photograph, for example from a digital camera, it is likely to be a JPEG. JPEGs are commonly used in publishing and for web pages.

TIPS: MAKE IT BIG!

1. When sourcing JPEG images, look for large images. The loss of quality will be less when you scale it down than if you have to scale it up.

2. Never copy and paste an image, always save the image to a folder and **import** it into your DTP document.

PNG

PNG (portable network graphic) is a relatively new file type.

PNG files have the option of a transparent background. This is particularly useful when you want to layer graphics.

The transparent area on a graphic is called the 'alpha channel'. To remove the background the image must be fully cropped then saved as a PNG file.

PNG files can be fully cropped to remove the background completely.

BLUE stick

This is useful when layered graphics are required.

FINAL LAYOUT 1

ORIGINAL GRAPHICS AND TEXT

Fruit Pop

Refreshing – Fruity – Fizzy and Natural

QUESTION 1

Layout 1 is a promotional graphic for 'Fruit Pop', a natural soft drink aimed at teenagers.

The final layout is shown to the left and below it the original text and images that were used in the layout.

The original graphics and text were all edited in a DTP package before being placed in the final promotional layout.

DTP EDITING

1. Name the editing features that have been applied to each of the three original items (two graphics and the text), to make them ready for use in the final layout? Do not include 'scaling or resizing' in your answers.

a) Landscape picture – two DTP edits

b) Flashbar – three DTP edits

c) Text – three DTP edits

d) Bottle – one DTP edit

EXPLANATION OF LAYOUT IMPROVEMENTS

2. Explain how editing each of the graphics and text improves the final layout.

a) Landscape picture
The edits improve the layout by...

b) Flashbar
The edits improve the layout by...

c) Text
The edits improve the layout by...

d) Bottle
The edit improves the layout by ...

FINAL LAYOUT 2

ORIGINAL GRAPHICS AND TEXT

La Fleur

By Verlaine

Layout 2 is a promotional graphic for La Fleur, a lady's perfume.

The final layout is shown to the left and below it the original text and images that were used in the layout.

The original graphics and text were edited in a DTP package before being placed in the final promotional layout.

DTP EDITING

1. Name the editing features that have been applied to each of the four original items (three graphics and the text), before they could be used in the final layout. Do not include 'scaling or resizing' in your answer.

a) Girl photograph – two DTP edits

b) Perfume bottles – two DTP edits

c) Blue square – two DTP edits

d) Text – three DTP edits

EXPLANATION OF LAYOUT IMPROVEMENTS

2. Explain how editing each of the graphics and text improves the final layout.

a) Girl photograph
The edits improve the layout by…

b) Perfume bottles
The edits improve the layout by…

c) Blue square
The edits improve the layout by…

d) Text
The edits improve the layout by…

DESKTOP PUBLISHING

JUICE BOTTLE

1. DTP editing:

a) Landscape picture – two DTP edits
Edit 1 – A transparency has been applied. Will accept the same answer citing brightness, contrast, colour intensity.
Edit 2 – The graphic bleeds off the edge of the page.

b) Flashbar – three DTP edits. Any three from:
Edit 1 – The outline has been removed.
Edit 2 – The transparency is applied.
Edit 3 – A gradient colour fill is applied.
Edit 3 – The fill has been colour-matched to the lid of the bottle.

c) Text – three DTP edits. Any three from:
Edit 1 – The Fruit pop font has been converted to a fun style.
Edit 2 – The slogan flows along a curved path.
Edit 3 – The slogan uses a script font.
Edit 4 – The slogan colour is reversed.

d) Bottle – one edit
Edit 1 – A drop shadow has been added.

2. Explanation of layout improvements:

a) Landscape picture – The edits improve the layout by reducing the impact of the strong colours. The transparency is a gradient transparency, giving less colour intensity at the bottom of the layout where text needs to be legible. The bleed enables edge-to-edge printing and prevents the layout from being contained within a border. It creates a more expansive layout suggesting there is more beyond the edge of the page.

b) Flashbar – The edits improve the layout by removing the outline which achieves subtlety. The transparency enables the text to be read without obscuring the background graphic: it allows continuity. Matching the colour to the bottle lid creates unity.

c) Text – The fun style of the product name is likely to appeal to a youthful target market; the flow text along a path creates an informal feel and contrasts with the rectangular features in the layout; the slogan font looks freehand and natural to match the product. The reverse text makes the slogan easier to read on the flashbar.

d) Bottle – The drop shadow adds depth and emphasis to the most important item in the layout.

PERFUME ADVERT

1. DTP editing:

a) Girl photograph – two DTP edits. Any two from:
Edit 1 – The image was fully cropped from the background.
Edit 2 – The image bleeds off the page.
Edit 3 – The image is layered to the front of the layout.

b) Perfume bottles – two DTP edits
Edit 1 – The bottles are fully cropped from the background.
Edit 2 – The bottles have been mirrored or copied, flipped and have a transparency applied or colour intensity adjusted to create a reflection.

c) Blue square – two DTP edits
Edit 1 – The blue square has been tilted or rotated.
Edit 2 – The blue square has a drop shadow applied.

d) Text – three DTP edits
Edit 1 – Suitable font styles have been applied: a flamboyant font and a more formal one.
Edit 2 – The 'La Fleur' text has been colour-matched to one of the bottles.
Edit 3 – A tilt or rotation has matched the text angle to the tilted box.

2. Explanation of layout improvements:

a) Girl photograph – The edits improve the layout because the cropped image has more visual impact and adds a flowing curved shape; this contrasts with the rectangular layout. The bleed brings a modern look; it creates an expansive layout not contained by borders. It suggests there is more beyond the edge of the page. The layering of the image on top of the layout, by overlapping the blue square, creates dominance and depth.

b) Perfume bottles – The edits improve the layout because cropping the bottles creates clean shapes that add contrast to a rectangular layout. The reflection or mirror edit creates depth and a shiny texture that presents the product to a female target market.

c) Blue square – The edits improve the layout because the rotation or tilt is eye-catching: it stands out more. The drop shadow brings depth to the layout.

d) Text – The edits improve the layout because the large script style font has impact and suggests a feminine product. Colour matching the text and product helps create unity in the layout. The font used on the company name is elegant and formal, suggesting that this company takes its product and its customers seriously.

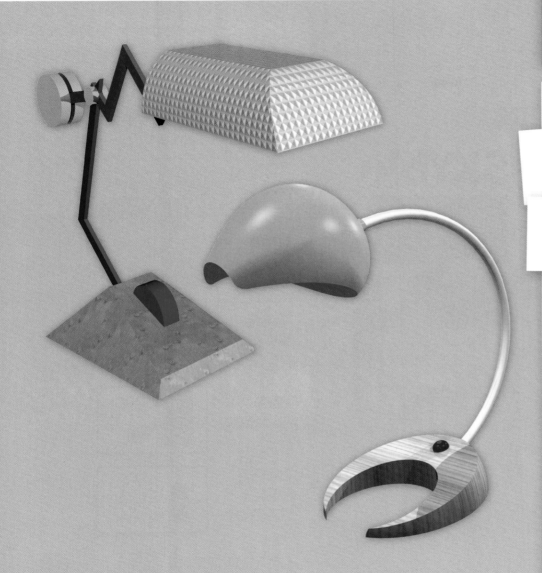

CHAPTER 15

DESIGN ELEMENTS AND PRINCIPLES

THE CUTTING EDGE

DESIGN ELEMENTS AND DESIGN PRINCIPLES

Good graphic design relies on the graphic designer understanding what makes a layout work. The graphic designer breaks the layout down into smaller parts and works with each part in turn. These smaller parts are called **design elements** and **design principles**.

You need to understand design elements and principles and be able to write about them in the course exam. You will also use them in your own promotional layouts. You should become familiar with this list:

- Alignment
- Balance
- Colour
- Contrast
- Dominance/emphasis
- Unity
- Depth
- Harmony
- Line
- Repetition
- Shape
- White space

You will not be asked about all of them in the exam but you can refer to any of the elements and principles in your answers. So it's worth making the effort to understand them all. The next few pages will help you do this.

HOW TO USE THIS SECTION

Having an understanding of design elements and principles will allow you to apply this knowledge in your unit work and your Assignment. It will help you improve layouts whether they are done manually or produced on the computer.

It is important to look at design elements and principles **in combination**: how they work together. It is just as important to apply design elements and principles in combination with **DTP features**.

The most useful DTP features are shown on the right, with design elements and principles shown far right.

Using design elements and principles effectively is vital if you are to create exciting promotional displays. Learn them and try them out on your computer screen. Experiment with creative layouts and your work will sparkle.

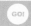 **EXAM TIP**

Don't think of Design elements and principles in isolation. Consider how they work in combination with DTP features and effects.

DTP FEATURES

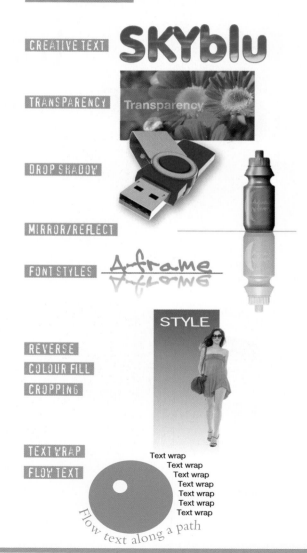

CREATIVE TEXT — SKYblu

TRANSPARENCY — Transparency

DROP SHADOW

MIRROR/REFLECT

FONT STYLES

REVERSE
COLOUR FILL
CROPPING

STYLE

TEXT WRAP
FLOW TEXT

Text wrap
Text wrap
Text wrap
Text wrap
Text wrap
Text wrap
Text wrap

Flow text along a path

DESIGN ELEMENTS AND PRINCIPLES

LINE

SHAPE

DEPTH
HARMONY — TICHO

UNITY
WHITE SPACE — TRIM TORCH

BALANCE
COLOUR
ALIGNMENT — Balance

DOMINANCE/EMPHASIS
CONTRAST
REPETITION

Lines can be an important element in a layout. They are used to **separate** parts of the layout, **connect** parts of the layout or create **emphasis** by underlining features.

The top blue stick layout is nicely proportioned but lacks focus, unity and impact.

HOW LINE IMPROVES THE LAYOUT

The second layout, right, is the same but with two horizontal lines added. These lines bring a number of benefits to the layout:

- They pass through and link both sides of the layout.
- The top line underlines and emphasises the product name.
- The bottom line passes behind the memory stick, creating depth: it pushes the memory stick forwards.
- The lower line separates the space at the foot for the slogan.
- Positioning the lines at the top and the bottom of the layout connects the two areas, creating unity.
- The lines are positioned carefully to create strong alignment. This helps to organise and give structure to the layout.

TIP

Remember, lines should support the purpose of the layout and enhance the layout without dominating it.

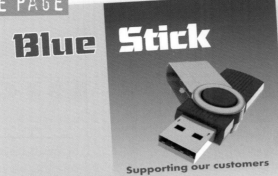

ACTIVITY

1. Study the two layouts below and explain what the use of line brings to the layout in each case.

Select from the list of design elements and principles and use them to help describe your answers.

Decide what moods and ideals the layouts suggest and explain, in each case, how the use of line contributes to these moods and ideals? Use the list of moods and ideals to help you.

Design elements and principles

- Contrast
- Harmony
- Alignment
- Dominance
- Unity
- Colour
- Depth

Moods and ideals

- Technological
- Calming
- Exciting
- Relaxing
- Stylish
- Safe
- Sophisticated
- Eco-friendly
- Static
- Moving
- Modern

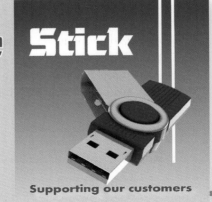

Good alignment helps improve the structure of the layout. It makes a page feel organised and easy to follow. It contributes to neatness and sharpness.

The example on this page shows how a badly aligned layout can be re-aligned to create a much more organised layout.

POOR ALIGNMENT

The 'Big Apple' layout, 1, is poorly aligned: it looks untidy and confusing.

When guidelines are added to the layout (2), the lack of alignment is more evident. The guidelines identify edges of items where alignment can be made.

HOW TO CREATE STRONG ALIGNMENT

Use a grid, guidelines and the 'snap' feature when setting up a layout. This easy-to-use function helps ensure that the alignment is accurate.

Most of the items in a layout are rectangular: columns of text, pictures, graphics, lines and colour fills are all rectangular, even the page itself is rectangular.

Guidelines help to line up items in the layout. Each item is moved or pulled into position to line up the edge with other items in the layout. Even the round apple has been carefully aligned with two other items.

STRONG ALIGNMENT

The same layout, 4, is now accurately aligned.

The result (4) is a much more pleasing layout that looks and feels organised and is easier to follow.

Use alignment in your own layouts. Look for edges that can be aligned and do it accurately. Strong alignment creates **organised, structured** and **easy-to-follow** layouts.

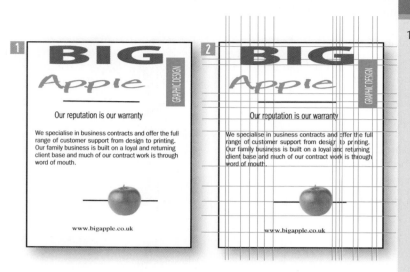

1. Study the layout items below. They have been produced for an A5 size promotional layout. Your task is to sketch, using all the layout items, two thumbnail ideas for the promotional layout: one portrait and one landscape. The layouts should demonstrate strong alignment and depth. You may resize the items and it is fine to use lines to represent the body text. Render the layouts in colour.

www.inshapegym.org

Fitness Gym

Sign up for a free two-month membership this August. Come and try our high quality equipment. Meet new friends and get in shape. We have relaxation rooms and a sauna.

Understanding balance is simple.

In most layouts there is a rectangular space to fill. When the product is placed in the middle of the page (example, top left) it creates a symmetrical layout but leaves two tricky areas, on either side, to fill.

When the main item is offset (placed to one side) it creates an asymmetric layout leaving a single space which is easier to fill (example, far right).

The asymmetric layout is more eye-catching: it creates contrast because the two sides don't match.

RULE OF THIRDS

When a layout space is divided into nine equal rectangles, the four lines dividing the space provide **focal points**. Placing important features on or close to a line can create a more visually pleasing layout.

Impact points, where the lines cross, are key areas to locate important features.

"SKATEBOARDING HELPS A TON WITH BALANCE ... IT GETS YOUR SENSES TO BE SPOT-ON."
Shaun White

SYMMETRICAL BALANCE

Achieving a balanced layout is difficult when the focal point is in the centre. The above layout is cluttered and looks disorganised. The content is too spread out and there are too many different areas to look at and read: it does not flow.

FINE TUNING

The final layout has been fine-tuned:

● The bottle has been scaled up.

● The product name has been shrunk to fit the space on the right and the 'Fruit Juice' text has been sized and aligned.

The layout has:

● an organised, neat structure

● text grouped together making it easy to follow

● an asymmetric, rule of thirds, balance

● visual impact.

ASYMMETRIC BALANCE

Moving the bottle off-centre creates asymmetry. This is more eye-catching. Text is confined to the top and right of the layout. It flows and is easier to read.

DESIGN ELEMENTS AND PRINCIPLES

Using colour creatively can make an enormous difference to the impact of a layout. It is important to consider colour **combinations** in a layout, not just individual colours. It is how colours work together that makes a difference.

Used well, colour combinations can:

* make a product stand out
* give an layout visual impact
* unify a layout (tie it together)
* connect with a target market
* suggest a mood.

To understand how to use colour in a layout it helps to learn the basics of colour theory. For detailed notes on colour theory see pages 142–145.

The layouts on this page promote the 'Kurve Chaise' lounger by Big Splash DESIGN. The lounger has three colours: lilac, purple and pale brown. These are fixed colours; they will not change. The colours chosen for the rest of the layout need to work with those three colours.

The layout is split into three areas, each with a colour-filled flashbar.

The chosen colour scheme should help unify these areas.

WHEN COLOURS DON'T WORK

This scheme includes too many colours: 11 in total. They work against each other and the images of the Kurve Chaise lounger get lost in the rainbow. There is no unity or harmony and the contrast is conflicting.

WHY COLOURS WORK

The third colour scheme uses green on all three flashbars. This creates contrast with the purple on the lounger: it makes the purple stand out. The circles and the 'Big Splash DESIGN' text use the same purple as the lounger. Purple becomes the **accent colour**: it stands out and ties the three parts of the layout together.

HOW COLOURS WORK

This colour scheme includes only the colours that already appear in the lounger, plus one other: four in total. Because the same colours appear in each of the three areas they help unify the layout. The colours don't fight with each other. They harmonise the layout and support the relaxed mood of the product.

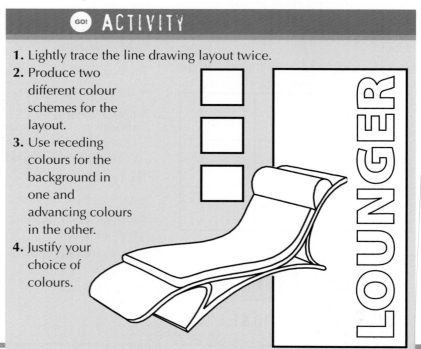

GO! ACTIVITY

1. Lightly trace the line drawing layout twice.
2. Produce two different colour schemes for the layout.
3. Use receding colours for the background in one and advancing colours in the other.
4. Justify your choice of colours.

LOUNGER

CONTRAST | BE DIFFERENT AND STAND OUT!

Contrast is about differences and especially opposites. Opposites – like black and white, vertical and horizontal or circles and squares – stand out when they are used together in a layout. They become eye-catching and can help give a layout visual impact.

FINE TUNING CHANGES

Below are shown the simple changes made to each item between layout 1 and layout 2. We call this fine tuning. It's important not to rush this process as it makes the difference between an average graphic and a fantastic one.

LAYOUT 1

The promotional layout above lacks contrast. The chair images are all the same size, the fonts are in the same typeface and size and the colours harmonise. Nothing stands out or catches the eye. While the alignment is strong, it lacks visual impact.

LAYOUT 2

The fine tuning of this second layout improves it, especially its visual impact. The key changes are related to contrast, creating differences throughout the layout.

- The 2D chairs have been shrunk and the 3D one scaled up, creating contrast in size.
- The large size of type used on the title contrasts with smaller text used elsewhere.
- A very different typeface is used on the title.
- The background colour creates contrast with the blue in the chair.
- The vertical colour fill and text contrast with horizontal items.
- A circle is added to contrast with rectangles.

- The text colour is reversed to white creating contrast with black.

The result is a visually dynamic layout. The dominant features are the large chair and the title 'Slab Chair' but there is unity, depth and contrast and the whole layout has impact.

Original items

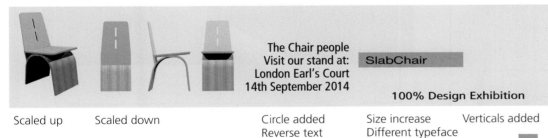

Scaled up Scaled down Circle added Size increase Verticals added
 Reverse text Different typeface
 Colour change

Changes that create contrast

DESIGN ELEMENTS AND PRINCIPLES

137

Creating the illusion of depth on a 2D page is an important way to give your layouts more visual impact. It is easily done and this page will demonstrate seven ways to create depth in a 2D layout.

Try these techniques in your own layouts.

Using a pictorial image as opposed to a 2D one is a simple way of creating the illusion of depth.

Placing a line or a box behind the image, so that the image cuts through the box, will give depth.

Placing a colour fill or flashbar behind the image also creates depth, if the image breaks out of the colour fill.

Placing text behind the image can create depth.

Placing other images behind the main image can create depth.

TICHO PEN

Using a drop shadow can create depth because the shadow represents a surface.

Using differences in scale (large and small, near and far) can create depth.

GO! ACTIVITY

1. List the techniques used to create depth in this layout.

138

Layouts are often made up of many different parts or items. It is important to connect these different parts together in some way so that they appear to be part of the same layout. There are many ways to achieve this.

This page looks at some of these methods. You should try them out in your own layouts and choose those that suit each layout best.

Overlapping an image onto text can create unity. It makes a physical connection between the text and the image.

Lines can do the same! Placing the lines behind the image connects and unifies the combination.

Using a colour fill behind two items can connect them. The text and torch are connected by the blue flashbar.

Repeating colours in different parts of the layout (repetition) can tie items together: use the eye-dropper tool for this.

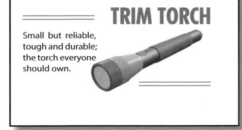

Repeating features in separate positions can create unity. The double lines tell the eye that this is a unified layout.

Using harmonious colours can have a unifying effect. The colours in the torch are used elsewhere in the layout and the mid-tones all balance across the display.

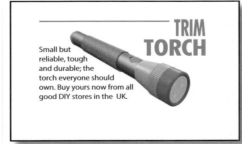

Positioning items close to other items can create unity. The text wrap positions text close to the image, creating a connection.

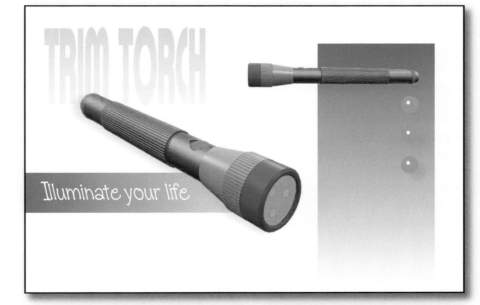

Illuminate your life

🔘 ACTIVITY

1. List and justify the techniques used to create unity in this final layout.

DESIGN ELEMENTS AND PRINCIPLES

DOMINANCE AND EMPHASIS | STAND OUT IN THE CROWD

Graphic layouts are often scanned quickly by the reader. If the layout is bland or without a focal point it may not hold the reader's attention long enough to get its message across.

Your layouts will include graphics and text. The text may be split into two or three parts: a title or heading and body text (a short paragraph or description), plus possible further information.

These contents need to be arranged to create a strong **focal point**. Normally this is the main graphic or photograph on the page.

Dominance and emphasis are related elements. Let's explain them:

- **Dominance** occurs when one item stands out more than others: it dominates the layout.
- **Emphasis** happens when an item is made more eye-catching.

There should be an order of dominance in the layout that leads the reader.

1. The main graphic or picture should dominate the layout.

2. The title, heading or product name should be next.

3. Less important items should be grouped and positioned carefully to support this order of importance.

LACKING DOMINANCE AND EMPHASIS

The layout on the right has been aligned carefully but it lacks visual impact:

- The space is filled but there is no focal point.
- The images are too similar in size and are spread out around the layout.
- The product name does its job but lacks impact.

WITH DOMINANCE AND EMPHASIS

There are a number of ways to introduce dominance and emphasis to improve a layout. The layout here has been improved by:

- Creating a focal point by enlarging an image and positioning it carefully.
- Grouping smaller images and scaling them down to make the focal point more dominant.
- Changing the font to create contrast.
- Using an underline to add emphasis.
- Leaving 'white space' around the product name to emphasise it.
- Reducing the number of colours to add contrast: the background colour pushes the images forward.

This layout now has a dominant focal point, an emphasised product name, a structured layout and a simple but effective colour scheme. It now has visual impact.

GO! ACTIVITY

1. This **Circ lamp** advert has been designed to appeal to a target market that includes young married couples. Explain the methods the designer has used to create: **dominance, emphasis, unity** and **contrast**.

WHITE SPACE: NOTHING TO LOSE

White space does not need to be white. The term refers to blank areas or empty space on a page. Leaving empty areas on a layout has three main purposes:

- It can allow the reader's eyes to rest, especially if the layout is busy.
- It calms a layout and allows breathing space: it makes a busy layout feel less busy.
- It can make an item in or beside the white space, stand out more: it creates emphasis.

Try leaving white space around titles and product names in your own layouts: give them breathing space and help to create a visual impact.

The rectangle is the predominant shape in graphic layouts. This is because computer screens and magazine pages are rectangular. Photographs and columns of text are also rectangular.

Using other shapes in a layout can help introduce contrast and create visual impact.

Don't allow the shapes you use to dominate the layout. They should support the message, promote the product and connect with the target audience.

> "THE ONLY WAY TO PREDICT THE FUTURE IS TO SHAPE IT."
>
> Alan Kay

🔵 ACTIVITY

The fourth layout uses shape to add contrast.

1. Describe two other techniques that have been used to create unity and depth in the same layout.

The layout above has the images in frames or boxes. The result is a formal and structured layout based on rectangular shapes. The layout is bland: it lacks contrast and variety.

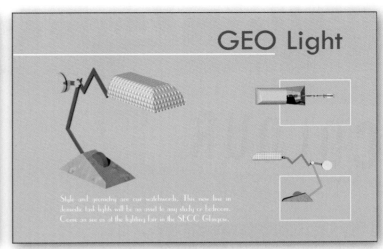

Cropping the main image introduces another shape. This makes it less formal and more contemporary, but the layout is still too bland: the text looks clumsy.

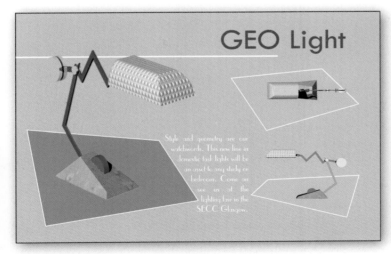

All the images have been fully cropped in this third version. Asymmetric shapes have been used in place of frames and the text is wrapped around the main shape. The result is a modern, informal feel that complements the lamp.

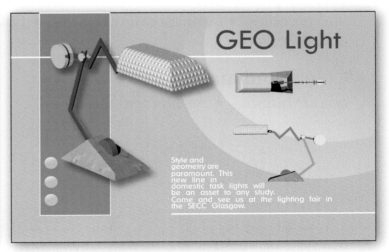

The fourth layout uses another rectangle and softer ellipse shapes. It shows how shape can be used to create a different 'feel'. The circles on the left repeat the soft shapes, and create unity and rhythm.

CHAPTER 16

COLOUR

COLOUR THEORY | BASICS

INTRODUCTION

The use of colour plays an important part in illustration and graphic design. Colour is used to make graphics look realistic and to help designers create a mood or feeling.

Questions about colour can appear in the course exam and you will certainly use and justify the use of colour in your project work.

PRIMARY COLOURS

The primary colours – red, yellow and blue – work in various combinations to produce all the other colours.

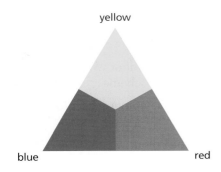

SECONDARY COLOURS

The secondary colours – violet, orange and green – are made by mixing two primary colours in equal quantities, e.g. red and yellow make orange.

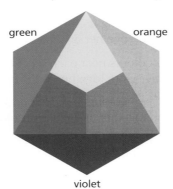

TERTIARY COLOURS

Tertiary colours are made when a primary colour and a secondary colour are mixed in equal quantities. They take their name from the two mixed colours, e.g. red and orange make red-orange.

THE COLOUR WHEEL

The colour wheel (shown here) was designed as a way of showing how colours relate to each other. The outside ring shows the three primary, three secondary and six tertiary colours.

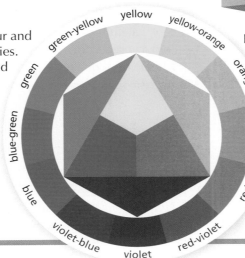

HARMONY

Harmony is created when colours close to each other on the outside of the colour wheel are used together. Harmony is easy on the eye. For example, the blue and green in this bottle create a relaxing image.

CONTRAST

Contrast occurs when colours far apart on the colour wheel are used together. Contrast is eye-catching and makes objects stand out. Contrasting colours are described as **complementary**. For example, in this bottle the green makes the red look redder and the red makes the green look greener.

WARM COLOURS

Reds, yellows and oranges are **warm colours**; they evoke feelings of warmth. They are also known as **advancing colours** because they appear to be closer to the viewer than other colours. For example, if you painted your bedroom in these colours it would seem warm but it would also feel smaller because warm colours make the walls look closer.

COOL COLOURS

Blues, greens and violets do exactly the opposite. They evoke feelings of being cold and are known as **cool colours.** They also appear to be further away and are called **receding colours**. For example, if you painted your bedroom in these colours it would appear cold but it would also feel bigger because cool colours make the walls look more distant.

COLOUR

TONE

Tone is the term used to describe how strong or weak a colour is. All colours can be produced in a full range of tones, from strong tones with lots of depth to weak tones, which are very pale. You will learn how to apply different tones on page 147.

Five flat tones

Weak/light Strong/dark

Graded tone

THE EFFECTS OF LIGHT ON SURFACES

Surface tones on 3D objects change depending on the way light falls on the surface.

On flat-sided objects such as cuboids, the tone on the surface facing the light source is pale, while the tone on the surface facing away from the light source is dark or strong. Each surface has a flat tone.

Objects with curved surfaces reflect light differently. The tone on a curved surface changes from dark to light as the surface curves towards the light source. This is called graded tone. Cylinders, spheres and cones have graded surface tones.

TINTS AND SHADES

Tints and shades help designers by increasing the colour options they can use. Designers rarely work with pure colours. Instead, they use tints and shades to create different moods and feelings.

Add black or grey to make a shade. Dark shades make objects appear heavy.

Add white to make a tint. Pale pastel colours give the impression of softness.

CHOOSING A COLOUR SCHEME

Interior designers and graphic designers are very careful when they choose colour schemes. As a simple rule, designers use only two or three main colours. To help them, they use colour charts and colour wheels similar to one shown on page 143 but with many more colours, including tints and shades. An example of a designer's colour wheel is shown here.

Designer's colour wheel

RULES FOR CHOOSING A COLOUR SCHEME

When choosing a colour scheme, use **one** of the following rules. It will help you to put together an effective and balanced colour scheme.

1. Any colours near each other (within any third of the colour wheel) will always work together to create a harmonious colour scheme.

2. Any two colours that are opposite each other on the colour wheel look good together and make a bold scheme.

3. Any three colours that are equally spaced on the colour wheel work together to make an exciting scheme.

GO! ACTIVITY

1. Look carefully at the colours used in the two graphics below. Pick out the colours used from the designer's colour wheel. Which of the three colour scheme rules do they each satisfy?

COLOUR AND MOODS

Different colours create different moods and feelings. Designers make use of this by selecting colours which help to support the atmosphere they want to create. This page gives examples of the moods that different colours create. This knowledge will help you when you are choosing colours for your own layouts and graphics. When you design, don't select colours individually: instead, think of the effects created by colour combinations.

THE FUNCTION OF COLOUR IN COMMUNICATION

- As a symbol, for example in flags.
- To give instructions, such as in traffic lights.
- To show group identity – think of team colours.
- To organise and identify, for example in colour-coding.
- To promote businesses with company logos and corporate colours.
- To promote sales through packaging.

GO! ACTIVITY

1. Select a large colour advertisement from a magazine. Write a brief report about the advertisement that:
- **a)** identifies the target market (who the poster is aimed at)
- **b)** states why the colours have been chosen (what mood has been created)
- **c)** identifies where contrast and harmony have been used.

RED

Warm, exciting, vibrant, passionate, dangerous, revolutionary, active, aggressive, courageous, festive.

ORANGE

Warm, happy, sunny, cheerful, appetising – full of flavour and energy.

YELLOW

Warm, energetic, happy, sunny, lively, cheerful, glowing, sparkling, bright – most easily seen.

GREEN

Cool, restful, natural, calm, soothing, fresh, quiet, informal, healing, tranquil.

BLUE

Cool, elegant, sophisticated, heavenly, formal, classy, wisdom, relaxing, soothing.

PURPLE

Rich, pompous, regal, luxury, creativity, mystery, ambition, wealth.

VIOLET

Cool, peaceful, solitary.

NEUTRALS

Greys: natural, restful, calm, elegant, dignified, comfortable, studious.

Browns: natural, earthy, safe, reliable, good, secure, reassuring, comfortable.

BLACK AND WHITE

White: pure, goodness, innocence, perfection.

Black: dramatic, power, elegance, stylish, sophisticated, formality, mystery.

COLOUR

CHAPTER 17

PENCIL ILLUSTRATION

WHAT YOU WILL LEARN

- **Shading theory**
 tones • tone boxes • light

- **Shading, toning and rendering skills**
 technique • flat tones • graded tones • texture • detail

- **Advanced effects**
 desertscape

RENDER

Learning and practising the techniques shown here will give you an understanding of how light, shade , tone and texture can bring realism to a graphic. Your teacher will take you through the illustration skills you will need to complete each task.

The illustrations in this section are all done in coloured pencil. Buy a good set so that you can practise at home.

TONE BOXES

You will learn to apply two types of tone:

- flat tone for flat surfaces
- graded tone for curved surfaces.

Shading a tone box lets you practise applying tone. Always use a sharp, soft 2B or coloured pencil for shading. Make broad pencil strokes. Light tones need light pressure. Dark tones need more pressure and repeated strokes.

Shade flat tones in the following order: 1, 5, 3, 2, 4.

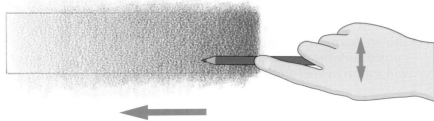

For graded tone, work from dark to light, easing pressure as you go.

SHADING AND TONING

Shading and toning is used to make drawings and sketches look solid and give them form. This is done by understanding the effect that light has on the surfaces of an object.

RENDERING

Rendering takes shading and toning one stage further: it adds texture or pattern to surfaces, suggesting a particular material or product.

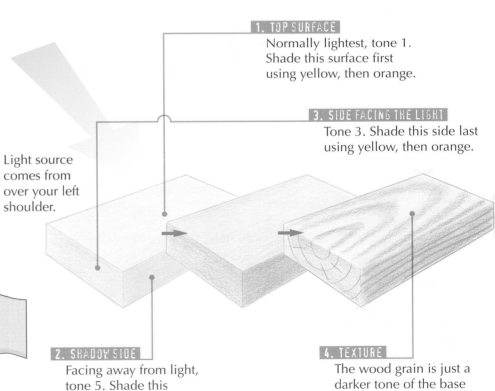

1. TOP SURFACE
Normally lightest, tone 1. Shade this surface first using yellow, then orange.

3. SIDE FACING THE LIGHT
Tone 3. Shade this side last using yellow, then orange.

Light source comes from over your left shoulder.

2. SHADOW SIDE
Facing away from light, tone 5. Shade this surface second using yellow, then orange.

4. TEXTURE
The wood grain is just a darker tone of the base colour, yellow/orange.

PENCIL ILLUSTRATION

CURVED SURFACES

Rendering curved surfaces requires a little more skill. There are three main curved forms: cylinders, cones and spheres.

LEARNING SKILLS

These shading and toning exercises will help develop your skills. Try to show a change in tonal scale across a curved surface. You should work from dark to light. Place your highlights carefully, off-centre.

SPHERE

Draw a circle and add tone, circling towards the highlight near the top left.

Build the tone gradually working from dark to light.

Add detail by applying darker tones and lines to create realism. Firm in the outline.

CYLINDER

Draw a cylinder and add tone, working from the dark outer edges towards the highlight near the top.

Do the same for the blue section. Carefully match the highlight.

Add a reflective highlight to the end and a shadow below. Firm in the outline.

CONE

Draw a cone and add tone, working from the dark outer edges towards the highlight left of centre.

Render the inside with the highlight opposite to the tones on the front.

Add the second colour. Be careful to match the highlights. Firm in the outline.

- Decide which direction the light is coming from (in this case, top left).
- Work from dark to light.
- Place the highlight off-centre, facing the light source.

CONTRAST AND DETAIL

Contrast and detail make your illustrations more eye-catching.

- Pick out surface detail carefully in light and dark tones.
- Make dark tones as dark as possible without being shiny. Keep pale tones very light.
- Place highlights and dark tones close together to create contrast.
- Joins or gaps provide opportunity for dark shadows and crisp highlights.

RENDERING

The rendered geometric objects shown below are a good way to practise the skills you will need. You can create them very quickly. Sketch or draw outlines and copy the techniques shown here. The objects all have curved surfaces, similar to those that will appear in later project work.

SHINY METALLIC SURFACES

Shiny metallic surfaces can be rendered using a desertscape. Imagine the shiny object in a desert. It reflects the simple environment: blue sky, a sandy ground colour and a blue and black horizon line.

Draw the outline in three colours. Add a blue and black horizon line.

horizon line

Add blue sky tones.

Finish with sandy ground tones and detail.

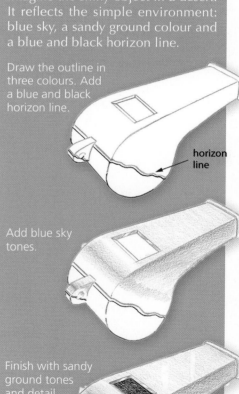

PROJECT | GRAPHS AND CHARTS

WHAT YOU WILL LEARN

- **Four main types of graph and chart**
 pie chart • bar graph • line graph • table • choosing the correct type

- **Layout design and planning**
 thumbnails • sourcing images • target market • content

- **Creating a graph**
 using DTP • elements and principles • visual impact

- **Evaluating your graph**
 layout report • content • target market • visual impact

INTRODUCTION

Statistics are part of our everyday lives. Sales figures, government spending, sports league tables and retail price increases are all areas in which facts and figures change frequently. Such information can be very complex and difficult to understand. Graphs and charts make statistics more visual. Turning facts and figures into graphics can highlight important parts and make the information much easier to understand.

There are four main types of graph and chart: pie chart, bar chart, line graph and table. You must select the correct type when designing your own graphics.

USE OF GRAPHS AND CHARTS

The types of graph and chart shown on this page are used in newspapers, magazines, brochures, websites and on television. They generally accompany an article or story, often with a supporting picture or graphic. Your graphs and charts must be self-explanatory and stand alone without an accompanying story or article. In order to achieve this you must include a short note to help make the information clear.

The graphs and charts shown on this page show the basic form and would not achieve a pass in the unit or Assignment work. To achieve a pass the graph or chart must be the correct type, complete, and enhanced graphically to support the message or subject matter. The following pages demonstrate how each of the graphs on this page can be enhanced to achieve a unit pass or a good Assignment mark.

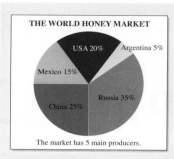

THE WORLD HONEY MARKET

USA 20% · Argentina 5% · Mexico 15% · Russia 35% · China 25%

The market has 5 main producers.

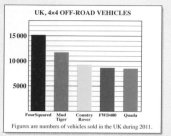

UK, 4×4 OFF-ROAD VEHICLES

FourSquared · Mud Tiger · Country Rover · FWD400 · Quada

Figures are numbers of vehicles sold in the UK during 2011.

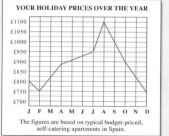

YOUR HOLIDAY PRICES OVER THE YEAR

J F M A M J J A S O N D

The figures are based on typical budget-priced, self-catering apartments in Spain.

Participation in the most popular sporting activities						
How Scotland's fitness participation has changed in 40 years						
	1972			2012		
	M	F	Total	M	F	Total
Cycling	4%	1%	2.5%	28%	12%	20%
Golf	4%	1%	2.5%	14%	4%	9%
Jogging	1%	0%	0.5%	16%	8%	12%
Pilates	0%	0%	0%	1%	8%	4·5%
Swimming	8%	6%	7%	14%	12%	13%
Walking	2%	1%	1.5%	20%	22%	21%
Yoga	0%	1%	0.5%	2%	8%	5%

PIE CHART

A pie chart is usually shown as a circle. This circle represents the 'complete' or 'whole' number and is divided into segments by lines running from the centre. Each segment forms part of the whole number.

- Use pie charts to display parts of a 'whole number'.
- Do not use them when there are too many segments or if some slices will be very thin.
- Do not use a shape that is too difficult to divide up accurately. The shape does not need to be a circle but must divide up simply and accurately.

BAR CHART

A bar chart can be a row of bars showing how values vary over a period of time, for example, or a row of bars showing how different values compare with one another.

- Use bar charts when you want to highlight individual figures rather than show an overall flow of figures.
- Use bar charts when comparing different items or figures.
- Do not use bar charts when too many bars are required. This would make the chart difficult to follow.
- Do not use bar charts when the overall flow of figures is more important than individual values – use a line graph instead.

LINE GRAPH

A line graph is often used to show quantities plotted over a period of time. The x-axis (horizontal scale) represents time. The y-axis (vertical scale) represents the quantities. The line/curve is then plotted on a grid.

- Use line graphs when it is important to show a gradual change in figures over time, for example.
- Do not use line graphs when some quantities are tiny and others are huge – use a table instead.

TABLE

A table displays numbers or words in rows and columns. A spreadsheet is a computerised table that can be used to calculate data. It can also produce graphs and charts.

- Use tables when the individual figures, rather than the overall flow, are most important.
- Use tables when comparing numbers that are too far apart to be shown on a chart.
- Use tables when presenting large amounts of very precise information.
- Do not use tables when you can use one of the other three types of chart.

ENHANCED GRAPHS AND CHARTS

ENHANCING YOUR GRAPH OR CHART

The graphs and charts on this page have been taken from the previous page and have been enhanced to National 5 level.

It will be your task to create a graph or chart that presents information so that it can be understood easily and that has been enhanced to give it visual impact and relevance to the target audience.

CREATING AN EFFECTIVE GRAPH OR CHART

To achieve a unit pass or a high mark in the Assignment the graph or chart should:

- be the correct type to display the information or data
- be graphically enhanced to support the subject matter and connect with the target audience
- be complete, with no vital parts missing
- demonstrate a high standard of layout.

WHAT MAKES A COMPLETE GRAPH OR CHART

Every graph or chart should have:

- a 'snappy' and clear title to introduce it
- a short note to help make the information clear
- a graphic to support the subject matter and enhance the presentation
- a pie chart, bar graph, line graph or table to display the data or statistics.

If everything is in place, your graph or chart should be clear, easy to understand and have visual impact. It is important to be aware of the different methods you can use to produce your graph or chart. The examples on this page use a combination of manual techniques and DTP.

PIE CHART

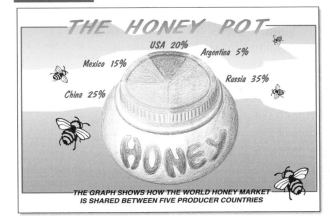

The text and background are produced using DTP while the honey pot is created using coloured pencil. The bees are clip-art images and are positioned to create depth in the layout.

BAR GRAPH

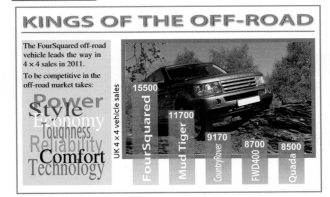

Using images is an easy way to enhance the graph and support the meaning of the data. This graph was produced on a DTP package using a library image.

LINE GRAPH

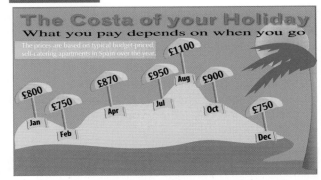

This line graph is made using 2D graphics software. It combines simple shapes and colour fills in a bright holiday-themed layout. The line graph is the top of the sand dunes and, while some months have been left out, the flow of price changes over the year is clear.

TABLE

OUR LEAN, MEAN, FITNESS REGIME

How Scotland's fitness participation has changed in 40 years

	1972			2012		
	M	F	Total	M	F	Total
Cycling	4%	1%	2.5%	28%	12%	20%
Golf	4%	1%	2.5%	14%	4%	9%
Jogging	1%	0%	0.5%	16%	8%	12%
Pilates	0%	0%	0%	1%	8%	4.5%
Swimming	8%	6%	7%	14%	12%	13%
Walking	2%	1%	1.5%	20%	22%	21%
Yoga	0%	1%	0.5%	2%	8%	5%

Participation levels in Scotland

The table is made using spreadsheet software. This is enhanced by careful choice of colour to provide visual impact and unity. The cropped images support the message and make the table visually appealing.

DESIGNING YOUR OWN GRAPH OR CHART

UNDERSTANDING THE BRIEF

You may be asked to create a graph or chart in your Assignment, so working from a brief and specification in your unit work is useful experience.

Study the brief and specification below and follow the example shown. It is important that you follow a process when you are designing your graph or chart.

THE BRIEF

UK Music magazine is planning a feature on listening preferences in music. Specifically, how the music we listen to varies depending on gender and age. They need a graphic designer to create a graph to show a comparison between the music preferences of teenage males and females.

They have supplied statistical data that should be displayed in the graph:

- **Survey size:** 2000 teenage music listeners.
- **Gender balance:** 1000 males and 1000 females.

Male listening preferences:

Dance/techno	80 respondents
Heavy metal/heavy rock	320
Indie/grunge	160
Pop	100
R&B/hip-hop	220

Female listening preferences:

Dance/techno	100 respondents
Heavy metal/heavy rock	150
Indie/grunge	160
Pop	350
R&B/hip-hop	240

FOLLOWING A PLAN

The steps below will help you put together a graph or chart that is correct, accurate and has visual impact.

1. Record or paste the brief onto paper.
2. Analyse the brief and specification.
3. Identify the target market.
4. Identify any other conditions or constraints.
5. Select and sketch out the best type of graph or chart for the job.
6. Research and source images that you could use in your layout.

DESIGN SPECIFICATION

Your graph or chart should do the following:

- Name-check 'UK Music' Magazine.
- Present the data clearly.
- Distinguish between and compare male and female responses.
- Appeal to the target audience: 16–28 year-old male and female readers.
- Include positive images of young people.
- Include a catchy title.
- Explain the purpose of the graph.
- Create a youthful feel to the layout.

Brief

'UK Music' require a graph or chart to display the teenage music preferences data supplied. The graph is aimed at their reader target market:

Age range – 16 – 28 years
Gender – male & female

Survey size: 2000 teenage music listeners
Gender variance: 1000 male and 1000 female

Male listening preferences

Dance & techno 80
Heavy metal & heavy rock 320
Indie & grunge 160
Pop 100
R&B & hip-hop 220

Female listening preferences

Dance & techno 100
Heavy metal & heavy rock 150
Indie & grunge 160
Pop 350
R&B & hip-hop 240

Specification – My graph should:

- Name-check 'UK Music' Magazine.
- Present the data clearly.
- Distinguish between male and female responses.
- Appeal to our target audience.
 16–28 year old male & female readers.
- Include positive images of young people in the layout.
- Include a catchy title.
- Explain the purpose of the graph.
- Create a youthful feel in the layout.

Graph Research

Pie charts may make it difficult to fit in percentages and several types of music. A bar chart may make it easier to do this. I could use a colour key to explain the music types.

Graph designs

I could use two pie charts

Female Male

Female 100 80 Male

Female Male

Pie chart split in half may help make the comparison

Pie chart could be split in half and coloured to show a comparison between male & female music preferences

Female preferences
350 240 160 100 150

Male preferences
320 280 220 80 100

- Heavy metal & heavy rock
- Indie & grunge
- R&B & hip-hop
- Pop
- Dance & techno

SOURCED IMAGES

PRELIMINARY GRAPH OR CHART LAYOUTS

Preliminary layouts can be drawn or sketched using coloured pencils or assembled using a cut and paste method. Follow the steps below:

1. Select the type of graph or chart you want to use. In this case the bar chart may be a better way of making a comparison between male and female data.

2. Study the images you have sourced and select one or two.

3. Sketch preliminary ideas for your graph.

4. Ensure that you have all the parts in place:
 - a snappy title
 - a graph
 - images to support the message
 - text to clarify the information.

5. Check that your chart can be understood by asking someone else to read it.

6. Annotate your preliminaries to explain what you are trying to achieve.

SELECTING IMAGES

The male and female images selected for this graph have been picked because they are exciting and reflect music, movement and fun.

The background graphic is a concert crowd that should provide atmosphere. Select images that you think may work: the figures here can be easily cropped. This will allow layering when they are placed over the background.

CROPPING IMAGES

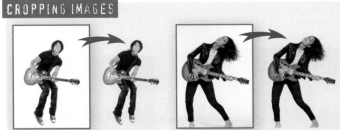

YOUR FIRST DRAFT GRAPH

Your first draft DTP layout is a starting point but not the finished item. Base your first draft on your preliminary layout. You will find that it is easier to move things around and change colours on screen. This is often where the really creative work begins.

The bar graph here may let me show a comparison between male and female music tastes better than a pie chart can

Female Preferences Male Preferences

Graph
Thumbnail Layouts

Making a ragged edge on the background will appeal to the young target market and make it look grungy. I'll need to find out how to do this

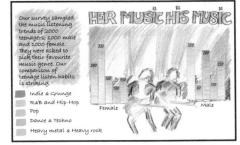

Our survey sampled the music listening trends of 2000 teenagers; 1000 male and 1000 female. They were asked to pick their favourite music genre. Our comparison of teenage listen habits is striking.

- Indie & Grunge
- R&B and Hip-Hop
- Pop
- Dance & Techno
- Heavy metal & Heavy rock

A coloured key can help explain the different music types

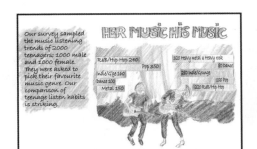

Our survey sampled the music listening trends of 2000 teenagers; 1000 male and 1000 female. They were asked to pick their favourite music genre. Our comparison of teenage listen habits is striking.

I could write styles directly on to the bars. I need to be clear about the five music styles that I have figures for.

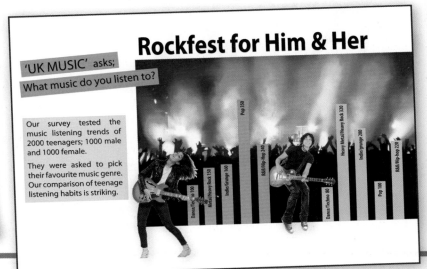

'UK MUSIC' asks;

What music do you listen to?

Rockfest for Him & Her

Our survey tested the music listening trends of 2000 teenagers; 1000 male and 1000 female.

They were asked to pick their favourite music genre. Our comparison of teenage listening habits is striking.

FINE TUNING YOUR GRAPH OR CHART

Fine tuning involves taking a critical look at your first draft and trying out changes that will improve the layout. Improvement may not happen immediately but you should persevere until you find a combination of colours, shapes and positions that work.

Don't forget: the careful use of design elements and principles can turn a weak layout into an exciting one.

FINE TUNING IMPROVEMENTS

The background and other text boxes were made ragged and distressed to make it look rough and exciting.

The girl was replaced to create more colour contrast.

The two bar graphs were integrated. This makes it easier to compare the male and female data. Colours were changed and the graph was tilted to add to the edgy feel.

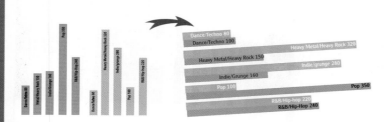

The yellow colour fill was also distressed and the text on top is tilted and coloured to create an edgy, rough look.

Our survey sampled the music listening trends of 2000 teenagers; 1000 male and 1000 female. They were asked to pick their favourite music genre. Our comparison of teenage listening habits is striking.

What music do you listen to? Our survey sampled the music listening trends of 2000 teenagers; 1000 male and 1000 female. They were asked to pick their favourite music genre. Our comparison of teenage listening habits is striking.

What music do you listen to? Our survey sampled the music listening trends of 2000 teenagers; 1000 male and 1000 female. They were asked to pick their favourite music genre. Our comparison of teenage listening habits is striking.

Fonts have been changed to a rough textured style that will appeal to a younger target audience and colours have been tweaked to create eye-catching contrast.

The new title has more punch and a final check confirms that all the essential parts of the graph are in place.

Oh, and the graph has visual impact!

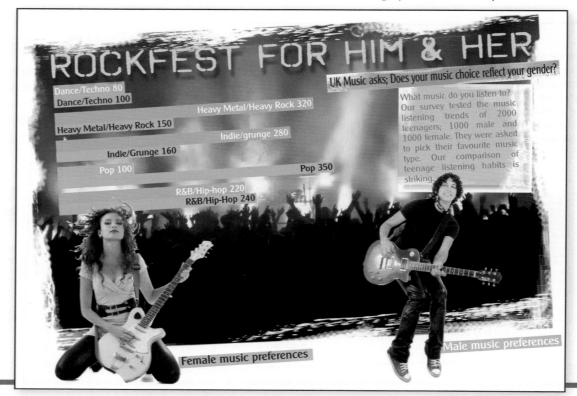

EVALUATION

You do not need to produce a written evaluation for every project. However, an evaluation can be done quickly and you will find it helps you learn about DTP features and design elements and principles: knowledge that you will need for the course exam.

PREPARING YOUR EVALUATION

Copying down the brief and specification will help remind you of the task you were set and enable you to check that you have met each point on the specification and brief.

EVALUATE THE GRAPH FIRST

State which specification points you have met. Read page 151 in this book to ensure your graph has all the component parts in place.

EVALUATE YOUR USE OF DESIGN ELEMENTS AND PRINCIPLES

Evaluate your use of design elements and design principles. Focus on the most important ones and explain how they improve the layout.

EVALUATE YOUR USE OF DTP FEATURES

List the DTP features you have used and explain how they help to improve the layout.

Layout report for my UK Music listening preferences graph

Brief

UK Music magazine require a graph or chart to display the teenage music preferences data supplied. The graph is aimed at their UK Music magazine readers.

- *Survey size:* 2000 teenage music listeners
- *Gender variance:* 1000 males and 1000 females
- *Target audience:* male and female readers of UK Music magazine; age group 16–28 years

Your graph should do the following:
- Name-check UK Music magazine.
- Present the data clearly.
- Distinguish between and compare male and female responses.
- Appeal to our target audience: 16–28 year-old male and female readers.
- Include positive images of young people.
- Include a catchy title.
- Explain the purpose of the graph.
- Create a youthful feel to the layout.

The graph

I think the graph meets the specifications well.

I have chosen the best type of graph to display the figures and make a clear comparison between male and female data.

It includes positive images of young people, name-checks UK Music magazine and has a youthful feel.

The title is catchy, the purpose is explained in the note and all of the important components of a bar graph are in place.

DTP techniques I have used and how they improve my layout

- *Distressing the background* – creates a textured effect that the young target will like. It was simple to do.
- *Font style* – the rough title font has impact and the young readers should connect with it.
- *Combining the bar graphs* – this makes a comparison of the male and female information much easier.
- *Fully cropping figures* – this allowed me to layer backgrounds behind them to create depth. They also personalise the layout and create movement.

Design elements and principles used and how they improve the layout

- *Emphasis* – tilting the graph, the background and text was risky but it makes them stand out more.
- *Colour* – there is strong contrast that adds vibrancy and excitement. Orange contrasts with blue. The green bars on the graph pick out the girl's guitar strap, creating unity.
- *Depth* – there is an obvious foreground and background in the layout and I've emphasised this by layering one part behind the other: the heads of the figures are placed carefully in front of colour fills. It adds depth and impact to the layout.
- *Unity* – the yellow/orange accent colour ties the layout together.

CHAPTER 19

PROJECT | GIZMO

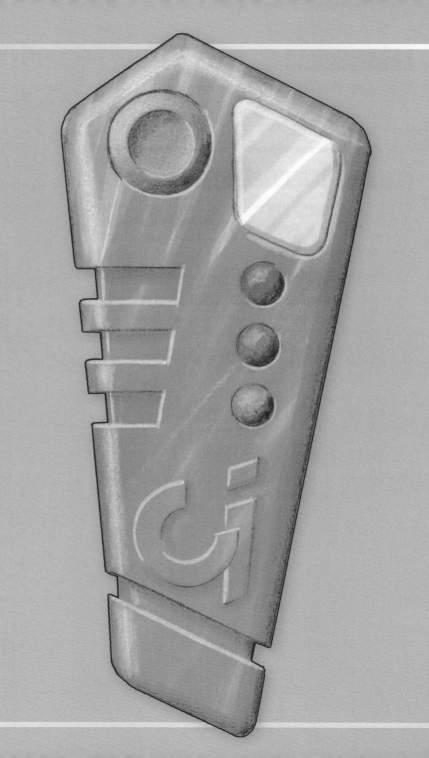

WHAT YOU WILL LEARN

- **Marker pen illustration**
 equipment • skills • technique

- **Preliminary designs**
 ideas • logos • target market

- **Illustration step-by-step**
 applying tone • highlight and shadow • detail

- **Planning a layout**
 thumbnails • elements and principles • DTP features

- **Creating a layout**
 using DTP • visual impact • evaluating

WHY MARKER PENS?

This project will develop your manual skills in 2D illustration using **marker pens** and **rendering pencils**. It will also develop your creativity and your use of DTP when you design a promotional layout.

Most marker pens come in a colour range called the **Pantone matching system**. This is a range of colours, tints and shades that are used in inks, paints, fabrics and plastics, as well as in on-screen colours.

Marker pens are an excellent way to apply colour manually. Designers and illustrators use them extensively because they offer a wide range of pre-mixed colours.

EQUIPMENT

Marker pens come in a range of qualities and costs. The two main types are water-based markers and spirit-based markers. Spirit markers are expensive but offer an excellent quality and colour range.

BLEEDPROOF PAPER AND THE SMUDGE TEST

A high quality, coated paper called **bleedproof paper** is required for the best results. Only one side of the bleedproof paper can be used; the other side is coated to prevent bleed-through and will not absorb ink. Do a **smudge test** to check you are working on the correct side. Make a small mark with the pen in the corner of the paper and rub it with your finger.

No smudge – correct side

Patchy and smudged – wrong side

SKILLS AND KNOWLEDGE

Marker pens are often double ended. The **chisel tip** is used for wide strokes to colour large areas. The **bullet tip** allows detailed work to be done. Sometimes a brush tip is provided for fine work.

Marker pens dry out quickly if the cap is not on correctly: always replace it firmly.

HEALTH AND WELLBEING

Spirit markers give off vapours, so ensure your work area is well ventilated. Make your teacher aware if you have relevant allergies or feel dizzy.

Bullet tip

Chisel tip

BLEEDPROOF PAPER

Marker Pen

Marker Pen

TECHNIQUE

You will use two methods of applying marker ink in this project.

1. Blocking in is colouring an area to achieve a smooth even fill. Keep the pen moving and colour the whole area. If it's patchy you can go over it again.

2. The strike-through method starts at the bottom-right corner of an outline. Work in strokes across and up and going beyond the outline's edges. It leaves a textured surface, ideal for showing reflections on plastics and metals.

In your Assignment and some unit assessments you will work from a brief. This is a short statement that introduces the project or task. Read it carefully and make notes. The brief that introduces this project starts below. Read it and work through the task, creating your own ideas and solutions. Your teacher may tackle it with you in your Graphic Communication class.

THE BRIEF

GIZMO UK is a manufacturer of modern electronics that is expanding its range of small, hand-held, electronic products. It is inviting young designers to submit ideas for these products:

- Golf range finder
- Dictaphone
- Diving depth gauge
- Electronic key-fob
- Personal alarm
- Compact camera
- GPS direction finder
- Torch
- Remote control
- MP3 player
- DAB radio
- Gaming device

DESIGN SPECIFICATION

We are looking for a hand-held design that will catch the imagination of a target market. You will only be designing the body styling of the product. Don't worry about the electronics. We will develop that side of the product in our lab.

Your design should incorporate some of these features:

- modern body styling
- buttons or switches
- some form of grip
- a break-line for battery access
- an embossed logo
- a screen
- an eye-catching colour scheme
- a speaker
- an LED.

PRODUCT AND TARGET MARKET

GIZMO UK requires a modern concept for a new hand-held, electronic product. This proposal is for a portable GPS direction finder.

Remember you must include the following information in your design proposal: target age range and gender, activity the product is designed to support, product name and slogan.

GIZMO DESIGN WORK

Remember, you don't need to worry about the function of the product. You are only styling it and designing with shapes and colours. Try to make your designs look modern and stylish: stick to geometric shapes and avoid 'blob' type shapes.

Keep your design sketches in 2D and freehand: you'll find it easier to explore shapes that way. Try out colour combinations to see which colours work together.

TIPS

Keep the buttons simple; circular if possible. You'll see why on page 160.

GO! ACTIVITY

1. Copy the design proposal, left, remembering to confirm the product you are designing, the target market you are designing for, the product name and the activity it supports.
2. List the features you want to incorporate.
3. Create design concepts for the new product.
4. Produce a rendered image for the design team to work from.
5. Present your design on a promotional poster, including a product name, logo and a marketing slogan.
6. Produce a report on your poster to explain its design.

The example shown here will help you plan your own task.

Gizmo UK requires a modern concept for a new. hand-held digital product.

I have chosen to submit my design for a **PORTABLE GPS DIRECTION FINDER –**

My new design is aimed at the following target market:

Age range – 18 to 40 years
Gender – Male & Female
Product name – COOL-IT GPS
Activity supported – Trekking & Cycling in Remote areas
Slogan – Our motivation is getting you to your destination

LOGO DESIGNS
Cool it Gps

Gizmo design concepts

speaker

logo

too curvy

Rendering with markers is straightforward but it's best to follow this step-by-step guide.

1. MASTER DRAWING

From your chosen design, make an accurate line drawing of your gizmo.

Make sure it's dark enough to trace from, as you will come back to this more than once.

We call this outline the **master drawing**.

2. PENCIL TRACING

Trace the line drawing lightly onto bleedproof paper. Be sure to trace it onto the correct side.

You can use a sketching pencil or a coloured pencil. The colour of marker you intend to use will determine how dark it needs to be.

This one is to be rendered in orange which is quite transparent so the lines will need to be light.

3. STRIKE-THROUGH

Use the **strike-through** method when applying ink. Starting at the bottom-right, move across and up the outline in strokes that extend past the outline.

Don't make it too regular: vary the angles and curve the strokes.

Leaving some gaps and varying the tone creates a reflective texture.

It looks untidy but bear with it.

4. ADDING SHADOW

Assume the light source is shining down from the top left. The edges on the right and bottom will be in shade and will be darker.

Use the chisel tip marker to darken the tone along the bottom and right edges.

Areas in shade, underneath the embossed logo and the break-line, should be darkened with the bullet tip end of your marker. (See the close-up image for reference.)

Darken areas below and to the right of the raised features.

5. ADDING HIGHLIGHTS

Edges facing the top and left should be picked out with a white highlighter pencil.

Use a ruler on straight edges.

Highlights can be placed directly onto sharp edges. Where the edge is rounded (like the outline edges) keep the white highlight back from the edge. (See the close-up image for reference.)

Keep the highlight back from a rounded edge.

6. HIGH AND LOW LIGHTS

Using a black low-lighter pencil, add shadow to the edges right and bottom.

Blend out the highlights and shadows on rounded edges.

- Take care not to over-do the black shadows.
- The highlights though, should be bold.

You may need to trace from the master drawing if you can't see your outlines.

7. BUTTONS

Block-in your chosen colours onto sticky labels. Leave them on the pad when you do this.

Use colours that contrast with the body colour so that they stand out.

Peel them and position them carefully on the gizmo.

8. SCREENS

a. A screen is not difficult to create if you use a sticky label.

Draw the outline accurately and in pencil on a sticky label.

b. Choose a pale marker pen: green, grey or blue and strike-through at an angle. Leave a gap or two to simulate reflections.

c. To make the screen appear raised, use the bullet tip on the bottom and right edges. Add highlights to the top and left edges.

It is ready to cut out and stick in place.

This page shows how to render two types of button: convex and concave.

The techniques are simple. Try them and experiment with buttons that you design yourself.

CONVEX (DOMED) BUTTON

1. Your blocked-in button should look like this and have an even, flat tone.

2. Add a white pencil highlight to the top left. Keep back from the edge.

3. Add shadow to the bottom-right. It should be darkest at the bottom-right rim.

4. Extend both light and dark tones to meet. Fade them out as they come together.

5. Add a white line and a black line to the body around the button. These represent the hole made for the button on the gizmo.

CONCAVE BUTTON

1. A flat, even tone is also the starting point for a raised and concave button.

2. Using a circle template or a coin add a light and a dark rim inside the button.

3. Add a white highlight and dark shadow inside the circle. Ensure they fade as they come together.

4. The tones are reversed on the outside of the circle. It should now represent a conical button with a concave centre.

5. Add a white line and a black line to the body around the button to represent the hole made for the button on the gizmo.

PROJECT | GIZMO

161

CROPPING

The illustration is ready to be cut out or cropped. There are three ways to prepare your illustration for use in a promotional graphic:

1. Manually cut out the illustration with a craft knife and cutting mat and paste it directly onto a prepared layout.

2. Cut out the illustration manually, paste it onto plain white paper and scan it into a DTP file.

3. Scan the illustration including the strike-through marker lines and crop it fully with DTP software.

FULLY CROPPED ILLUSTRATION

Option 3, full cropping, was used on this gizmo.

The electronic methods allow the gizmo to be scaled in the promotional layout.

If you are cutting the illustration manually, do it carefully: this is often the point at which good work is spoiled.

Use a craft knife, safety rule and a cutting mat to trim straight lines and sharp scissors for curves.

Note how some features are more defined when the illustration is cut out.

The shape has more impact and the edge details, like the break-line and grip notches, provide detail and sharpness, especially against a plain or simple background.

Try to ensure your gizmo has similar eye-catching features.

PROMOTIONAL LAYOUT

Once your illustration is finished, you can start thinking about your promotional layout. Sourcing pictures or designs to use in the backdrop can place your gizmo in context. Source a selection of high quality images that you think may work with your gizmo. This gizmo is orange so images that contain green or blue will create contrast and ensure that the gizmo stands out.

This gizmo is a GPS system for use in remote countryside so images that reflect this may help promote the product. Abstract backdrops may also promote the advanced technology of the gizmo and you have the option to design your own backdrop using colour fills and shapes.

THUMBNAIL LAYOUTS

Preliminary designs for promotional layouts are called thumbnails. Create four thumbnail layouts: two landscape and two portrait. Two of these should contain sourced backdrops and in two you shoule create your own backdrops.

Include your gizmo illustration and the backdrops you have chosen to create exciting layouts. You should consider what can be done with design elements and principles and the DTP features learned earlier in this book.

Thumbnail 1

Flow text connects the gizmo with the trekker

Cropped Gizmo makes the shape stand out

Transparency to make text visible

Dramatic scenery puts the gizmo in an outdoor context

OUR MOTIVATION IS TO GETTING YOU TO YOUR DESTINATION

THE NEW GPS DIRECTION FINDER FROM GIZMO.UK.COM

COOL it GPS DIRECTION FINDER

Accent colour purple to unify with purple button

Purple harmonises with the button

Sweeping curves suggests movement

Orange line against purple helps product details to stand out

Text wrap connects the slogan with the Gizmo

Thumbnail 2

My own backdrop design, simple and sharp

The graded fill is subtle and pushes the Gizmo forward

Line separates text and adds depth

COOL it GPS

OUR MOTIVATION IS TO GET YOU SAFELY TO YOUR DESTINATION

A NEW PRODUCT FROM GIZMO.CO.UK.

Thumbnail 3

Curved lines and circles to contrast with the rectangular shapes and the geometric Gizmo

OUR MOTIVATION IS GETTING YOU TO YOUR DESTINATION

COOL it GPS

FROM GIZMO.UK

Orange Gizmo should be dominant against a blue backdrop

The large trekker figure sets the outdoor theme

Thumbnail 4

Purple transparency makes a formal rectangular structure

Text may be too cramped It doesn't lead the eye to the GPS

GIZMO COOLit GPS DIRECTION FINDER

May need to make Gizmo bigger to create dominance

Three bold colours add impact but may be too dominant

I'm going to take thumbnails 1 & 2 forward to develop into first drafts. I like the simplicity of layout 2 and the background on thumbnail 1 should push the orange Gizmo forward.

DTP CHECKLIST

cropping		drop shadow	
bleed		transparency	
flow text		rotate	
colour fill		text wrap	
reverse			

ELEMENTS AND PRINCIPLES CHECKLIST

alignment		depth	
balance		line	
colour		shape	
dominance		unity	

FIRST DRAFT DTP LAYOUTS

DRAFT DTP LAYOUTS

DTP layouts can be put together and edited very quickly. Layouts 1 and 2 were chosen and produced as **first drafts**.

Try designing two layouts yourself, one using an image and the other with a backdrop you have created.

Once the draft layouts are prepared, view them on-screen as a print preview or PDF file to see how they will look when printed. This will help you to evaluate your drafts and begin your final promotional layout.

Evaluation of draft layouts

Layout 1: I like the flow text and the reverse text. It leads the eye from the gizmo to the figure.

The figure personalises the advert and should appeal to the target market.

I'm not sure about the white margins and may try a colour. Using a portrait layout may help.

Layout 2: The curves work well without dominating the layout. It's simple but not striking. Maybe it needs more contrast.

The blue makes a strong contrast with orange but against a white background it's a bit bland.

"IDEA BY SELF IS COLD. JUST SIT THERE, DO NOTHING. IF WANT DO SOMETHING, NEED FIRE."

Fakegrimlock

Draft layout 1

Draft layout 2

The final layout has depth, contrast, unity and dominance. It displays the gizmo effectively and the well-chosen background graphic should connect with the target market.

The choice of font supports the modern product and the flow created by the slogan leads the eye and suggests movement. The colour choices create unity and excitement at the same time, and the strong alignment gives the layout a sharp and organised look.

EVALUATION OF FINAL LAYOUT

WHY EVALUATE YOUR LAYOUT?

The evaluation of your final promotional layout is very important. If the final layout brings your ideas together in a great promotion, your evaluation should let everyone know exactly how it works and why it is exciting. Preparing an evaluation will also help reinforce your knowledge of design elements and principles and DTP features: knowledge you will need for your N5 course exam.

Follow the evaluation structure on this page, carry out each of the steps and let everyone know how good your layout is and why it works so well.

PREPARING YOUR EVALUATION

1. Write down the brief: it's easier to check that you have met it if it's written in the evaluation.

2. Screen capture the layout and include it in your evaluation.

3. List the DTP features you have used and state how they improve the layout.

4. List the design elements and principles you have used and state how they improve the layout.

5. Write a conclusion that describes why you are pleased with the layout and how it connects with the target market.

PROMOTIONAL LAYOUT

Gizmo layout Report

Brief: Design a portable GPS Direction finder for use in remote areas. Illustrate the new design and create a promotional layout for use in magazines.

Target Market: both genders, ages 18–50. Their activities include: walking trekking cycling, skiing, mountain biking and climbing.

DTP Features I have used and how they improve my layout:

- Fully cropped illustration – this gives the shape of the gizmo more impact and allowed me to layer backgrounds behind it to create depth.
- Transparency – the transparent colour fill connects the backdrop and the bottom margin and allows the text and logo to stand out.
- Flow text along a path – it leads the eye from the gizmo to the trekker and suggests movement, but it also emphasises the gizmo by underlining it.
- Reverse text – the reverse text adds contrast and ensures there is not too much black in the layout.
- Bleed – the bleeds help create a stronger layout without a margin. It suggests freedom and space: important to the target market.

COOL i.t. – GPS Direction Finder

Getting you to your destination is our motivation

The new GPS Direction Finder from GizmoUK.com

Design elements and principles used and how they improve the layout:

- Alignment – the product name aligns with the orange line and slogan. The transparency also aligns carefully. It creates a clean, sharp, organised layout.
- Line – the orange lines help separate sections and emphasise the product and company names. They also make it look more formal and connect parts of the layout horizontally.
- Colour – orange is my accent colour. It is used in different areas and unifies the layout. The blue colours in the backdrop contrast with orange and are receding colours. They give the impression of distance while pushing the gizmo forward to establish dominance.
- Balance – I positioned the gizmo off-centre to create an asymmetric balance and leave a useable space and to use the focus points in the rule of thirds. It also gives the rugged scenery room to breathe.

Conclusion

I am really pleased with this layout. It promotes the product and the rugged outdoor scene should make a positive impression on the target market.

CHAPTER 20

PROJECT 1
SPORTS BOTTLE

WHAT YOU WILL LEARN

- **Pictorial sketching**
 form • proportion • line quality • detail

- **Pencil rendering techniques**
 tone • contrast • highlights • shadow • texture

- **3D CAD modelling**
 modelling plan • revolving • shelling • assembly

- **Production drawings**
 assemblies • component drawings •
 dimensioning • applying drawing standards

- **Planning and creating a layout**
 draft layouts: elements and principles • using
 DTP features • visual impact • evaluating

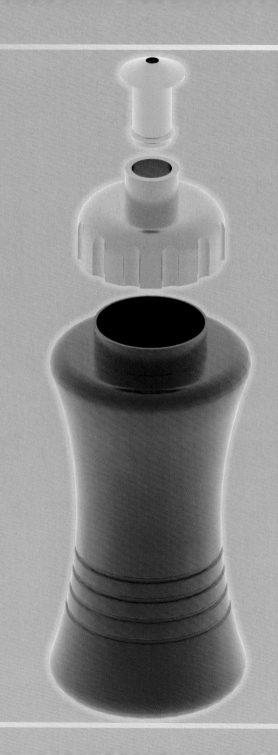

SETTING THE SCENE

THE BRIEF

A plastic drinks bottle is to be designed for use by young, female sports players.

The bottle has three parts: a body, a cap and a drinking spout. The basic dimensions are shown on the preliminary design sketches, right.

SPECIFICATION

The bottle should:
• incorporate the three parts shown
• be based on geometric forms
• have a product name or logo clearly visible
• appeal to the target market
• include some form of grip.

GO! ACTIVITY

1. Re-style the shape of the bottle but try to stay close to the existing proportions.
2. Create an exciting colour scheme and logo.
3. Draw or sketch a pictorial view of the bottle.
4. Illustrate the pictorial view using coloured pencils.
5. Develop preliminary sketches including a modelling plan.
6. Construct a 3D CAD model of the parts.
7. Assemble the parts.

8. Create dimensioned production drawings and an assembly drawing.
9. Create a CAD illustration of the bottle in a simple 3D scene.
10. Display the bottle in a contemporary promotional layout.
11. Evaluate your promotional layout.

SPORTS BOTTLE

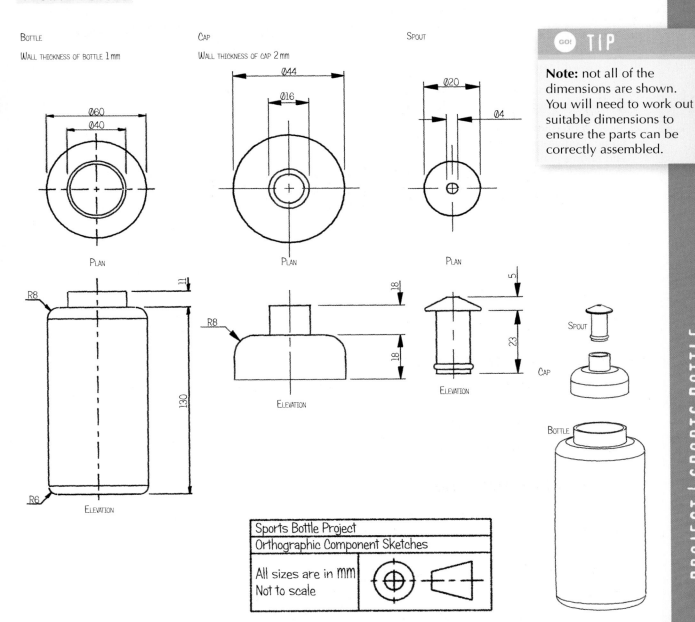

CREATING DESIGN IDEAS

Prepare ideas for your bottle design. Take care to ensure that the designs are not too complicated, as you are going to render it in colour and build it as a 3D CAD model. In addition to this, write down any information that helps with your design work. For example:

1. Decide who your target audience is: age, gender and interests.

2. Select a product name and a company name. Remember your target audience and choose a name that is likely to appeal to them.

3. Design a logo: keep it simple and bold.

4. Select themes that you might want to get across to your target market.

5. Sketch your ideas in 2D, which is the best way to create new design ideas.

6. Try out colour schemes and the logo on your designs. See pages 142–145 for advice on colour and colour combinations.

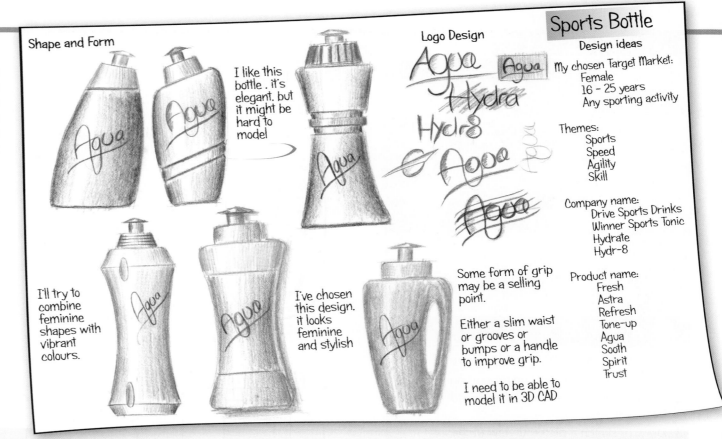

Shape and Form

Logo Design

Sports Bottle

I like this bottle. it's elegant. but it might be hard to model

I'll try to combine feminine shapes with vibrant colours.

I've chosen this design. it looks feminine and stylish

Some form of grip may be a selling point.

Either a slim waist or grooves or bumps or a handle to improve grip.

I need to be able to model it in 3D CAD

Design ideas

My chosen Target Market:
Female
16 – 25 years
Any sporting activity

Themes:
Sports
Speed
Agility
Skill

Company name:
Drive Sports Drinks
Winner Sports Tonic
Hydrate
Hydr-8

Product name:
Fresh
Astra
Refresh
Tone-up
Agua
Sooth
Spirit
Trust

SKETCHING YOUR BOTTLE

You can sketch a pictorial outline of your bottle or draw one. Sketching the bottle will demonstrate your sketching skills and it is excellent practice. You can never do too much sketching.

Follow the guide here to sketch an outline of your own bottle.

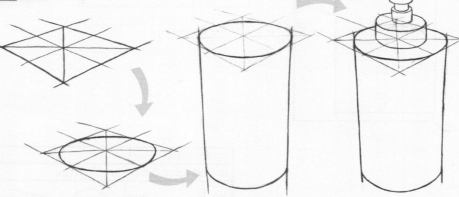
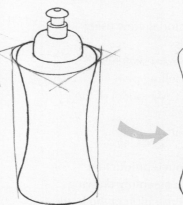
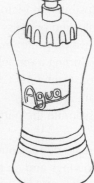

Construct and sketch a perspective circle.

Sketch verticals and add the curve at the bottom to create a cylinder.

Add the cap and drinking spout.

Round the shoulders and sketch out the body shape.

Add detail including grip features and logo.

RENDERING YOUR BOTTLE

COLOURED OUTLINE

In this part of the task, you can demonstrate your manual illustration skills.

You need a coloured outline to render. Carefully trace the outline of your bottle in colour.

The bottle shown here is more complex than you will need to produce to achieve the unit assessment, but it will help develop important skills. It's worth setting the bar high and giving yourself a challenge in your unit work.

ADDING TONE

Render the flat surfaces first on the top of the bottle and cap.

Work from dark to light on curved surfaces, leaving a highlight to the left of centre and on the top shoulder of the bottle. The challenge is to blend tones towards these highlights.

Don't add the darkest tones straight away: build them up gradually.

DETAIL AND CONTRAST

Adding detail can lift the illustration by creating realism and contrast.

Contrasting colours are an obvious feature but try to create tonal contrast by making dark tones really dark and leaving crisp highlights. This emphasises the 3D form and creates visual impact.

Make dark tones as dark as you can

Leave crisp highlights

PICTORIAL SKETCHING

The pictorial sketches you produce when you create your bottle will be used in your pictorial sketching assessment. Be sure to submit sketches that show your construction work.

The rendered bottle and any of your practice illustrations can be used in assessment. Show a combination of flat tone and graded tone and ensure that you have applied highlights and shadows consistently.

Render flat surfaces first

Leave highlights on rounded edges

Dark and light tones close together create contrast.

Build graded tone gradually, working from dark towards the highlight

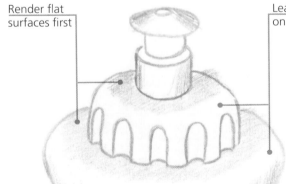

Shadows emphasise the 3D form

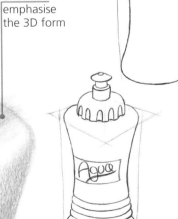

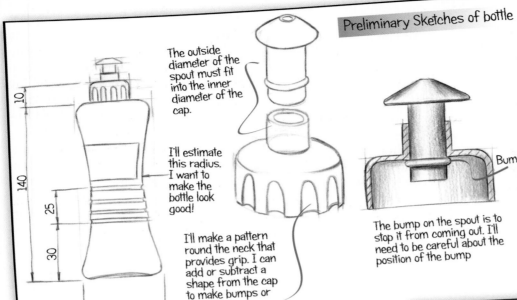

Preliminary Sketches of bottle

The outside diameter of the spout must fit into the inner diameter of the cap.

I'll estimate this radius. I want to make the bottle look good!

I'll make a pattern round the neck that provides grip. I can add or subtract a shape from the cap to make bumps or grooves

The bump on the spout is to stop it from coming out. I'll need to be careful about the position of the bump

Bump

Preliminary graphics give you an opportunity to showcase your sketching skills. You will need to include enough information so that you can model each of the components.

The types of preliminary graphics you produce is up to you. Have a look at the sketches on this page: they are 2D and pictorial, some have dimensions and some are rendered. Both sheets include preliminary graphics but one is called a modelling plan.

As long as you can demonstrate that there is enough detail to enable 3D models to be built, you will pass your assessments.

GO! ACTIVITY

1. The modelling plan below does not include assembly details. Using a pencil and paper, create an assembly plan. Make sure you specify which surfaces you will select and which constraints you will apply. Create clear annotated sketches.

Preparing a **modelling plan** is important as it will:

- develop your planning and problem-solving skills
- improve your knowledge of 3D CAD modelling
- help make the 3D CAD modelling easier
- help prepare you for questions in the course exam
- improve your sketching skills.

When you prepare a modelling plan try to sketch your plan rather than draw it. Make sure your dimensions are accurate and use a combination of 2D and pictorial sketches.

Remember to use British Standards Conventions and Symbols.

Add annotations to explain the following:

- Which **workplanes** you will use.
- When you need to create a **new sketch**.
- When you will **subtract** or **add** material.
- Which modelling method to use: **extrude** or **revolve**?

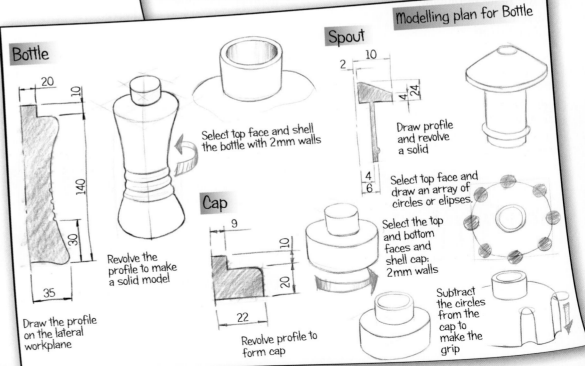

Modelling plan for Bottle

Bottle

Select top face and shell the bottle with 2mm walls

Revolve the profile to make a solid model

Draw the profile on the lateral workplane

Spout

Draw profile and revolve a solid

Select top face and draw an array of circles or elipses.

Select the top and bottom faces and shell cap: 2mm walls

Cap

Revolve profile to form cap

Subtract the circles from the cap to make the grip

CREATING THE BOTTLE

DRAW THE PROFILE

As the bottle is cylindrical, the most effective technique to use is **revolve**.

Draw the profile on the front workplane, using the dimensions you sketched in your preliminary graphics.

REVOLVE INTO A BOTTLE

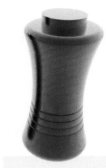

Select the centre line as the axis to rotate the profile around.

In this example, the shoulders have not been rounded yet. It is sometimes easier to draw profiles without radii and use the fillet tool afterwards.

FILLET EDGES

The sharp edges of the bottle are removed by using the fillet edge feature.

SHELL THE BOTTLE

Select the top face and use the shell feature to make the bottle hollow and remove the top face. Set the wall thickness to 2mm.

If you are confident, you may want to use the helix command to create a cosmetic thread on the bottle. See pages 85 and 87 for help with creating a helix.

Save this component part and create a new file for the cap and the spout. It is good practice to name the file with the prefix 'PRT' so you remember it is a component part and not an assembly.

CREATING THE CAP

The cap for the bottle is also created using a revolve feature. The cap must fit the neck of the bottle and be large enough for the spout. Use your dimensions from the preliminary planning page.

Select the centre line as the axis to rotate the profile around.

The top edge of the cap needs a fillet feature to remove the sharp edge

The grip has been added by arraying a circle around the outside edge of the cap.

Array a circle around the base of the cap. The circle should cut into the cap. Take care not to cut the flutes too deep.

Select the top and bottom face and use the shell solid tool to make the model hollow and create a hole through the cap.

CREATING THE SPOUT

The spout also uses the revolve feature. Use dimensions from the preliminary sketches and your modelling plan.

Revolve around the centre axis.

Note that the centre axis is offset from the profile. This allows you to create a cylindrical component with a hole.

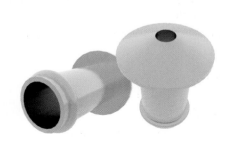

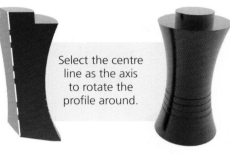

Assembling 3D models is an important process: if you do it correctly you can easily create a wide range of assembly drawings later on.

Learn to use your 3D CAD assembly constraints; you will need them in your Course Assignment and exam.

Begin an assembly file within your 3D CAD software and load all three components.

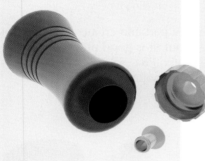

Rotate the bottle component so it stands vertically.

Lock or fix the component so it doesn't move.

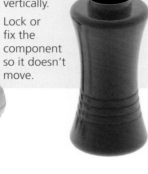

Select both the cap and the bottle and use the centre axis command. This will allow you to align both cylindrical components.

Again, use the centre axis command to align the spout to the hole in the cap.

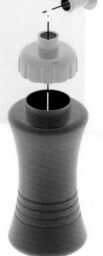

Select the top surface of the bottle and the bottom surface of the cap and use the 'Mate' command to join both components together.

Use the mate command to place the spout in the open or closed position.

Exploded drawings are used to show how components assemble. Save a copy of your bottle assembly as an **exploded view**. This will allow you to create exploded pictorial and orthographic drawings.

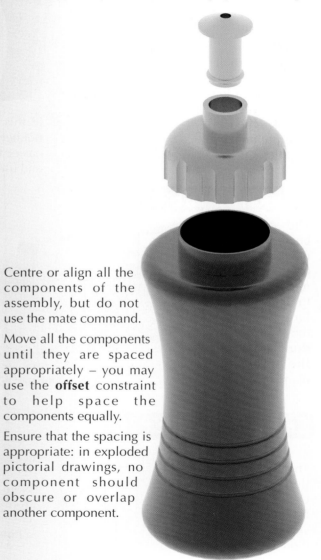

Centre or align all the components of the assembly, but do not use the mate command.

Move all the components until they are spaced appropriately – you may use the **offset** constraint to help space the components equally.

Ensure that the spacing is appropriate: in exploded pictorial drawings, no component should obscure or overlap another component.

CREATING A MINI ENVIRONMENT OR SCENE

Creating a promotional layout can be done with your manually rendered bottle or your CAD version.

You need to produce a 3D mini environment or scene to display your CAD model in.

Your environment should add to the visual impact of your presentation graphic. You should make use of colour, tone, material, light and shadow.

Keep it simple!

Keep your scenes simple. What may appear like a good idea initially, can end up being confusing. In the example above, a scene was created with two walls and a base. When rendered, there were too many reflections that detracted from the visual impact of the illustration.

Render your image at a high resolution, otherwise it will lose its visual impact when you import it into your DTP software. See page 127.

Your teacher will show you how to set your visualisation software to a high resolution.

Low resolution

High resolution

ADDING GRAPHICS TO YOUR 3D MODEL

There are several ways to add surface graphics to your 3D model.

The simplest way is to create the graphics –in this case the Agua logo – in a DTP program and paste it to the surface. The sequence below shows how this can be done. Applying surface detail like this adds complexity to your 3D CAD.

Draw a shape to use as a label. Contour it to the shape you need.

Carefully wrap it in place and apply a gradient fill.

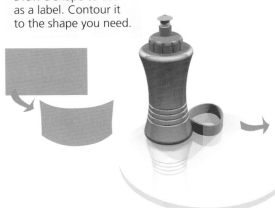

Select a suitable font style and adjust to fit the label. Text can flow along a path or be curved to fit a curved surface.

The underline adds emphasis and detail.

Careful adjusting will help it wrap to the surface correctly and to look realistic.

Your 3D CAD software will allow you to create production drawings. However, all 3D CAD drawings require you to edit and present features properly and clearly. Ensure your drawings are presented using the correct drawing standards.

Your assembly drawing normally omits dimensions, but shows how all the components are combined.

Always show centre lines when your drawing has cylindrical components.

Enlarged views can be a simple way of presenting small or detailed features. Always title your enlarged view and include the scale of the magnification.

Label components of the assembled pictorial view.

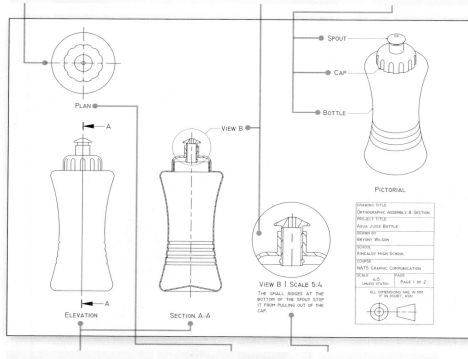

You must title each view. Titles are positioned under each drawing.

Keep all your titles aligned. This makes your drawing easier to read.

Add descriptive text about the drawing.

Producing a sectional elevation using 3D CAD software is often simple. Learning to do this in your unit task will make you more confident for the Course Assignment and the Higher course. Your teacher will show you how to create a sectional view with your 3D CAD software.

CLARITY IS KING!

Component drawings should be fully dimensioned to support manufacture. Drawings need to be clear to the reader. Use a sensible typeface for titles and keep plenty of white space between views and components. Keep all your text to a sensible size and font. 'Technic', 3mm is ideal for titles: TITLE $\frac{1}{3}$

An exploded pictorial view will show how your model assembles. You will need to create a new assembly of your 3D model, with all components aligned or centred, but not mated together. You do not need to do this to pass the unit, but it is a valuable skill for your Course Assignment.

Keep all dimensions aligned. Use the correct dimension type.

Title each component

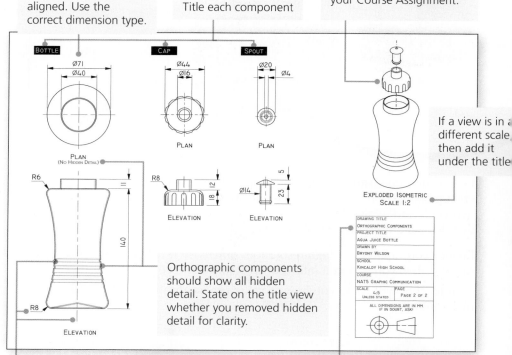

If a view is in a different scale, then add it under the title

Orthographic components should show all hidden detail. State on the title view whether you removed hidden detail for clarity.

Always use the correct line type and weight:

——————— Outlines (1pt)

— — — — Hidden detail (0.5pt)

——————— Leader lines (0.5pt)

— · — · — Centre lines (0.5pt)

◄———————► Dimension (0.5pt)

Your title box is an essential part of your drawing. Include details such as:

- drawing title
- project title
- your name
- your school
- course name
- drawing scale
- pages

- dimensions in millimetres
- third angle projection symbol
- date completed

PROMOTIONAL LAYOUT

RESEARCH

The bottle is being promoted to a target market of young, sporty females. Source positive images likely to appeal to the target market. It will make the design of the promotional layout easier.

3D PRELIMINARY LAYOUTS

The preliminary layouts in this project can be created directly on the computer. There is no need for annotated thumbnails or visuals but you still need to select your preferred layout.

The brief states that the promotion should be modern and targeted towards a young, sporty female market. Select two of your sourced images and create preliminary DTP layouts.

Don't forget to use design elements and principles and the DTP features you have learned to create exciting layouts that meet the brief.

SELECTING YOUR PREFERRED LAYOUT

Print both draft versions and keep them safe for assessment. These will replace thumbnail designs in this project.

Evaluate these layouts before deciding which one to develop further. Get a second opinion if you need one: it's always good to listen to another opinion about your work.

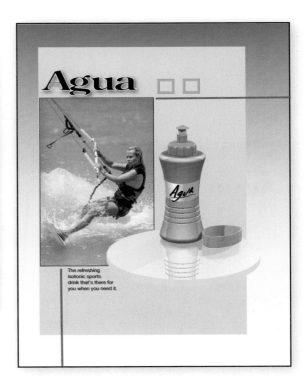

Don't settle for one of your initial layouts. Choose the one you prefer and fine-tune by making small adjustments to the position, size or colour of the content.

Develop the layout until it promotes the bottle in a positive way to a young, sporty, female target market.

Final layout

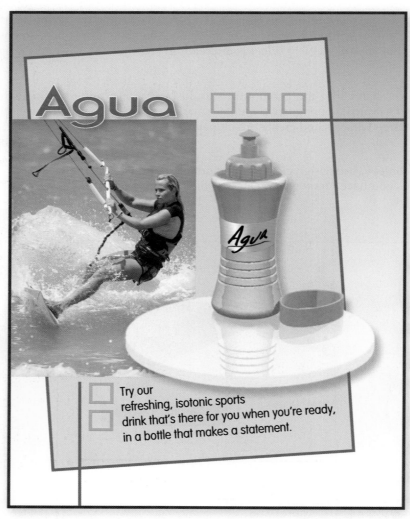

Draft layout

LAYOUT REPORT

Your layout report should explain how you used **design elements and principles** to improve your layout.

It should also explain how you used **DTP features.** Covering these two areas will help you pass the unit assessments and prepare you for the course exam.

LAYOUT REPORT

Agua Drinks Bottle

The draft layout I selected was good but the final layout benefits from several improvements:

- The new bottle is bigger and more dominant.
- The bottle is fully cropped and the curves stand out in the rectangular layout.
- Layering and positioning the glass table and the letter 'g' carefully gives depth and unity.
- The orange squares are colour-matched to the orange drinking spout to create unity.
- The tilted box is eye-catching and adds contrast.
- The image bleed is modern and gives an eye-catching, asymmetric balance.
- Text wrap connects the text with the bottle

The layout is modern looking and shows an active female in a positive sports activity. The purple and orange colours are contrasting and the reflection of the bottle gives depth and a glossy texture. The blue background is receding and gives the impression of distance. The advancing orange colours are pushed forward and stand out well.

PROJECT I
PHYSICAL
MODELLING

WHAT YOU WILL LEARN

- **Designing a 3D physical model**
 equipment • idea generation • function

- **Making the model**
 equipment • modelling skills • use of DTP • CAD/CAM

- **Preparing a design proposal**
 target market • visual impact

Designing and making a 3D card model allows you to use the graphics skills you have developed, particularly your experience of geometry and surface developments. You don't need to make a model for your unit work, but it may be required in the Course Assignment so it's best to get experience now.

THE BRIEF AND SPECIFICATION

The local council in your area is opening a juice bar for youths. Sample images are shown below. Young people are asked to get involved in the design and decoration. One of the products they want to have is a table-talker: a cheap, recyclable, temporary object that stimulates conversation at the table or bar. In this case the stimulus could be about any one of the following topics:

- healthy eating
- the dangers of drugs
- where to find emotional and relationship support
- leading an active lifestyle
- dealing with bullying
- enjoying sports

DESIGN SPECIFICATION

Your table-talker should:
- promote awareness of one of the topics listed in the brief
- promote a juice bar name of your choice
- be made from recyclable card
- present a positive message to cafe users
- sit on a table or bar or fix to a wall
- have an interesting geometric design
- have a secondary function of your choice

Your task is to design and create a table-talker that promotes one of the above conversation topics and meets the design specification. Please submit your idea as a full design proposal.

RESEARCH AND IDEAS

Design work begins by ensuring that you have a copy of the brief and specification. This will provide a reference point and checklist as your design develops.

Your next task is to sketch ideas for the table-talker and think of a name for the juice bar.

Keep your sketches simple: think of the display surfaces but don't add surface detail.

Annotations will help explain your thoughts.

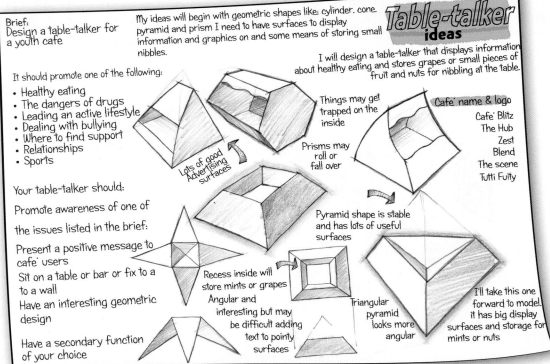

Brief:
Design a table-talker for a youth cafe

It should promote one of the following:
- Healthy eating
- The dangers of drugs
- Leading an active lifestyle
- Dealing with bullying
- Where to find support
- Relationships
- Sports

Your table-talker should:
Promote awareness of one of the issues listed in the brief:
Present a positive message to cafe users
Sit on a table or bar or fix to a wall
Have an interesting geometric design
Have a secondary function of your choice

Table-talker ideas

My ideas will begin with geometric shapes like: cylinder, cone, pyramid and prism I need to have surfaces to display information and graphics on and some means of storing small nibbles.

I will design a table-talker that displays information about healthy eating and stores grapes or small pieces of fruit and nuts for nibbling at the table.

Lots of good Advertising surfaces

Things may get trapped on the inside

Prisms may roll or fall over

Pyramid shape is stable and has lots of useful surfaces

Recess inside will store mints or grapes
Angular and interesting but may be difficult adding text to pointy surfaces

Triangular pyramid looks more angular

I'll take this one forward to model. It has big display surfaces and storage for mints or nuts

Cafe name & logo
Cafe Blitz
The Hub
Zest
Blend
The scene
Tutti Fuity

CAFE INTERIOR

PROJECT | PHYSICAL MODELLING

Modelling requires equipment as well as skills. It is important that you use the equipment correctly. Here are some of the tools you will use. Your teacher will show you the safe and correct method for using each item.

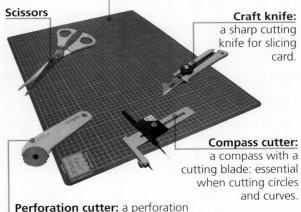

Scissors

Cutting mat: Essential to protect your desk when cutting paper or card. Always cut on a cutting mat.

Craft knife: a sharp cutting knife for slicing card.

Compass cutter: a compass with a cutting blade: essential when cutting circles and curves.

Perforation cutter: a perforation cutter will crease a line on card to give a sharp neat fold.

Safety rule: the safety rule is essential to prevent the sharp craft knife from jumping on to your finger.

Guillotine: trims sheets of paper and card.

Your initial ideas can be developed in two ways:

1. modelling your idea directly by making a maquette (a design model in card)

2. modelling your initial idea using 3D CAD before making a maquette.

Both methods will allow you to test and evaluate your initial idea before developing it into a working solution.

This example uses the CAD method. It allows quick 3D modelling of the table-talker, which can be exported to a package that produces a surface development of the model.

FIRST CAD MODEL

The first CAD model, right, was created by extrusion. Three extrusions were used in total.

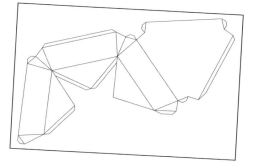

FIRST SURFACE DEVELOPMENT

The CAD model was exported to a program called 'Pepakura', which generates a surface development from the CAD model.

The surface development is printed on card and cut, folded and glued. This tests the model to make sure it assembles and does the job it is designed for.

Assembling the card model will help you work out the complexities of the process and help you plan improvements.

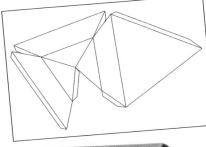

DESIGN DEVELOPMENT CAD MODEL

Don't settle for your first idea. This is when you need to work hard to make the model the best it can be. So, a quick evaluation has led to improvements to this design. It now includes corner folds that add visual interest.

SECOND SURFACE DEVELOPMENT

Export to Pepakura to produce the second surface development.

CUT AND ASSEMBLE

Print, cut and build the model.

Check that it meets the spec and that it provides suitable areas for display. The model is now ready to take surface detail.

PROJECT | PHYSICAL MODELLING

179

DESIGNING THE GRAPHICS AND TEXT LAYOUT

Graphic layouts can be designed manually on paper or on screen with DTP software. The option is yours – you can even do a bit of both!

The example here starts with work on paper using coloured pencils but quickly moves onto DTP layouts. The beauty of on-screen design work is that it is easy to try different colour schemes and font styles.

THE MESSAGE

The message of this table-talker is to encourage young people to lead a healthy lifestyle. The message must be positive and fun in order to engage the target audience.

First make some notes of the text you want to include. On a table-talker, the text can be simple to create impact or can be more complex to give detailed information.

Search for suitable images and figures and prepare your text.

A catchy slogan will help to get the message across. More detailed information, like contact details, will help young people to access local clubs and activities.

SOURCE IMAGES

Using simple images can help increase the visual impact of this table-talker, but you may also want to look for more detailed or background images.

Table-talker preliminary designs

I'm trying Zesty colours: green & orange to create a mouth watering combination.

Slogans:
Active for Life.
Active for Health.
Active in spirit
Zest Juice bar says stay active for a healthy life

Backgrounds will be colour fills to give impact and to keep the Layout and graphics simple

I'll try simple silhouettes to give the images impact.

Information:
www.liveactive.com
A list of locally available sports clubs & activities

Images :
Keep them simple by using shapes and silhouettes.

EDIT YOUR IMAGES

Select the images you feel will be most useful and edit them ready for use on your table-talker. In this case the silhouettes had to be fully cropped. They can be traced using the **auto-trace** feature and the colour fill can be changed or removed to suit the colour scheme.

FINE TUNING YOUR DTP LAYOUT

Once your colour fills are applied on-screen and your images and text are placed, you can start fine tuning.

The first draft layout is a faithful rendering of one of the preliminary designs.

The final layout uses a colour scheme and layout that is simple and has impact. The fonts have an informal style that will engage a younger target audience and the colours have been tweaked to be eye-catching and appealing. The images had a colour change and a white outline was added for impact.

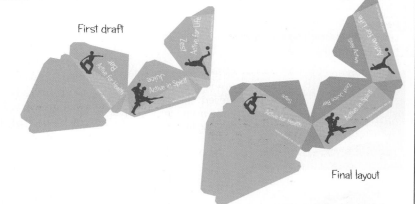

First draft

Final layout

CUTTING AND ASSEMBLY

Your model is ready to assemble. Cut it carefully. Use a safety rule with a cutting mat and craft knife for straight cuts and scissors for curves. You may find that double-sided tape is more effective than glue to fix the assembly.

While your unit work does not require that you make a physical model, making one will help prepare you in case you are asked to design and make one in the Course Assignment. It is also a useful way of passing unit assessments. The design proposal is a DTP layout that can be used in both 2D and 3D units.

The table-talker enables you to make good use of your graphic skills, particularly surface developments and CAD modelling to produce a real 3D product.

The brief asks for a full design proposal to be created and submitted for approval.

This involves photographing your model and displaying it to good effect in a layout. You will use of DTP features and design elements and principles in your layout. The design proposal should identify the design features of the table-talker and sell the idea to your client.

DESIGN PROPOSAL

Follow the guide here and use your skills and knowledge of DTP and design elements and principles to produce an exciting design proposal.

1. Photograph your table-talker from several angles.

2. Source and crop your images.

3. Prepare your text: include some extended text.

4. Produce thumbnail layouts: use your knowledge of design elements and principles (see pages 131–141).

5. Prepare a first draft of your preferred layout.

6. Fine-tune your layout to create a design proposal that sells the concept and explains its benefits.

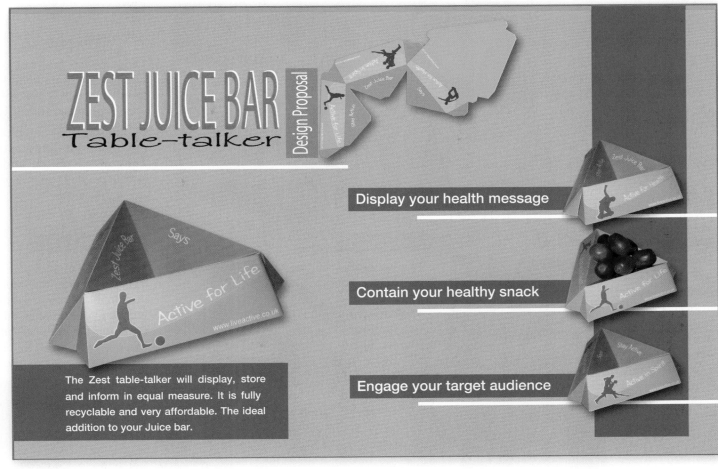

ZEST JUICE BAR
Table-talker

Design Proposal

Zest Juice Bar Says

Active for Life

www.liveactive.co.uk

Display your health message

Contain your healthy snack

Engage your target audience

The Zest table-talker will display, store and inform in equal measure. It is fully recyclable and very affordable. The ideal addition to your Juice bar.

3D MODELLING TIPS AND HINTS

DESIGN TIPS

There is a knack to designing and making 3D models: it requires skill and planning. In this course you won't have time to practise again and again but you can use techniques that will make success more likely.

Here are a few tips to help you:

- Designing curved edges onto your model can increase its strength and make it eye-catching.
- Giving your model an odd number of sides can give the structure greater strength.
- Try basing your designs on prisms and pyramids: they are stronger than cylinders and cones.

The maquettes (design models) and table-talkers here were all designed and made by Graphic Communication students.

CNC EQUIPMENT

Modern CNC (computer controlled) machines can be very useful when cutting your surface development.

LASER CUTTER

The laser cutter takes commands from a 2D CAD file and follows the profile of a 2D drawing. It uses a laser to cut the shape from sheet material, such as card or plastics. It can also be set to engrave fold lines so that folds are clean and crisp.

PLOTTER CUTTER

Drum plotters can often be modified to carry a cutting knife instead of a pen. The result is a plotter that will cut shapes from card or sticky back vinyl.

Both laser cutter and plotters are now common in industry and in schools. They are accurate and quick and produce a high-quality product.

CUTTING AND FOLDING TIPS

If your model is to be cut manually you should use a craft knife, safety rule and cutting mat. When you are cutting, try to cover the area you are keeping with your safety rule. It can prevent costly slips.

BOTTOMS UP

If your model has a base, leave a hole in it. This will enable you to get your fingers inside to help with gluing and fixing.

FIXING METHODS

Set yourself a challenge to design a way to fix the model together by interlocking the top, bottom or sides of the model. This will test your creativity. Look at existing, commercial methods and modify one to suit your model. It's a worthwhile problem-solving exercise.

COURSE ASSIGNMENT

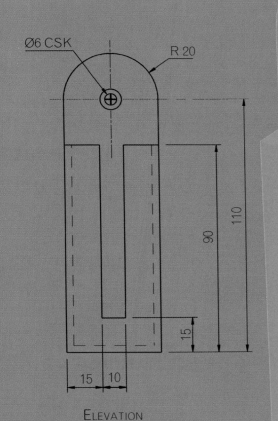

Ø6 CSK
R 20

110
90
15

15 10

ELEVATION

WHAT YOU WILL LEARN

- **Working from a brief**
 understanding the brief • target market • purpose • requirements of the brief

- **Preliminary graphics**
 sketching • dimensioning • annotating • illustration • modelling plan

- **3D modelling**
 which method to choose • assembly

- **Production drawings**
 assemblies • component drawings • pictorial drawings • technical detail

- **Promotional graphics**
 create a scene • planning • using DTP • evaluating

- **Assessment**
 how many marks? • what are they for? • how do you achieve them?

The Assignment represents 50% of your course mark so it's an opportunity to demonstrate your skills and pick up excellent marks. It begins with a written brief that will describe a challenge. This is normally followed by a series of specific tasks.

The brief will also contain images and data. You should read and study all of the information provided. It will highlight the type of graphics that you need to produce and will always include **preliminary**, **production** and **promotional** graphics.

The brief may also describe a target market or a colour scheme, a format, a logo or an image that should be incorporated into your promotional layouts.

You will have a maximum of ten A3 size pages on which to complete your Assignment.

It is vital to study the brief and data sheets. You need to ask yourself:

- What types of graphic are you being asked to create?
- What options do you have to choose from?
- What does the product do?
- How do the components assemble?
- What do you know about the target market?

For instance, in the example on page 185 two components are assembled using a 'T' Bar and slot (see data sheet 1). What stops the 'T' bar from sliding right through the slot?

BRIEF

The **Klik Design Institute** (**KDI**), has created a wall-mounted mobile phone holder called the **fone pokket**. It is designed to store and display a phone when not in use. It is a standard design that can be adapted to suit any phone. The detail drawings (data sheet 1) shows the standard fone pokket design.

The fone pokket comes in two parts: a wall bracket and a pocket to hold the phone.

The dimensions of the wall bracket are fixed and will not change.

The dimensions of the phone pocket should be modified to suit each phone type.

Your brief is to modify the dimensions of the pocket to suit a specific model of mobile phone and produce a range of drawings and sketches including preliminary, production and promotional graphics.

Advertising space inside tube trains and on buses has been purchased to promote the fone pokket. You will produce a promotional layout for one of these advertising spaces.

The fone pokket is aimed at a target market aged 16–24 years and should appeal to both genders.

ASSIGNMENT TASKS

1. **Research** the brief and target market and record your research for later use.
2. **Preliminary graphics:**
 a) Sketch and dimension a mobile phone for use in the fone pokket.
 b) Create dimensioned preliminary sketches of the pocket and a modelling plan to enable production drawings to be made.
 c) Create an illustration of one of the components.
3. **Production drawings:**
 a) Create CAD production drawings to include relevant manufacturing detail.
 b) Create a production drawing that shows how the mobile phone, pocket and wall bracket assemble.
4. **Promotional graphics:**
 a) Design and create a graphic layout to promote and display the fone pokket in one of the advertising spaces described.
 b) Include: the product name, a catchy slogan and additional information in the promotional layout.
 c) Include a positive image of a young person in the promotion.
5. **Evaluate** your use of design elements and principles and DTP features in your promotional layout.

184

DATA

The *fone pokket* should:

- hold the mobile phone securely
- allow the charger plug to be connected when the phone is in the holder
- appeal to both genders of a young target market, 16–24 years
- have a style that appeals to the target market
- include a company logo.

ASSEMBLY DRAWINGS

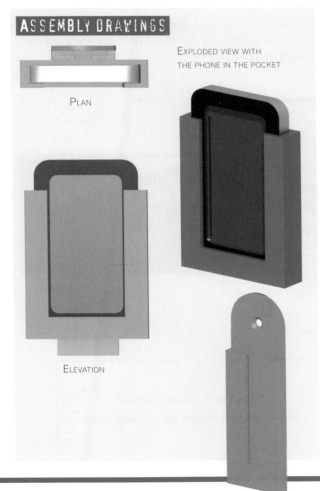

PLAN

EXPLODED VIEW WITH THE PHONE IN THE POCKET

ELEVATION

EXPLODED VIEWS

The exploded views show the front and rear of the phone, the phone pocket and the wall bracket.

The phone requires a loose fit within the pocket. The pocket assembles to the wall bracket using a 'T' Bar slider on the pocket into a slot in the wall bracket.

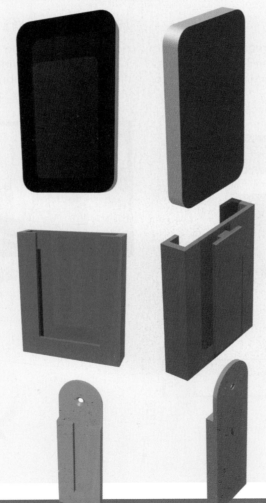

WALL BRACKET — DETAIL DRAWINGS

These sizes will not change

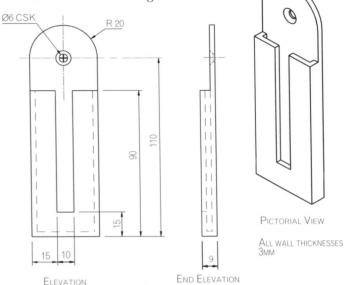

Ø6 CSK

R 20

110

90

15

15 10

9

ELEVATION

END ELEVATION

PICTORIAL VIEW

ALL WALL THICKNESSES 3MM

STANDARD MOBILE PHONE — CRITICAL DIMENSIONS

The critical dimensions are shown. You will need to determine these dimensions on your chosen phone and modify the pocket to suit.

THICKNESS

WIDTH

HEIGHT

PROMOTIONAL ADVERTISING SPACE

T-side advertising space on buses and tube car headline panels on tube trains has been purchased. These two advertising spaces are explained below. Choose one of the advertising spaces for your promotional layout.

Your promotional work should make best use of these spaces. Ensure your layouts are visually exciting, communicate your product information clearly and include high quality images.

You will need to recreate the exact proportions of the advertising space on your DTP package, so work carefully and produce an accurate template.

You will also need to produce preliminary layouts that have the same proportions. You might want to print your template and use it to plan your preliminary layouts.

BUS T-SIDE ADVERTISING SPACE

The T-side is a standard bus advertising space that is instantly recognisable on the high street. It allows for a more creative layout space with the T-shaped format. A T-side advert can feature a strong visual, as well as a tactical headline, to provide an eye-catching display .

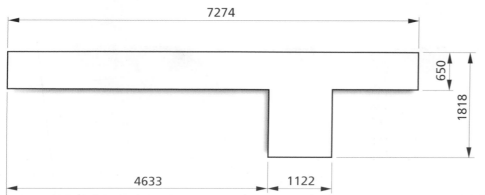

7274

650

1818

4633

1122

TUBE CAR HEADLINER PANEL

Advertising on a tube train can be very effective. Passengers have an average of 13 minutes 'dwell time' to study the information on a tube car panel. So make the most of this opportunity to show your product information in a positive and visually exciting way.

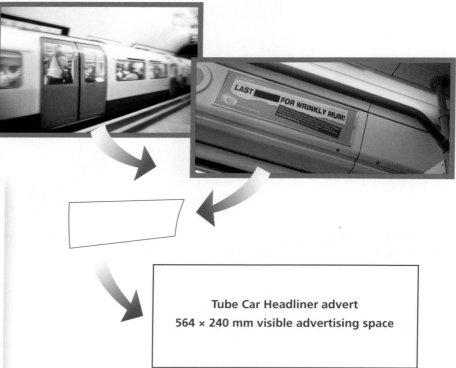

Tube Car Headliner advert
564 × 240 mm visible advertising space

ANALYSIS OF THE BRIEF

It is important that you are clear about what you need to do to complete your Assignment. Study the brief carefully. Break the brief into smaller parts and note down what you can do in each task. Always include the 3Ps in your analysis.

Pay close attention to the target market:

- Who are they?
- What styles do they like?
- What visuals will they respond to?

The brief will normally describe drawings of components that need to be 3D modelled. You must plan how you will do this.

Designing parts of the product is an opportunity to create a style that the target market will like. It can also showcase your graphic skills: grasp the opportunity.

Analysis of the Brief & Research

Tasks
Product – 'fone pokket'
Company – KLIK DESIGN INSTITUTE
Select a suitable font and work with the initials KDI to make a logo.
Target Market – 16 – 24 years old and both genders: Try out vibrant colour schemes and curvy styles – aesthetics will be important..

Preliminary Drawings
Sketch. measure and dimension my own phone.
Sketch and dimension the standard pocket. to fit..
The 'T' bar on the pocket will need to fit the slot in the wall bracket.
Pocket – may be restyled with a logo added.

Production drawings
Model three components..make a modelling plan.
Wall bracket – follow dimensions given.
Project production drawings with dimensions.
Assemble the components and create an exploded view or a section.
Project assembly drawings.

Promotional Graphics
Create a rendered image and a scene.
Create a promotional layout to fit the side of a bus or inside a tube train.
Draw a template of the advertising space..
Source images of young people. possibly using a phone.

Pocket re-styling – the pocket must appeal to the young target market.

Introducing a curvier shape may appeal to the target market

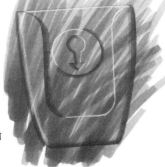

It could look striking if the colours of the two parts contrast in orange and purple

Logo Design

I'll work with the company initials and try to create a simple but memorable logo

Logo design raised on the surface will create texture and detail

A design on the inside surface would look good when the pocket is empty

ASSESSMENT

1. Analysing graphic brief and carrying out research activities. **5 marks.**
✓ The analysis is relevant and detailed. The target market is explored: the analysis covers all three graphic areas. Many specific tasks have been identified and have been taken forward: it is clear that these inform the rest of the Assignment. Marks awarded: 5

2. Communicating design features through use of light, shade, tone and/or texture. **3 marks.**
✓ Illustration skills are demonstrated in a design context using marker pens. Illustration work is very strong, suitably complex and the skills demonstrate understanding of form, light and texture. The skills and techniques are consistently applied. Marks awarded: 3

ORTHOGRAPHIC SKETCHES

You must provide enough information to allow 3D models to be built and assembled.

Orthographic sketches can be dimensioned, show true shapes and are better than pictorial sketches for this purpose.

Remember to apply the correct drawing standards and conventions:

- third angle projection layout
- correct line types
- correct dimensioning
- enough dimensions to build components
- centre lines on circles and arcs
- view titles and a title block, completed correctly.

Adding a checklist (top of the sheet) based on the brief, allows you to check off each task once it's completed.

TIPS

The quality of your sketching is important:

- Sketch freehand: don't trace your graphics.
- Use construction techniques to build your sketches.
- Learn to sketch straight lines.
- Learn to sketch a right angle.
- Train your eye to recognise and create good proportion.
- Use the correct drawing standards throughout.

COURSE ASSIGNMENT

Task checklist – My own phone
- Sketch and measure my own phone. ✓
- Identify and measure the three important sizes. ✓
- Measure the position of the charging socket. ✓
- Measure the diameter of the charger plug and work out the position and size of the gap required. ✓

Task checklist – Phone Pocket
- Sketch and measure the phone pocket. ✓
- Add the dimensions required to build the phone pocket. ✓
- Create a space for the charging socket & plug. ✓
- Work out how to create my own design.
- Add a title block, view titles and ✓
- 3rd angle projection symbol. ✓

Product – "fone pokket"	
Company – KDI	
Drawn by – D. Craft	
Date – April 2013	
Not to scale	
All sizes in mm	

My own phone

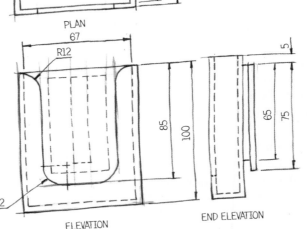

fone pokket

When the standard pocket is built I can subtract the two sides to create curves. This will look stylish and let users get into the charging socket.

GO! ASSESSMENT

1. Applying drawing standards: **3 Marks.**

✓ Correct drawing standards are applied throughout: line types, dimensions and projection methods are all correct. Title block is sufficiently detailed. Marks awarded: 3.

2. Including relevant and sufficient detail to inform development of production graphics: **3 Marks.**

✓ There is enough dimensioning and detail to support modelling. The modelling plan (next page) is also included in this assessment and is both detailed and correct. Marks awarded: 3.

MODELLING PLAN

Making a modelling plan is the best way to analyse a component and identify challenges. It helps you to work out how you will model a component. Remember, there are many different ways to model each component.

TIPS

- Use freehand sketches to create your plan. The sketches should be a combination of 2D and pictorial. This will showcase your sketching ability as well as your understanding of 3D modelling.
- Annotate your sketches to explain the modelling techniques you will use.
- The modelling plan should be with you at your computer when you begin your CAD modelling.

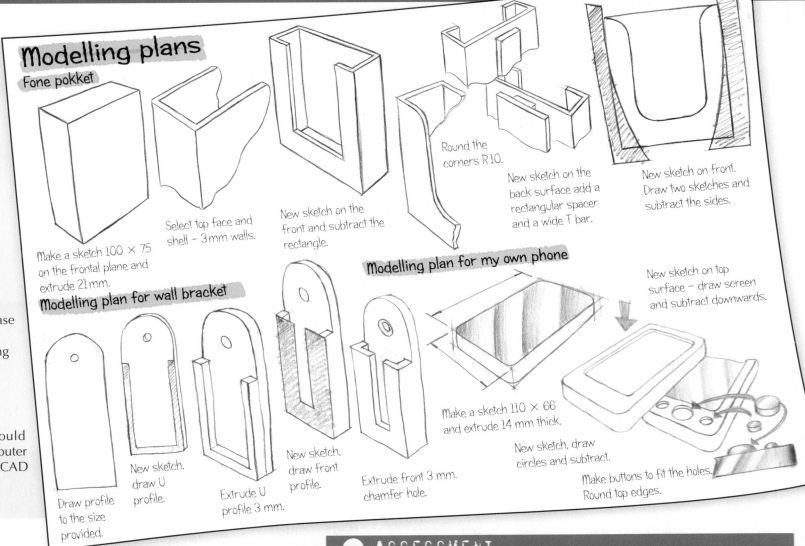

Modelling plans

Fone pokket

Make a sketch 100 × 75 on the frontal plane and extrude 21 mm.

Select top face and shell – 3 mm walls.

New sketch on the front and subtract the rectangle.

Round the corners R10.

New sketch on the back surface add a rectangular spacer and a wide T bar.

New sketch on front. Draw two sketches and subtract the sides.

Modelling plan for wall bracket

Draw profile to the size provided.

New sketch. draw U profile.

Extrude U profile 3 mm.

New sketch. draw front profile.

Extrude front 3 mm. chamfer hole.

Modelling plan for my own phone

Make a sketch 110 × 66 and extrude 14 mm thick.

New sketch. draw circles and subtract.

New sketch on top surface – draw screen and subtract downwards.

Make buttons to fit the holes. Round top edges.

GO! ASSESSMENT

1. Using proportion and representation of item. **3 marks.**
 ✓ The sketching is proportionally accurate and effectively represents the components. There is additional challenge through the use of partial views and assembly details all successfully carried out. Marks awarded: 3.

ASSIGNMENT | 3D MODEL

You are not awarded marks for making a 3D CAD model in your Assignment, but you are awarded marks for the production drawings and illustrations you make from it.

You should sketch a modelling plan before you create your 3D models. This will help you plan each component part and how they fit together.

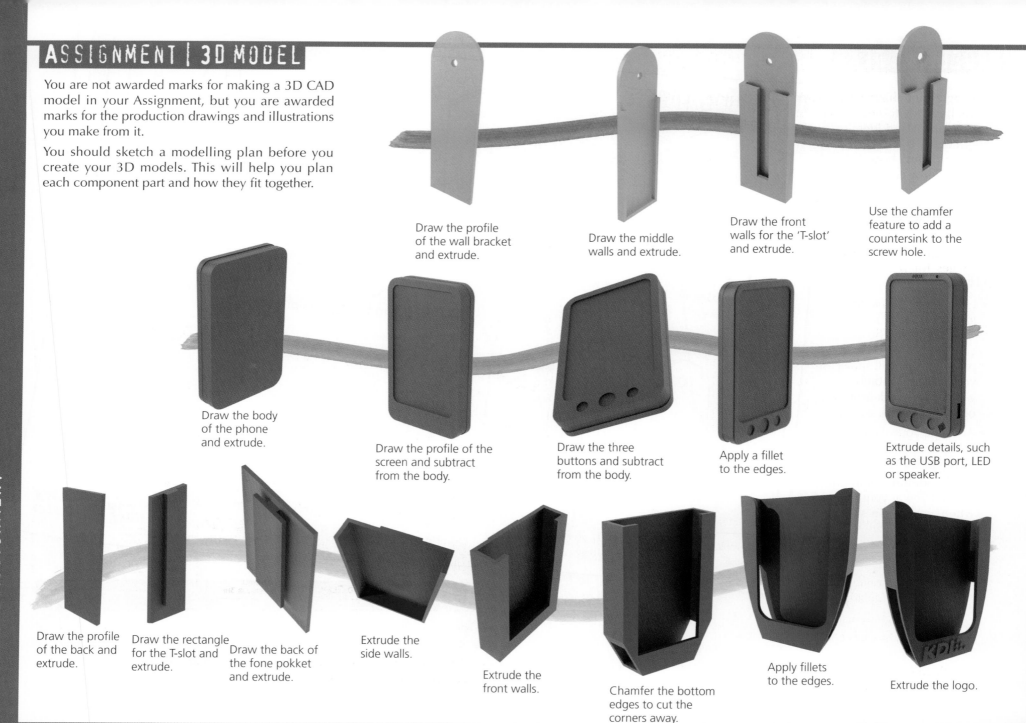

Draw the profile of the wall bracket and extrude.

Draw the middle walls and extrude.

Draw the front walls for the 'T-slot' and extrude.

Use the chamfer feature to add a countersink to the screw hole.

Draw the body of the phone and extrude.

Draw the profile of the screen and subtract from the body.

Draw the three buttons and subtract from the body.

Apply a fillet to the edges.

Extrude details, such as the USB port, LED or speaker.

Draw the profile of the back and extrude.

Draw the rectangle for the T-slot and extrude.

Draw the back of the fone pokket and extrude.

Extrude the side walls.

Extrude the front walls.

Chamfer the bottom edges to cut the corners away.

Apply fillets to the edges.

Extrude the logo.

The production drawings are an important part of your Assignment, worth 15 marks in total. They are marked against three assessment standards.

The production drawings you create can be produced using 3D CAD software.

You should ensure that you are meeting the Assignment brief. If you are asked to produce a particular drawing or view it is vital that you do it, or you will lose marks.

You will most likely need a minimum of two pages for production drawings. One page should be dedicated to individual component parts and include dimensions. The second page should include assembled views without dimensions.

In creating your production drawings, you should consider the following:

- Include at least one clear pictorial view.
- Include an enlarged view.
- Ensure that:
 - the drawings are detailed and accurate
 - you are using the correct projection methods
 - the views are aligned accurately
 - the line types are correct
 - the dimensioning is correct and sufficiently detailed
 - the view labels are in place
 - your title block is correct and detailed
 - the third angle projection symbol is in place
 - the correct scales are used.

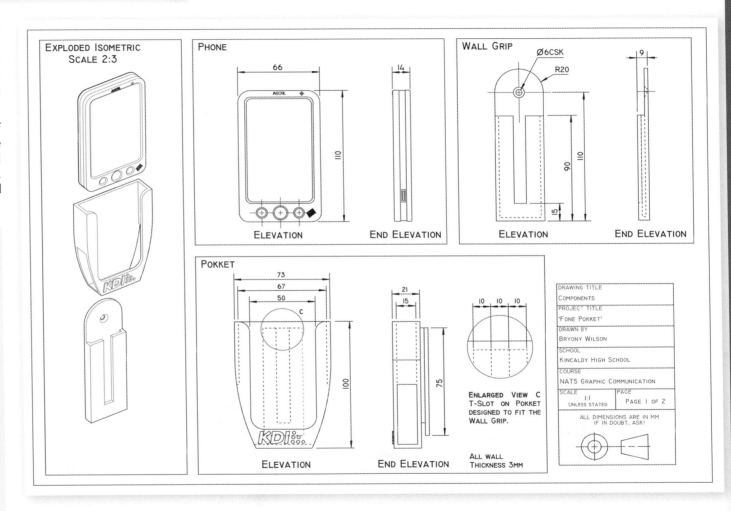

You do not need to dimension every part of the drawing. Having too many dimensions can make a page look cluttered and difficult to understand. Dimension important parts of each component.

My drawings meet the brief:

- There are sufficient dimensions on components to aid manufacture.
- The exploded and sectional views give details about assembly.

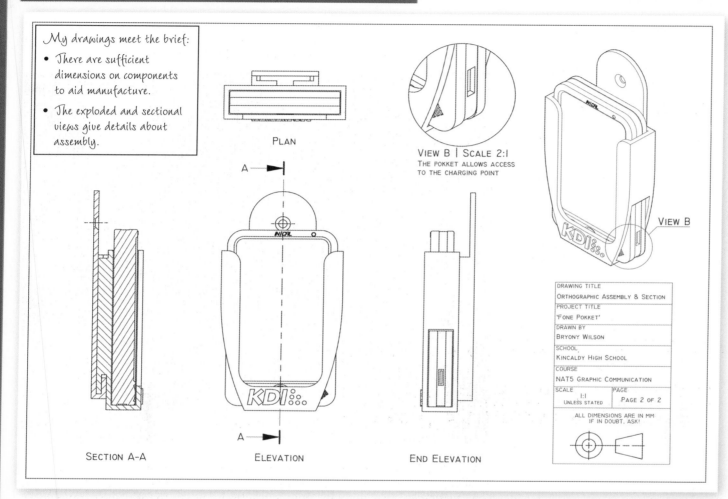

PLAN

A

SECTION A-A

ELEVATION

END ELEVATION

VIEW B | SCALE 2:1
THE POKKET ALLOWS ACCESS TO THE CHARGING POINT

VIEW B

DRAWING TITLE	
ORTHOGRAPHIC ASSEMBLY & SECTION	
PROJECT TITLE	
'FONE POKKET'	
DRAWN BY	
BRYONY WILSON	
SCHOOL	
KINCALDY HIGH SCHOOL	
COURSE	
NAT5 GRAPHIC COMMUNICATION	
SCALE 1:1 UNLESS STATED	PAGE PAGE 2 OF 2

ALL DIMENSIONS ARE IN MM
IF IN DOUBT, ASK!

Remember, while your 3D CAD software will generate production drawings from your 3D model, you will still need to edit and lay out the page properly. You may need to override some settings to ensure your drawings adhere to appropriate standards and conventions.

GO! ASSESSMENT

1. A range of 2D and 3D graphics that meet the needs of the Assignment brief. **9 marks.**
 ✓ The two production drawings shown on pages 191 and 192 have enough information to meet the requirements of the brief. Relevant assembly details are shown and component parts have a range of suitable dimensions. The drawings are accurate and show enough detail to assist manufacture. Marks awarded: 9

2. Adhering to drawing standards, protocols and conventions. **3 marks.**
 ✓ The correct conventions have been applied throughout the drawings and the views are titled and aligned. A range of dimension types has been applied correctly. The title blocks are detailed and correct. Marks awarded: 3

3. Providing relevant, clear, accurate, and sufficient technical detail to enable production using an appropriate method. **3 marks.**
 ✓ The drawings include a range of details that would aid the manufacture. Technical details include: enlarged views, sectional elevations, exploded and assembled pictorial drawings and assembled orthographics. There is more technical detail here than is required. Marks awarded: 3

ASSIGNMENT | ILLUSTRATION

The illustration and presentation of your product is worth 7 marks in total.

Most 3D CAD software will allow you to illustrate your 3D model. Illustrations represent how the product will look when manufactured and are used in promotional documents. Illustrations should highlight key aspects of the product and have visual impact. Visual impact can be achieved by:

* ensuring your illustration is rendered at a high resolution
* the product is displayed clearly, either in context or in a suitable scene
* materials, lights, shadows and reflections are added to enhance the look of the product.

MAKING A SCENE OF YOURSELF...

KEEPING IT SIMPLE

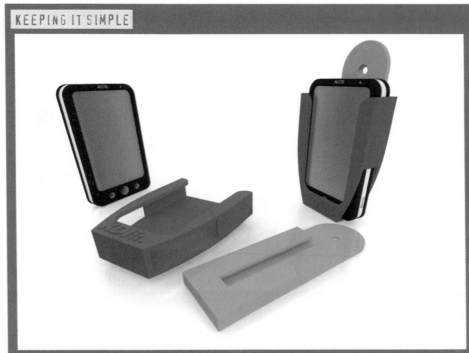

The illustration of your product can be simple yet effective. In this example models are arranged on a surface that is white and does not show until shadows are created: it is subtle and effective.

You will be using your illustration within your promotional DTP. It is a good idea to plan your layout and illustrate your CAD model to fit with your DTP, so try to plan your modelling scene when you prepare DTP thumbnails.

IN CONTEXT

Illustrating the product in a scene can achieve visual impact, but it is often more challenging to use these images in promotional layouts. In this example, two walls and a surface were created. It is fine to submit this scene for assessment without placing it in a promotional document.

GO! ASSESSMENT

1. Using illustration and presentation techniques effectively. **7 marks.**
 ✓ In both the examples on this page, the illustrations make effective use of materials, highlights, shadows and reflections. They are sharp and clear and have been rendered at a high resolution, and give the model and scene visual impact. Marks awarded: 7

ASSIGNMENT | THUMBNAIL LAYOUTS

Preliminary designs for promotional layouts (thumbnails) will allow you to create an exciting layout that you can bring to life on the computer. This example shows thumbnails for both layouts: you only need to tackle one.

Read your brief and consider these questions:

- What type of images will appeal to the target market?
- What colours might they like?
- What does the brief ask for?
- What size of space do you need to fill?
- How much text can you use?

Don't forget design elements and principles and the DTP features learned earlier in this book: these will help give your layouts visual impact.

GO! IMPORTANT

You must measure out the advertising spaces before you plan your layouts. It is vital that you work with accurate dimensions and the correct proportions.

GO! TIP

Thumbnails don't have to be sketched. In this example images of young people have been printed and stuck onto the thumbnails with glue. Thumbnails for both adverts are shown here but only one is required.

194

Notes on the Brief

Young target market. 16 – 28 years. Promotional layout should appeal to both genders.
Advertising space: 'T' Bar on busses. Headliner Panel on tube train

Include:
- the product name – 'fone pokket'.
- a catchy slogan.
- additional information.
- a positive image of young people.

fone pokket
Thumbnail Designs

Bus 'T'-Side Layouts

Pale blue backdrop to contrast with orange parts and recede to create distance or depth

I could reverse the text colour to create contrast and lighten the colour scheme

Flow text can lead the eye from one end to the other

A cropped exploded view can sit in this space and be a focal point

Angular lines will make a subtle pattern and add depth to the layout

Orange is a very visible secondary colour and will stand out well. Though maybe not on a red bus!

Tube train Layouts

The proportions of this layout will allow the fone pokket to sit over a narrow backdrop to create depth

I'll try a drop shadow with the 3D scene to create depth and dominance.

Asymmetric layouts can be more eye-catching than symmetrical ones

Fully cropped figures will create interesting shapes against a rectangular backdrop but I'll choose colours in clothes carefully to create contrast

Two people in the advert will link the two ends of the layout. This creates unity.

GO! ASSESSMENT

1. Planning effective promotional graphics. **3 marks.**
✓ The thumbnails are detailed and demonstrate a variety of creative ideas.
✓ The annotations are evaluative, consider a number of DTP features and demonstrate a firm grasp of the use of design elements and principles.
✓ The content meets the brief, proportions are accurate and there is a focus on visual impact.
Marks awarded: 3.

ASSIGNMENT | PROMOTIONAL LAYOUTS 1

PROMOTIONAL T-SIDE BUS ADVERT

Use your thumbnail layouts to put together a draft DTP layout.

Check the brief to ensure you include all the required items.

Evaluate your first draft and make small improvements to your layout with fine tuning.

Draft layout

Final layout

FINE TUNING

Fine tuning your layout is vital to give it visual impact.

This final layout makes seven main changes from the draft layout: see if you can spot them.

In your own layout try adjusting:

- the positions of the main items
- colours and colour fill styles
- the images you have selected
- font styles, sizes and colours
- DTP features such as drop shadow, flow text, text wrap, transparencies etc.

Check the following:

- Are items accurately aligned?
- Is there enough contrast?
- Have you considered other design elements and principles?

The assessment standard below is covered twice to help clarify the assessments of each of the promotional layouts in this book.

GO! ASSESSMENT

1. Producing promotional graphics to meet the requirements of a brief. **3 marks.**
 ✓ The requirements of the brief have been met: market, purpose, content and style are all covered in the layout. Marks awarded: 3

2. Using illustrations effectively in the production of promotional graphic publications. **3 marks.**
 ✓ The illustrations enhance the layout by creating two focal points. The exploded view makes best use of the vertical space and gives information about the number of parts and helps clarify assembly. Careful positioning connects the user with the product and product name.
 ✓ The illustrations are sharp, high quality images that help bring visual impact to a challenging, elongated layout. Marks awarded: 3.

3. Using layout techniques, design principles and elements, and DTP. **7 marks.**
 ✓ DTP features used effectively include: full cropping, flow text, reverse text colour fills, drop shadow, font styles and rotate. The scene is well-lit and the shadows cast are subtle but effective.
 ✓ Design elements and principles employed include: contrast, unity (through colour and layering) depth, dominance, balance and texture.
 ✓ Each contributes effectively to the visual impact of the layout.
 ✓ The levels of complexity and detail and the scale of the content are appropriate to the situation: on the side of a bus. Marks awarded: 7.

ASSIGNMENT | PROMOTIONAL LAYOUTS 2

PROMOTIONAL TUBE TRAIN ADVERT

Create your tube train layout by following the same process as the T-side bus advert: first draft, fine tuning and final layout.

Draft layout

GO! ACTIVITY

Copy the table below. Identify and justify four main changes between the draft and final layouts.

Change	Justification	Design elements and principles introduced
1		
2		
3		
4		

GO! ASSESSMENT

1. Using layout techniques, design principles and elements, and DTP. **7 marks.**

✓ The narrow layout space is skillfully filled and has visual impact through its use of layering to create depth and a restricted colour pallet.

✓ Design elements and principles that are most effectively used:
- Contrast brings impact via colour.
- Size establishes dominance in the layout.
- The male figure is closer than the female and both break above the flashbar to create depth.
- Using orange as an accent colour creates unity.

✓ DTP features used effectively:
- Flow text along a path.
- Full cropping emphasises shapes.
- Creative colour fills add texture.
- Drop shadow gives depth.

Marks awarded: 7

Final layout

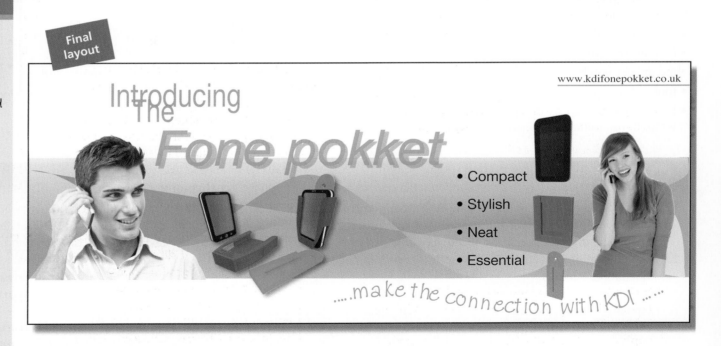

BRIEF

- Design and create a graphic layout to promote and display the fone pokket in one of the advertising spaces described.
- **Include:** the product name, a catchy slogan and additional information in the promotional layout, plus a positive image of a young person.
- **Target market:** a young target market, 16–28 years of age and both genders.

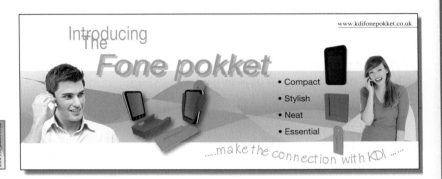

T-SIDE BUS PROMOTIONAL LAYOUT

The shape of the area made the layout challenging but I used the long proportions to create an advert that flowed from left to right. The two people, one at either end, help unify the layout: it looks like they are talking on the phone. This helps to illustrate my slogan, *"make the connection with KDI…"* The reverse text is fresh and legible.

I used a simple scene featuring an assembly of the *fone pokket* to create an interesting group, showing the three parts assembled and separate. The exploded view not only fits the vertical space well but shows how the wall bracket, pokket and phone will assemble.

DTP features that worked well:

- Flow text along a path to create a route from the product name to the girl. It complements the flowing background.
- Colour fills allowed me to create graded fills with a texture for the backdrop.
- Drop shadow used on the product name and the model creates emphasis and depth.
- Font styles are vital in advertising and the modern sans serif font I chose should appeal to a young target market.
- Cropping the CAD illustrations and the people creates contrasting shapes inside the 'T-side' advert.

GO! ASSESSMENT

1. Evaluating progress, justifying choices of graphic items produced and techniques employed. **5 marks.**

 ✓ Preliminary graphics – Evaluative annotations describe the choices made at thumbnail layouts.

 ✓ Production drawings – Drawings meet the brief throughout and this is evaluated by the annotation on the production drawings.

 ✓ Promotional graphics – The evaluation covers the impact of design elements and principles on the layouts in detail. DTP features that improve visual impact have also been evaluated effectively.

 ✓ Care has been taken to relate evaluations to the brief and a justification of the layout is given. Marks awarded: 5.

TUBE TRAIN HEADLINER PROMOTIONAL LAYOUT

The **design elements and principles** I used work with the **DTP features** to make an effective layout with visual impact that should connect with the target market.

- The rectangular shape and simpler proportions allow me to create depth by having the CAD scene overlap the blue background.
- I used blue in the backdrop to contrast with the orange bracket.
- The flowing background shapes create a path between the two people who are "making a connection". This ties in with the slogan.
- I've used a modern sans serif font style in the product name for impact. The slogan is a fun style to create contrast.
- I left white space above the product name to emphasise it.

DTP features that worked well:

- The bullet point list that creates visual rhythm.
- I still like the flow text, which harmonises with the flowing lines in the backdrop.
- Both figures are fully cropped and this allows me to place them against a new background. I kept their heads above the background to create depth.

PAGE 20

1. a) 4, **b)** barrel and shaft, **c)** shaft, **d)** Ø8, **e)** 7

2. a) metric thread Ø6, **b)** barrel, **c)** barrel, **d)** centre line, cutting plane and fold line, **e)** surface development of flights

PAGE 50 AND 51

Visualisation answer table		
Component		**Match**
1	Shelf	b
2	Upright	d
3	Cylinder	g
4	Surface development	j

5. To find the true shape of the sloping surface.

6. The distance between numbers 10 and 2 on the elevation.

PAGE 52

1. Note: there are 9 errors in total; you only need to identify 8.

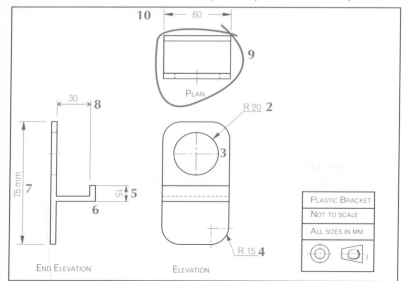

Drawing standard errors in the support bracket production drawing		
	Description of the error	**Marks**
1	This line should be a centre line, not a solid line	1
2	The radius dimension should be a Ø	1
3	The centre lines must extend past the circle	1
4	The dimension arrow should point towards the centre	1
5	The number is the wrong way up	1
6	There must be a small gap between leader line and outline	1
7	Units are stated in the title block, not on the drawing	1
8	Dimension arrows should be closed	1
9	The plan view is upside down	1
10	The number is positioned within, instead of on top of, the line	1

PAGE 60

1.

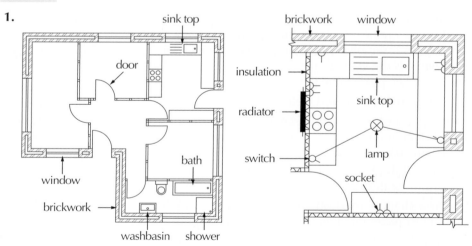

1. 3D CAD features used on: **body** – Revolve profile, Shell, Extrude; **glass** – Extrude or Revolve; **cone** – Revolve; **on fixing cap** – Revolve, Extrude, Array

1. See page 69 for a list of input devices.

2. See page 70 for a list of output devices.

3. CAD drawings can be emailed instantly.
3D CAD models can be viewed from any angle.
Multiple people can work on a CAD model (assembly) simultaneously.
Drawings generated via CAD can have different international standards applied.
CAD drawings require less storage space.
CAD drawings can be illustrated and animated.
CAD models can be simulated/tested.
CAD models/drawings can be used to manufacture.

4. Pan – move the view of a drawing up, down, left or right.
Rotate – turn an object or shape around at an angle.
Array – a circular or linear repetition of shape.
Constrain – lock a line with a set size, angle or position.

5. See page 95.

6–8. See page 95.

1–2. See page 130

1–2. See page 130

1. Layering the pen over the backdrop and product name.
Use of a pictorial main image.
Drop shadow under the pen.
The differences in scale between the main image and the smaller image.

1. Use of accent colours in different parts of the layout.
Layering or overlapping items.
Strong alignment can also help to create unity by linking the aligned items.
Alignment of product name and slogan.

1. Dominance: large, pictorial illustration (lamp), large product name.
Emphasis: positioning the lamp near a 'rule of thirds' focal point. The backdrop helps to push the lamp forwards.
Unity: the horizontal background image ties together the items it touches, as does the vertical colour fill.
Contrast: colours – blue and orange; depth – near and far; tone – light and dark.

1. Unity – the use of light blue as an accent colour around the layout; text wrap oval colour fills; the white line at the top connects the left side with the right
Depth – the Geo lamp overlapping the flashbar, drop shadow round the Geo lamp.

1. The left-hand graphic uses three equally spaced colours on the colour wheel to make an exciting colour scheme. The right-hand graphic uses colours near each other to make a harmonious colour scheme.

The modelling plan should come with suitably clear sketches or drawings and should include:
- Add the bottle and fix or lock in place.
- Add the cap and centre axis aligned with the bottle neck.
- Select bottom surface of the cap and the top of the bottle and mate.
- Add spout and centre axis aligned with the neck of the cap.
- Select underside of the spout top and the top face of the cap and off-set mate.

001/14112013

10 9 8 7 6 5 4 3 2

ISBN 9780007504794

Published by
Leckie & Leckie Ltd
An imprint of HarperCollins*Publishers*
Westerhill Road, Bishopbriggs, Glasgow, G64 2QT
T: 0844 576 8126 F: 0844 576 8131
leckieandleckie@harpercollins.co.uk www.leckieandleckie.co.uk

Special thanks to
Donna Cole (copy-edit); Anna Clark (project management); Ken Vail Graphic Design/Scott Hunter & Peter Linton (layout); Ink Tank (cover design)

A CIP Catalogue record for this book is available from the British Library.

Acknowledgements
We would like to thank the following for permission to reproduce photographs. Page numbers are followed, where necessary, by t (top), b (bottom), m (middle), l (left) or r (right).

P24 Scott Hunter & Peter Linton; p36 Scott Hunter & Peter Linton; p69tm Scott Hunter & Peter Linton; p69tmr 3D Solutions; p70bml Makerbot®; p70br CTR Future Ltd.; p76bmr RGB Ventures LLC dba SuperStock/Alamy; p79 Scanned by Kerry Rodden from original photograph by Ivan Sutherland; p85 C R Clarke & Co. (UK) Ltd.; p91r Moviestore collection Ltd/Alamy; p97l pistolseven/Shutterstock.com; p102tr Scott Hunter & Peter Linton; p103r Scott Hunter & Peter Linton; p104 Scott Hunter & Peter Linton; p110tr Art Directors & TRIP/Alamy; p110b Ciaran Griffin/thinkstock; p124–125 Neale Cousland/Shutterstock.com; p127 Maxisport/Shutterstock.com; p129 Photo Works/Shutterstock.com; p138 massi2/fotolia; p151bl Max Earey/Shutterstock.com; p177t Scott Hunter & Peter Linton; p179 Scott Hunter & Peter Linton; p181 Scott Hunter & Peter Linton; p182bl Scott Hunter & Peter Linton; p182tr CTR Future Ltd.; p186r Adrian Sherratt/Alamy.

We would like to thank the following organisations for permission to reproduce screenshots and logos.

P23–24 Pepakura Designer logo and screenshot used with permission from Tama Software Ltd.; p65 Microsoft Word® and Microsoft Excel® screenshots used with permission from Microsoft; Inkscape screenshot used with permission from Inkscape; Scribus screenshot used with permission from Scribus, moi3d screenshot used with permission from moi3d; Paint screenshot used with permission from Paint.net; Sitoo Web Premium used with permission from Sitoo; VideoPad screenshot used with permission from NCH Software; DraftSight screen image courtesy Dassault Systémes; KeyShot/keyshot.com/Shaun Redsar; p77 Autodesk screen shot reprinted with the permission of Autodesk, Inc.; p110 InDesign® screenshot used with permission from Adobe; p120 Logos used with permission from the following organisations. Argos, ArtiCAD, Frank Bennett author and commentator on cloud computing, eBay, EE Limited, The Entrepreneurs EDGE, Hilco UK, HSBC Holdings plc, JCB, Marks & Spencer, Network Automation, Next, NYX Cosmetics UK, PoliceWitness.com, ToysRus and Unilever.

Whilst every effort has been made to trace the copyright holders, in cases where this has been unsuccessful, or if any have inadvertently been overlooked, the Publishers would gladly receive any information enabling them to rectify any error or omission at the first opportunity.